THE ART OF
TOM LOVELL

AN INVITATION TO HISTORY

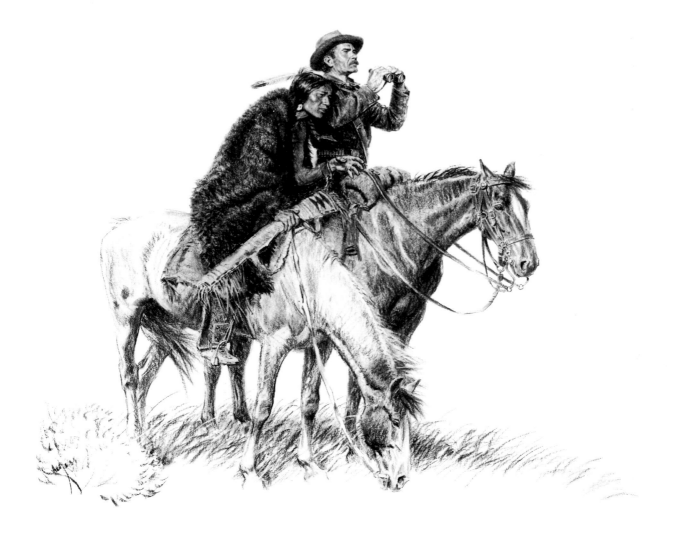

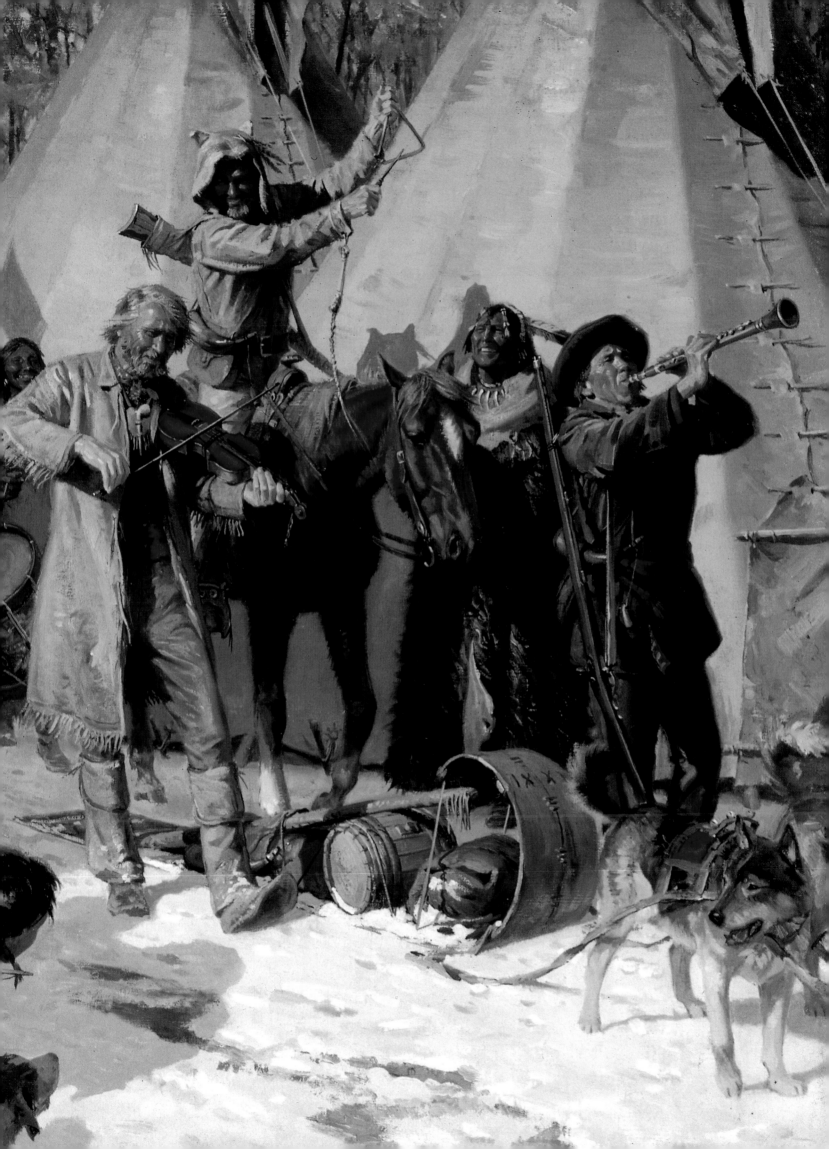

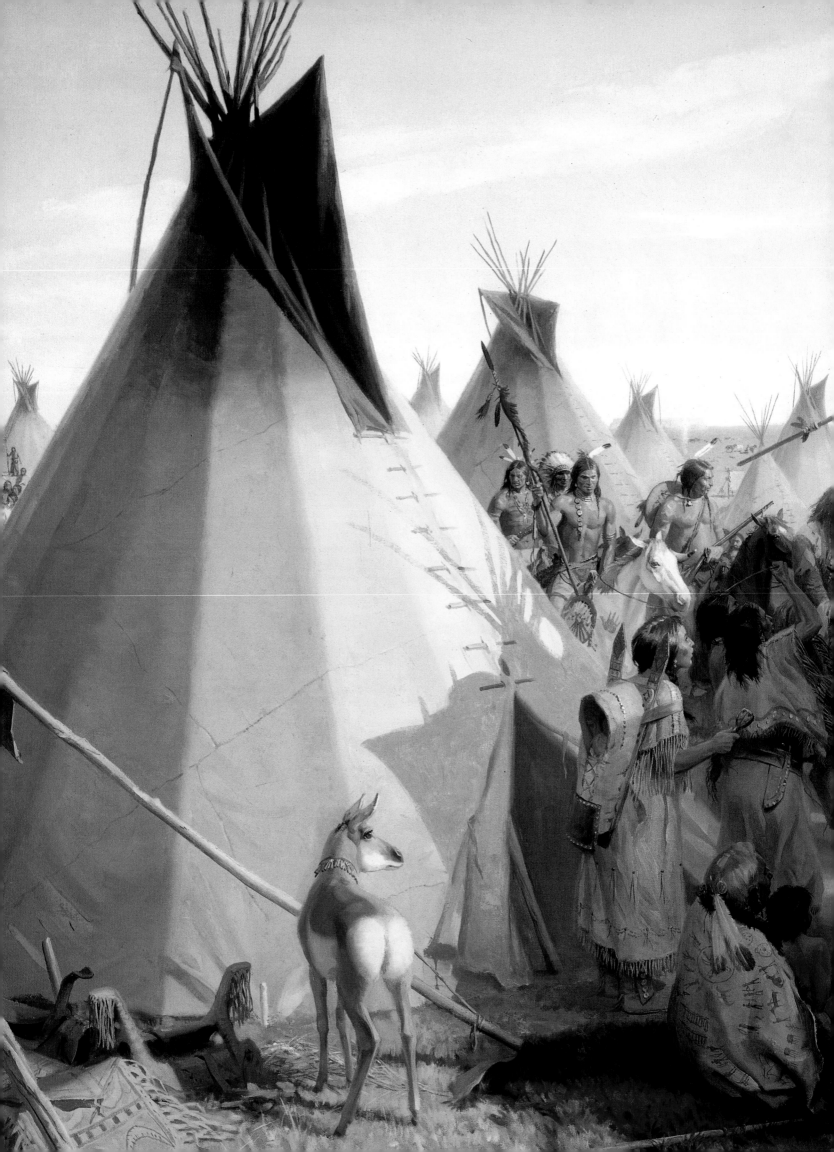

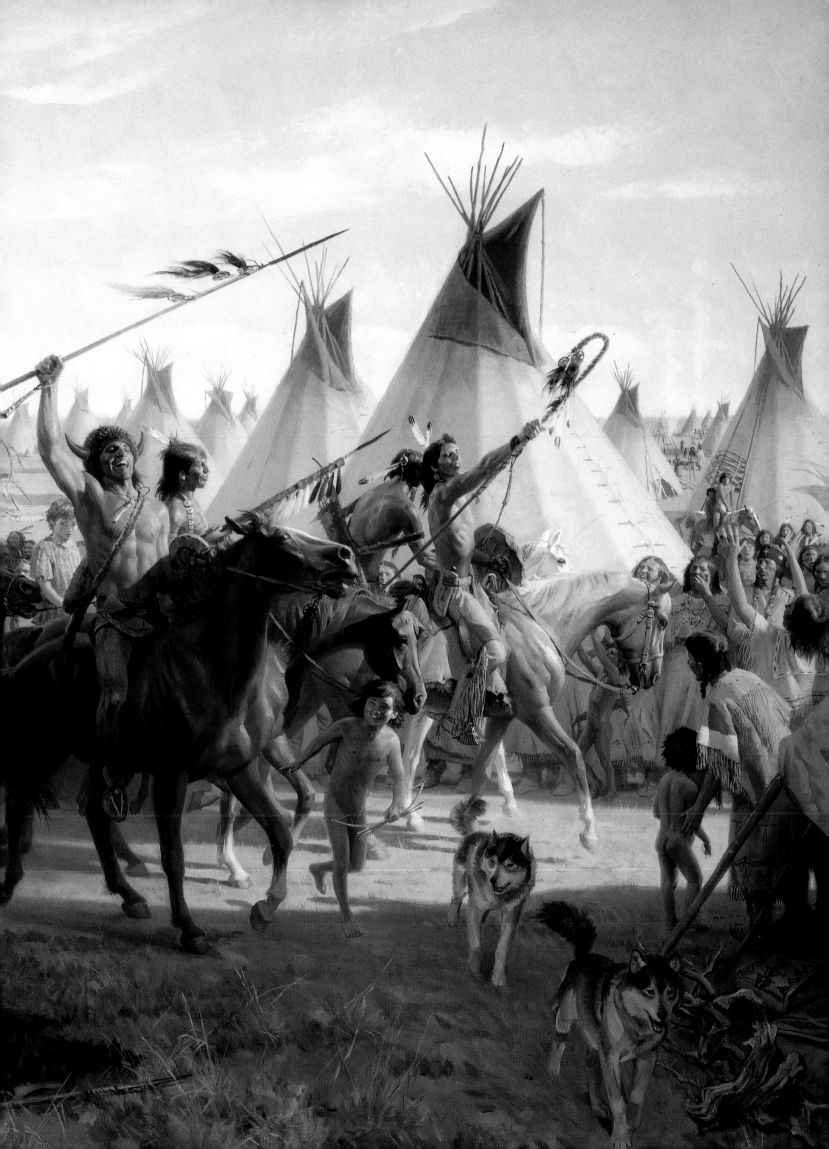

THE ART OF
TOM LOVELL
AN INVITATION TO HISTORY

Text By
DON HEDGPETH AND WALT REED
With An Introduction By
WALT REED

𝕸

WILLIAM MORROW AND COMPANY, INC.
New York

FOR DAVID AND DEBORAH

A WILLIAM MORROW AND COMPANY, INC., BOOK
PRODUCED BY THE GREENWICH WORKSHOP

LIBRARY OF CONGRESS
CATALOGING-IN-PUBLICATION DATA
Hedgpeth, Don.
The art of Tom Lovell: an invitation to history/text by Don Hedgpeth and Walt Reed: with an introduction by Walt Reed. – 1st ed. ISBN 0-688-12645-6
1. Lovell, Tom, 1909– —Criticism and interpretation. 2. Indians of North America—Pictorial works. 3. West (U.S.) in art. 4. Indians of North America— History. I. Lovell, Tom. 1909– II. Reed, Walt. III. Title.
ND237.L78H44 1993 759. 13—dc20 CIP: 92-47465

ACKNOWLEDGMENTS

The authors and the publisher have made every effort to secure proper copyright information. In the case of inadvertent error, they will be happy to correct it in the next printing. The Greenwich Workshop extends grateful thanks for permission to reproduce art by Tom Lovell that appears by permission of the following: Abell-Hanger Foundation and the Permian Basin Petroleum Museum, Midland, Texas, where the paintings are on display for pp. 20–1 *Pecos Pueblo, About 1500;* pp. 50–1 *Coronado's Expedition;* pp. 58–9 *Governor's Palace, Santa Fe, 1840;* pp. 90–1 *Comanche Moon;* pp. 110–1 *Camels in Texas;* p. 157 *Captain Pope's Wells;* all paintings copyright © Abell-Hanger Foundation. Continental Insurance Corporation for p. 146 *The Continental Soldier.* Fort Ticonderoga Museum for p. 147 *The Noble Train of Artillery* (on long-term loan from the Joseph Dixon Company). The National Cowboy Hall of Fame for p. 33 *The Wolf Men;* pp. 68–9 *The Handwarmer;* p. 112 *Target Practice.* National Geographic Society for p. 124 *Battle of the Crater;* pp. 122–3 *The Union Fleet Passing Vicksburg;* p. 128 *Surrender at Appomattox;* p. 129 *Youth's Hour of Glory;* p. 156 *Fall of Nicaea;* pp. 154–5 *Battle of Hastings;* pp. 152–3 *Viking Trading on the Volga River;* pp. 152–3 *Viking Winter Feast;* all paintings copyright by the National Geographic Society. The United States Marine Corps History and Museum Division for pp. 150–1 *Tarawa Landing;* and the United States Marine Corps for pp. 148–9 *Battle of Tenaru River.*

Book design by Peter Landa and Diane Kane
Printed in Italy by Amilcare Pizzi, S.P.A.
First Edition
93 94 95 10 9 8 7 6 5 4 3 2 1

Frontis Art

pp. 2–3 Detail from *Invitation to Trade*
pp. 4–5 Detail from *Professor Lowe's Balloon*
pp. 6–7 Detail from *Comanche Moon*

CONTENTS

INTRODUCTION

The art of Tom Lovell has long been highly esteemed by a select group: his fellow artists and those fortunate collectors who have had the opportunity to acquire his paintings or fine art prints. Others are familiar with his work from the 1950s for *National Geographic* magazine, who commissioned from Lovell major historical paintings of the Crusades, the Conquests of Alexander the Great, and the explorations of the Vikings. Tom's reputation began even earlier with illustrations which accompanied articles and fiction in national magazines ranging from detective pulps in the '30s to *McCalls*, *American*, *The Saturday Evening Post*, *Collier's*, *True*, and *Life* through the '40s, '50s, and '60s.

The public at large may not yet know about this modest artist; yet, when exhibited at the National Academy of Western Art at the National Cowboy Hall of Fame or the cowboy Artists' Annual shows at the Phoenix Art Museum, viewers congregate around his pictures. Although they may not always be able to articulate why, Lovell's admirers realize that they are in the presence of a master. His paintings are quickly sold, and he has won every major Western Art prize offered.

The quality that makes one artist different from another is difficult to recognize. It is his or her "style." Lovell stands out because he is in such command of his craft. His sense of color, for instance, is impeccable. He knows how to use complementary, primary, secondary, and tertiary colors appropriately. He sees the effects of color in the direct light and as reflected from surroundings, how to mute or enhance color as it recedes or advances in perspective. In short, he knows color theory and employs it as it has been learned and taught by generations of artists over the centuries.

He also knows the anatomy of both humans and animals, how they move, how their musculature determines their action, how to use foreshortening and to depict their form in and out of shadow.

With some sixty years of expertise, he could dispense with some of the preliminary work necessary to execute a piece of art (numerous revised and refined black and white and color studies). But it is not Lovell's temperament to take shortcuts. In fact, he enjoys best the testing and trials of many optional compositional variations in order to develop the strongest possible statement of his picture idea.

Having learned his craft through hard discipline, basic art training, and the help of Harold Von Schmidt, Mead Schaeffer, Donald Teague, and others, Lovell is concerned about the rising dependence of younger artists on the camera and the projector. While useful research tools, they have produced a paradox: a generation of artists who lack the initiative to learn to draw and paint. Such dependence on photography imposes a sameness of vision and limits the artist's individuality of interpretation to what the camera provides.

Lovell says, "The artist came into life blessed with a heightened perception of color, spatial relationships, and the fitness of visual things. Let him exercise these faculties, and they will do his bidding at an increased return all his life."

Beyond craft, it is the content of Lovell's pictures that establishes him as a master. Tom's career has been marked by an inner drive—first to learn to draw and paint, and later to make his pictures as accurate and effective as possible. During much of this time, he has been involved with historical subject matter and with recreating the past. Tom takes his picture-making as a serious responsibility. It is his mission to be sure that every element is truthful.

He thinks intensely about his subjects. Ideas for pictures evolve slowly after careful consideration of all the elements. After choosing a theme, he asks himself the big questions about how best to tell the story and then selects his components with great care. Research plays a large part in the process. Many of the ideas for his current pictures have been generated by the readings of journals or diaries of early settlers or documents of history. Yet, as he has stated, "Imagination is the prime ingredient. Research gathers the building blocks, then the creative process begins. Much emphasis has been placed on authenticity (when con-

AN ELDER With age came wisdom. Past hunts taught a man where the buffalo would be; past battles pointed up the strength and weakness of the enemy. The people would listen to such a man.

sidering historical subjects), yet I would give far higher marks to mood, spirit and strong design . . ."

It is this overriding concern with mood and spirit that lifts Lovell's work beyond his technical virtuosity, and the subject of his painting often dictated this mood. For example, hand-to-hand combat must deal with violence, and he certainly has done violent pictures, but he prefers to convey the sense of impending action rather than the act itself. His art teacher at Syracuse, Dr. Irene Sargent, taught him this principle through Myron's statue of the Discus Thrower. To avoid the depiction of a transient action, the sculptor chose the moment just prior to the throw. This insight has been a consideration in Lovell's choice of poses in almost every picture he has been involved with since.

He believes the more important picture themes may be found in the quieter drama of everyday life— the relationships between people that are universal, whatever the race or era presented. Many of his most successful paintings reflect this preference.

Lovell's precepts have served him well, and he has continued to grow throughout his career. Acknowledged the dean of Western painters, he has regularly won major awards from the Cowboy Artists of America and the National Academy of Western Art, including the Prix de West, twice. The Society of Illustrators voted him into their Hall of Fame in 1974 alongside heroes from his youth, Howard Pyle, Harvey Dunn, and N.C. Wyeth.

Lovell's paintings are housed in many public and private collections, including the U.S. Marine Headquarters in Washington, D.C.; the New Britain Museum, New Britain, Connecticut; The National Cowboy Hall of Fame; the National Geographic Society; the New England Life Insurance Company; and the Permian Basin Petroleum Museum in Midland, Texas, for which he executed a series of historical paintings.

Although most of Lovell's pictures recreate the past, once completed, the artist's interest turns to the future—his next painting. From his Santa Fe studio, with a view of the ever-changing light on the Sangre de Cristo mountains, he continues to conjure up the lives of the people who lived on the land before him. By vicariously re-living their adventures in his paintings, he adds to our understanding of the old West. The following pages present only a sampling of his life's work but demonstrate his standing as one of the finest painters of this genre, past or present.

—WALT REED

PART ONE
IN THE LAND OF THE BUFFALO

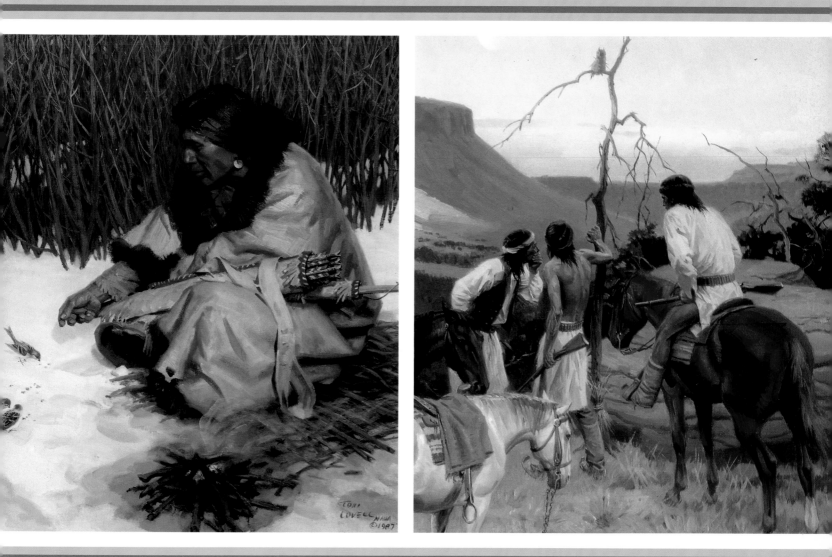

A wild country of free men,
stronghold of a proud warrior race. It encompasses
a zone of intimidating beauty and isolation,
where reality remains obscured by
the swirling mists of legends.

PART ONE

IN THE LAND OF THE BUFFALO

The Great Plains of the American West stretch out beyond the far bank of the great river, past dim horizons, and across broad prairies, into the deep shadow of magnificent mountains. *Llano Estacado*, as the *conquistador* called it, is a vast, limitless land evoking wonder and firing the imagination like ancient stories of mythical Valhalla. A wild country of free men, stronghold of a proud warrior race, where history is perceived imprecisely through smoke and blood, it encompasses a zone of intimidating beauty and isolation, where reality remains obscured by the swirling mists of legend.

In a dim, distant past, Stone Age hunters crossed the Bering Strait on fingers of land between Siberia and present-day Alaska. Over the millennia, these prehistoric people, confronted by advancing and retreating glaciers, spread out across two continents and developed into separate ethnological groups, with distinct languages and cultures.

Eventually the Great Plains of North America became the home of a number of tribes whose lives were centered on the buffalo. At the northern extreme were Blackfeet, Cree, and Assiniboin. Further south lay the hunting ground of the Crow and Cheyenne; to the east were the Sioux. Down on the central Plains were several tribes, including the Arapaho, Cheyenne, Kiowa, and Pawnee. At the southern edge of the Plains were the Comanche. From Canada to northern Mexico, they, and other smaller tribes, led simple, nomadic lives, in pursuit of the great buffalo herds from which they harvested meat, hide, and bone.

The buffalo was more than just a source of food. From tanned hides, the Indians fashioned their clothes and their homes. Rawhide was used for shields, lariats, the bags called parfleches, and to bind points on arrows and heads on war clubs. Horn and bone were shaped into a variety of tools and implements. Hair was used to stuff and pad cradleboards and pillows. Hides with the hair left on served as blankets and robes. The belly, or paunch, was used like a cooking pot. The skull of the buffalo was an important part of religious and ceremonial rituals. From swaddling clothes to burial shrouds, the buffalo was at the heart of Plains Indian culture.

Aided only by the use of domesticated dogs for pack animals, these primitive hunters traveled on foot, in the wake of the buffalo. Draped in buffalo robes and armed with stone-tipped weapons, they haunted the fringes of the herds. On rare occasions, they were able to stampede their quarry over cliffs to their deaths. Survival for the Plains Indian was linked irrevocably to the buffalo. Life revolved around the hunt.

A bold and arrogant stranger arrived on the southern Plains around 1540. He came seeking the legendary golden cities of Cibola and Quivira, and he was riding upon the back of an animal that the Indian had never seen. Since dogs were the only domestic animals known to the Indian, they called this mysterious and wonderful, new animal Spirit Dog, or Medicine Dog.

The Spanish claimed the Plains in the name of their king, but they settled for a tentative presence along the Mexican frontier. Lost, strayed, and stolen horses were soon in the hands of Indians who lived in proximity to the Spanish. Within two hundred years, the horse had been acquired by all of the Plains tribes and had profoundly changed their lives. In a society based in large measure on such highly mobile enterprises as hunting and warfare, the horse was the key to greatness. If the buffalo had been the Great Spirit's first special gift to the Plains Indian, then, surely, the Medicine Dog, the horse, was the second.

For most of the three centuries following Columbus' first voyage of discovery, except for the acquisition of the horse, the Plains Indian remained largely unaffected by the swelling tide of European immigration and settlement along the edges of the buffalo range. To the south, and on the other side of the Rockies in California, the Spanish had subdued other tribes by the sword and the cross. Far to the east, English colonists had accepted the Indian's initial hospitality and then proceeded to push them off their traditional homelands, establishing a precedent for future relations between Indians and whites. But for the most part, during the seven-

teenth and eighteenth centuries, the Plains Indian was left alone.

Few people had ever been, or ever would be, as content with their lot as were the tribes of the Great Plains. They believed themselves to be the favored children of the Great Mystery Power that had created their ancestors and given them this wonderful country and the buffalo.

A belief in supernatural forces was a paramount feature of Plains Indian life. Sky, earth, sun, and wind were all manifestations of the supernatural sphere; as were the trees, rocks, and animals with whom the Indian shared the land. Ceremonial rituals associated with the supernatural were basic to all the various traditional tribal religions.

An individual gained access to the spiritual realm through the vision quest, a solitary vigil of prayer and fasting. These quests were the source of prophesy and revelation concerning personal and tribal destiny. This was also the device through which one received magical powers that the Indian called medicine.

Collections of sacred objects, assembled at the direction of the spirits during vision quests, were called medicine bundles. What seemed a mundane assortment of items—feathers, seeds, rocks, bits of bone, the skins and skulls of small animals, and a ceremonial pipe—were of supreme religious significance to individuals and to the various secret clans of hunters and warriors.

Those individuals who devoted their lives to bridging the gap between the spiritual and the real worlds became shamans, or medicine men. They were the spiritual authority for each band of Indians. It was they who could interpret dreams and visions and understand the mystical meaning underlying natural phenomena. Medicine men were distinct from priests, who conducted tribal rituals and owed their station to an authority passed down within a single family.

A focus of all the sacred rituals was the ceremonial pipe. The smoke of a sacred pipe was the tangible expression of prayer. Traditional songs and dances were also part of the overall context of religious observance.

Most dramatic of all the mystical ceremonies was the sun dance, which was practiced in some form among almost all of the Plains tribes, although the northern tribes had much more elaborate rituals than did the southern.

The sun dance was conducted over a span of twelve days in the summer. For some bands, it was time to give thanks to the spirits for blessings received in the previous year and to seek good medicine in hunting and war during the coming seasons. For others, the ritual was associated with grief over kinsmen killed in battle and a plea to the spirits for revenge.

[17]

On the last climactic day, a select group of warriors underwent various forms of self-torture. Skewers were inserted through flaps cut in the skin of their chests and then attached to rawhide ropes and tied to a ceremonial pole in the sun dance lodge. The dancers strained against the ropes; some were even hoisted off the ground until the skewers tore through the skin. The ceremony was an eerie scene of blood, pain, endurance, and devotion, accompanied by the shrill notes of eagle-bone whistles and singing. The men who participated in the final agony of the sun dance were accorded special honor by their people, on whose behalf their sacrifice had been made.

Honor was a quality of supreme importance to the Plains Indian. The sun dancers and others who were particularly spiritual, such as vision seekers and medicine men, gained honor through the respect of their people. Honor was also earned by displays of exceptional skill and courage during the buffalo hunt, or in battle.

A state of perpetual hostility existed among many of the Plains tribes, and even among various bands within common tribes. Material considerations, such as hunting territory, or horses, often resulted in war, and traditions of revenge persisted for generations. The quest for honor through bravery in battle figured prominently in the inclination to war.

Before the Plains Indian came into conflict with the white man, war between the tribes often had the elements of a structured, ceremonial affair, just like many other aspects of tribal life. Killing an enemy was of less consequence than distinguishing oneself with acts of valor in the heat of battle. Performing acts of individual bravery, which were witnessed by others of the war party, was called counting coup, a certain path to honor.

Riding in and touching an enemy during a fight counted more coup than actually killing him. Many coup might be counted by dismounting in the midst of the battle and standing alone to face the enemy. If a warrior's medicine were strong enough, he might survive such an act of defiance. He would return to the lodges of his people as a hero. Stealing horses held special significance in the system of counting coup. Stolen horses were regarded much more highly than the dead bodies of the enemy.

This emphasis on honor had much in common with the code of the knights in medieval Europe. Such practices would put the Plains Indian at a distinct disadvantage when he faced the guns of white soldiers in the years to come.

Here then were the proud people of the Plains—Crow, Sioux, Arapaho, Cheyenne, Kiowa, Comanche, and still more—all bound by tradition and spiritual attachment to the broad, grassy prairies of the buffalo range. Here they lived over the centuries according to the seasons, in harmony with the natural environment. It was a golden time. The buffalo was an infinite bounty; the horse engendered a genesis of pride and nobility; and this wonderful, wide country was shared with spirit brothers, the wolf and the hawk. This was the time and the place, and these were the people woven together into a vivid tapestry of power and grace—the zenith of what the world would forever consider the archetypical American Indian.

These were the days of sunshine and glory: sweeping panoramas of sprawling encampments where children laugh and play under the caring eyes of the entire community; crisp autumn mornings with a hunting party parading through camp on horses with eagle feathers in their forelocks, prancing impatiently, eager for the chase; the dust clouds and drama of thundering buffalo herds and swift shadows of horsemen in pursuit of meat and honor.

At the beginning of the nineteenth century, rumors blew on the prairie winds of an alien presence on the range of the buffalo. Small bands of strange, pale-skinned men traveled along the rivers and out onto the Plains, moving toward the great mountains to the west. No one could be certain where the strangers had come from, or why they were here. Not even the most powerful of the shamans could foresee that this was the first wave of an enormous tide which would roll swiftly across the Plains, leaving the Indian a stranger in his own land.

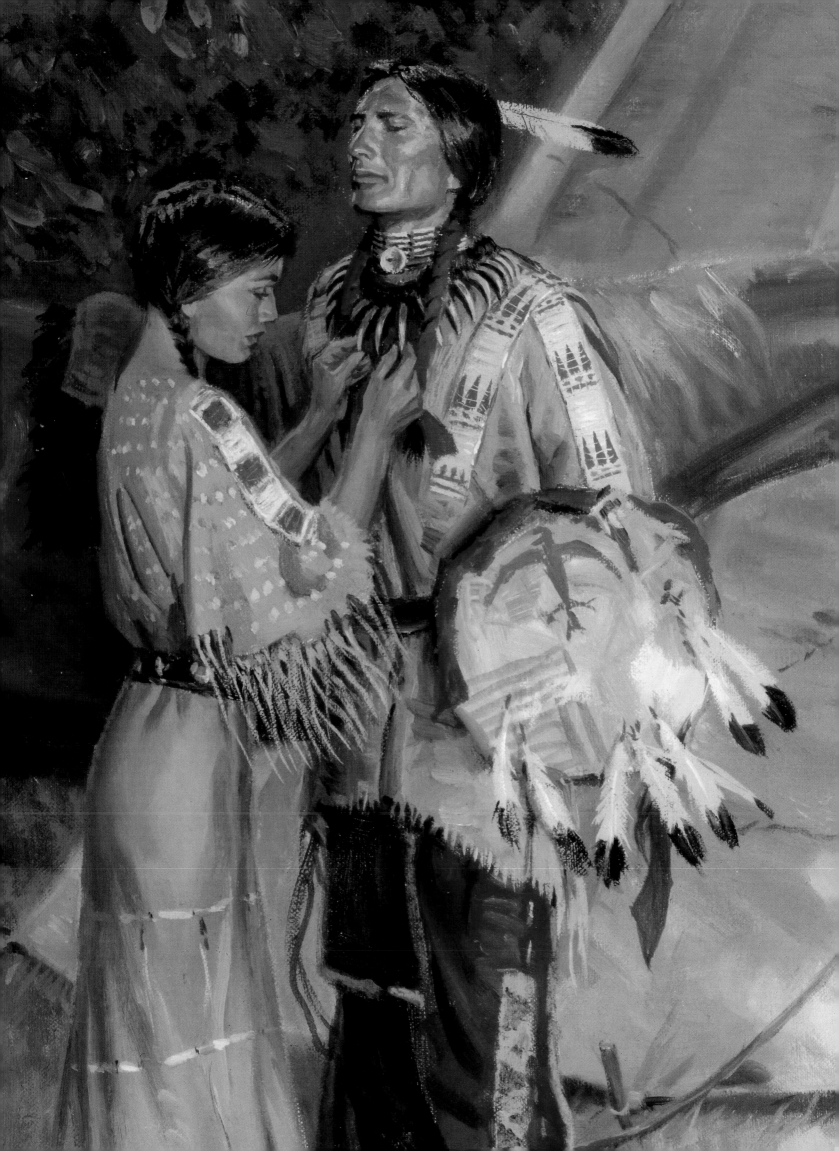

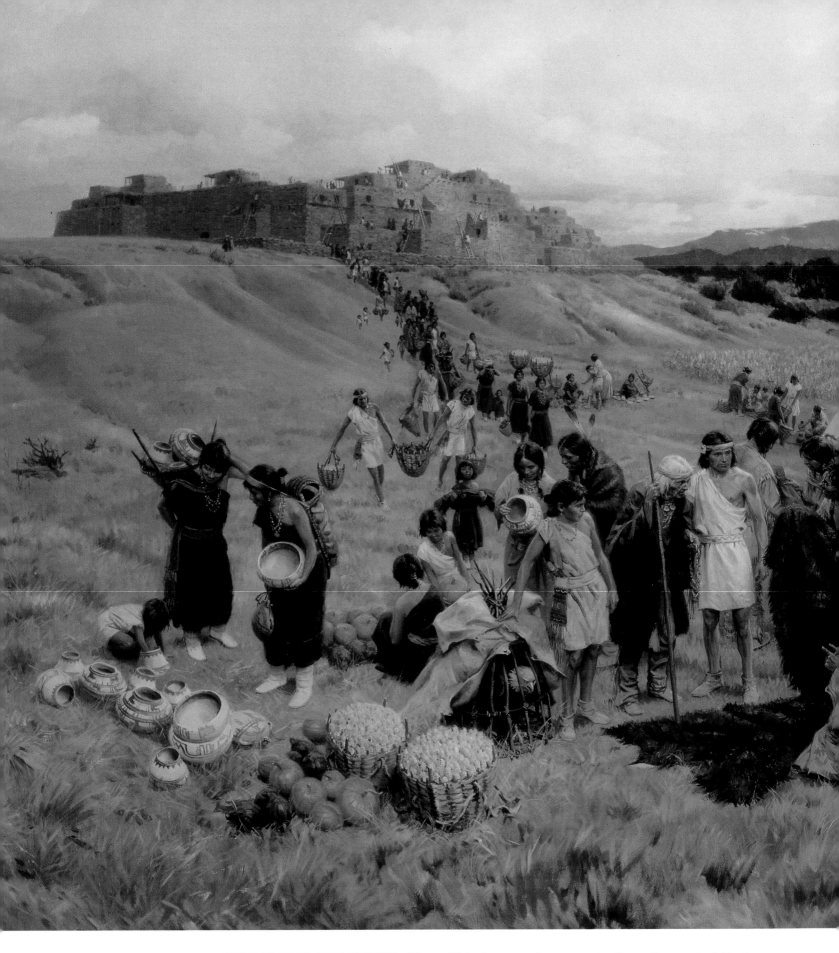

PECOS PUEBLO, ABOUT 1500

This famous place, twenty-five miles east of Santa Fe, was first settled by native Americans around 1200 A.D. and remained active for six hundred years. The location is not far from the southwestern edge of the Great Plains, where the vast buffalo herds ranged. It was a natural site for commerce between

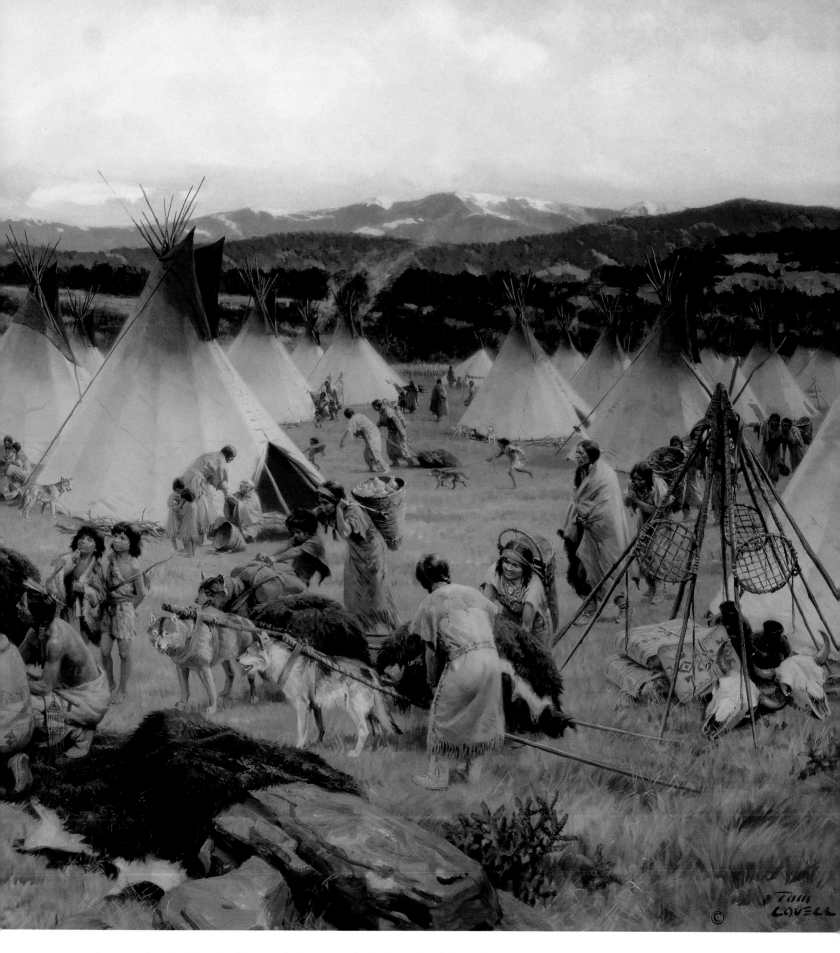

the agrarian Pueblo dwellers and the nomadic buffalo hunters of the plains. Civilization was well developed and in place here long before the arrival of the Spaniards from the south.

In this scene Pueblo and Apache chiefs meet and discuss values for their respective commodities. The Pueblos offer samples of corn, pumpkins, textiles, and pottery. The Apaches bring hides, meat, and tallow from the buffalo. An Apache makes the sign for *equal*, and the chiefs will share a pipe as a prelude to the trading. Peace prevails as men of goodwill sit together in the shadow of the ancient mountains.

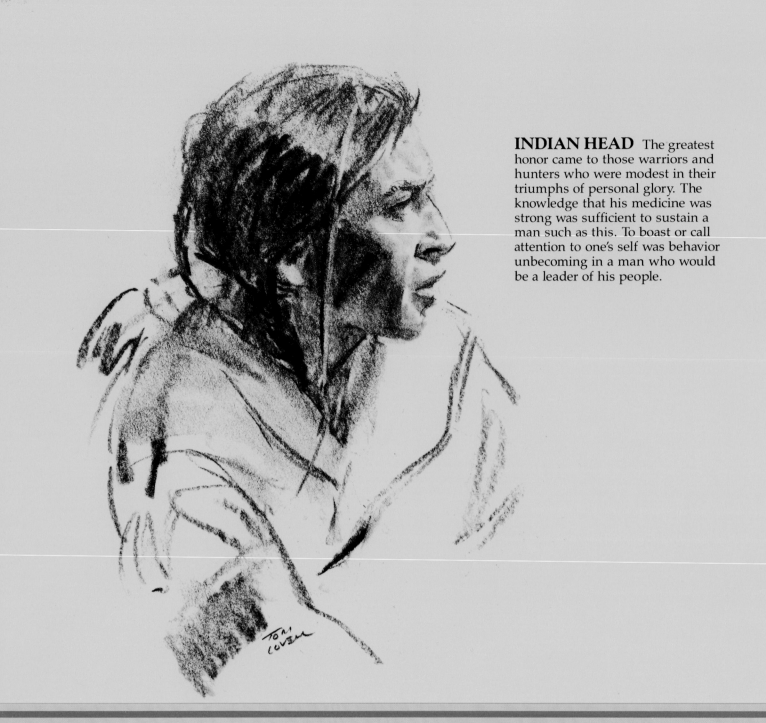

INDIAN HEAD The greatest honor came to those warriors and hunters who were modest in their triumphs of personal glory. The knowledge that his medicine was strong was sufficient to sustain a man such as this. To boast or call attention to one's self was behavior unbecoming in a man who would be a leader of his people.

THE HUNTER

The Indian lived in harmony with nature. The animals were his brothers, sharing in the bounty of that wonderful land where the buffalo ran. Here, a Sioux hunter has ventured away from camp on a cold, grey day. The closeness of his lodge and the clamor of the village has made him restless. Out here in the open, he is content. He shares the warmth of a small fire and a few crumbs of pemmican with some sparrows and embraces the silence.

The hunter's bow and arrows rest across his knees, still in their cases. Fresh meat would be welcomed back in camp, where a steady diet of dried buffalo has grown increasingly tasteless. Venison, or perhaps a fat rabbit would bring squeals of delight from his children. But meat is not what has brought him out here today. He seeks solitude to settle his soul.

The great buffalo herds have moved far to the south. He thinks about the rumble of hooves which will signal their return when the snow begins to melt. He sees himself on the hunts to come and remembers those of the past. And for now, he welcomes the company of the sparrows and is at peace with himself.

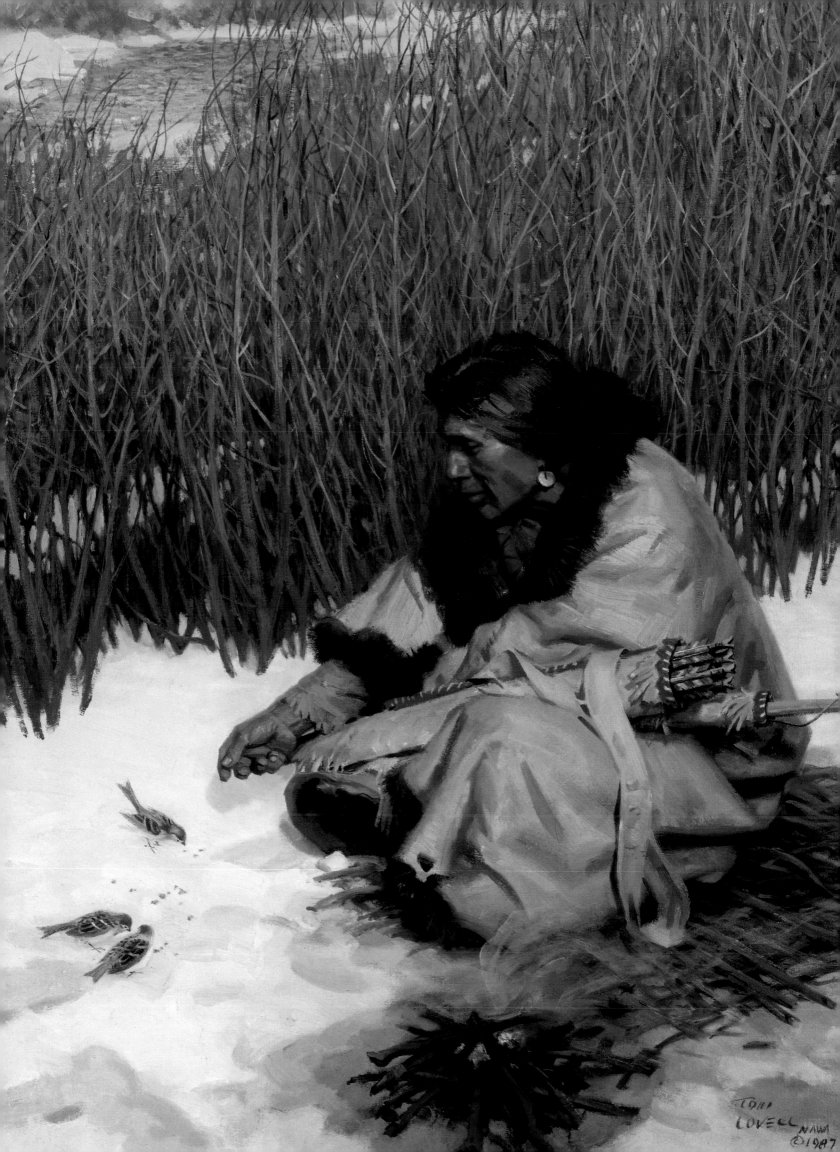

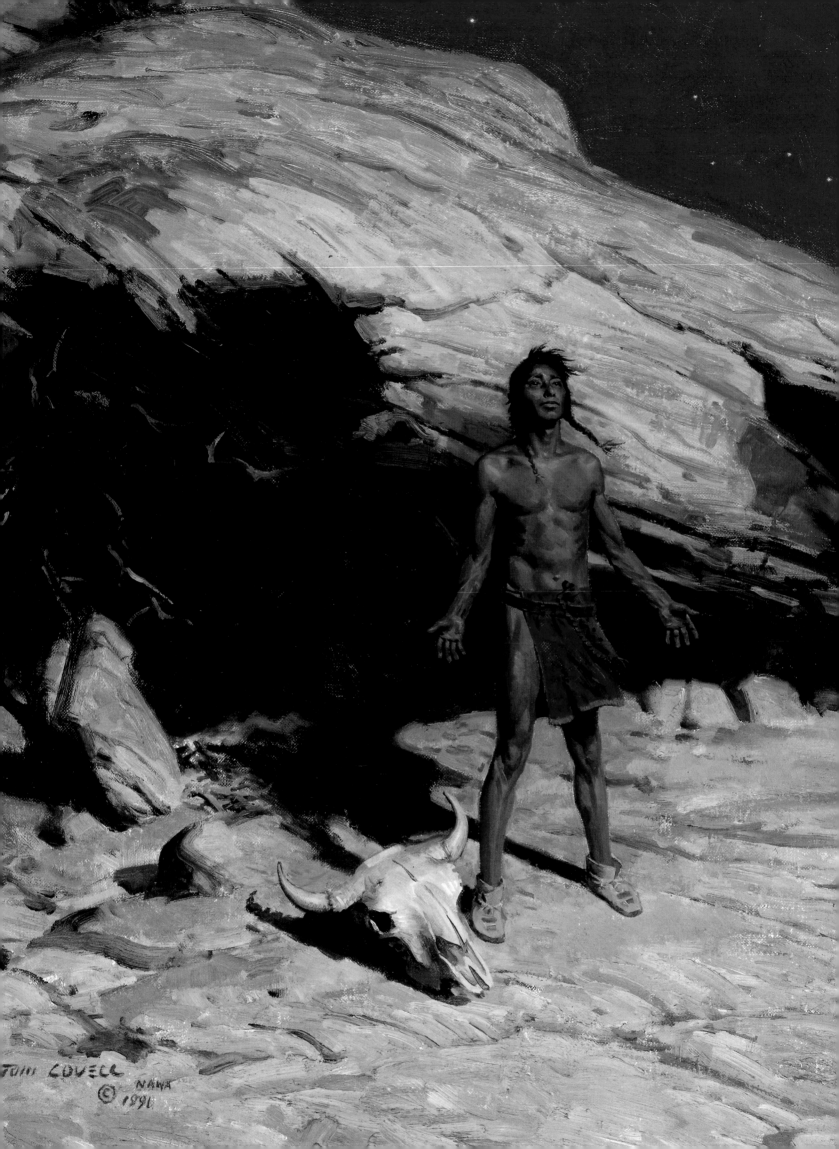

THE DUST SIGNAL In an act of defiance, a scout marks his ground before an enemy that has pursued him and is now in sight. This signal marks where he will make his stand.

◄ THE VISION SEEKER

Among the Plains Indians it was a widespread custom for a boy to undertake a vision quest as a rite of passage into manhood. The seeker would first purify himself in a ceremonial sweat lodge and then retire to a remote site and begin a fast of several days duration. This was an intensely personal ritual and would be repeated throughout a lifetime when there was a need for help from the mystical forces.

But the young brave's first vision quest was of singular importance. Cold, hungry, and alone on a barren rock ledge, he entreats the spirits to give him a vision. Through the vision he may receive his adult name, information about his personal medicine, or magic, even revelations of his own destiny. Here the young Indian has chosen a sacred place for his quest. The rock formation behind him has the shape of a gigantic buffalo skull to strengthen his medicine. Surely the spirits will be strong on this night.

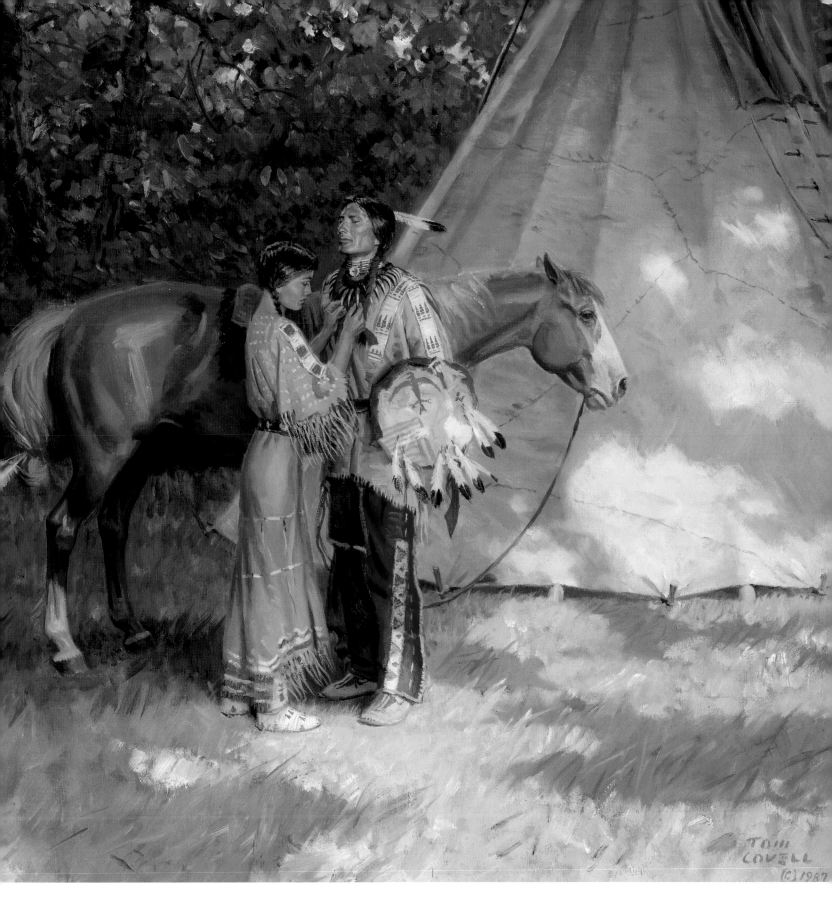

THE FINISHING TOUCH

A succession of ceremonies marked the passage of time for the Indians of the Old West. Entire communities came together for traditional dances and a variety of religious rituals and celebrations as the seasons passed. On such occasions, individual families vied with each other for recognition by outfitting themselves in their most elegant ceremonial dress. It was a measure of status within the tribal community. Indian women took great pride in their family's appearance, particularly that of their husbands. They tanned and prepared the hides from which they fashioned the garments, and they embellished them with intricate decorations of dyed porcupine quills, glass trade beads, shells, and small bones. In preparation for special occasions, the women would comb and braid the men's hair and see to their ornaments, such as the bear claw necklace the wife is arranging on her husband in this scene.

[27]

TIME OF THE COLDMAKER

Winter has always been a brutal season on the plains of North Dakota. Skin lodges provided little protection for the icy winds that blew down from the north. But the Mandans stayed warm in their comfortable homes of earth and wood. By 1750 the Mandans had

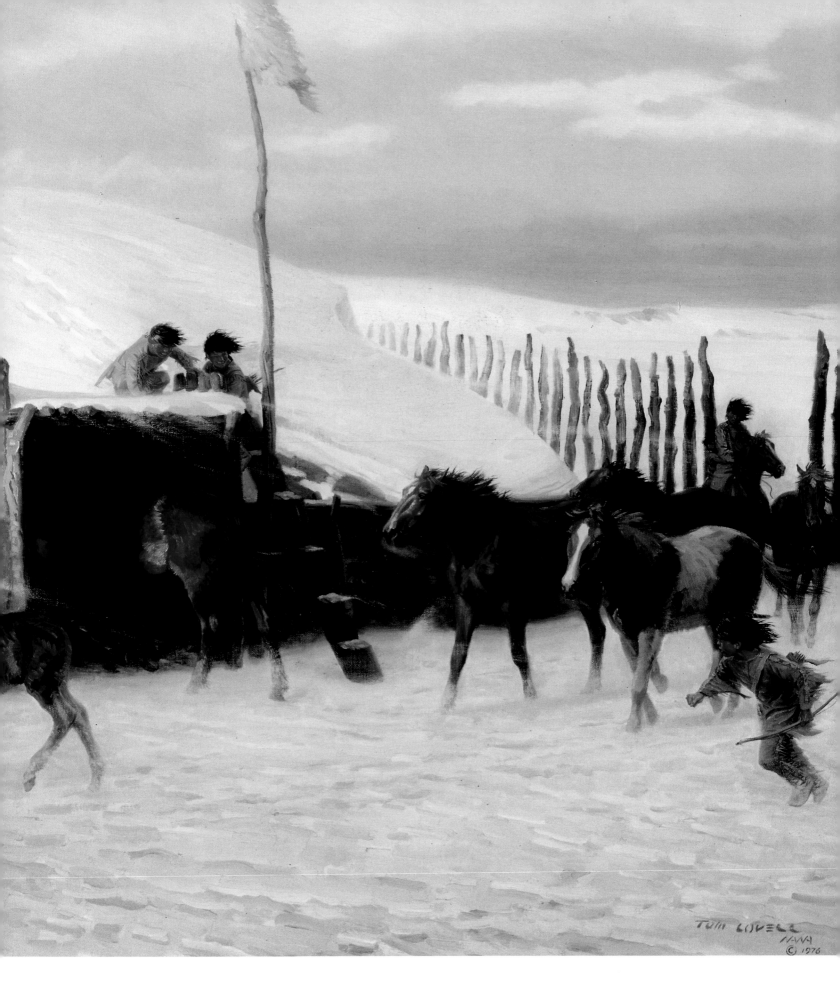

acquired horses, and buffalo hunting took on a great significance in their lives. Now they could lay up ample stores of meat to supplement the vegetables they grew, and the heavy buffalo robes kept them warm in the blizzards.

Mandans attached special importance to their horses. During winter days, the horses were loose-herded in the shelter of nearby cottonwood groves. At sundown, the prized, buffalo horses were brought into the lodges for warmth and security.

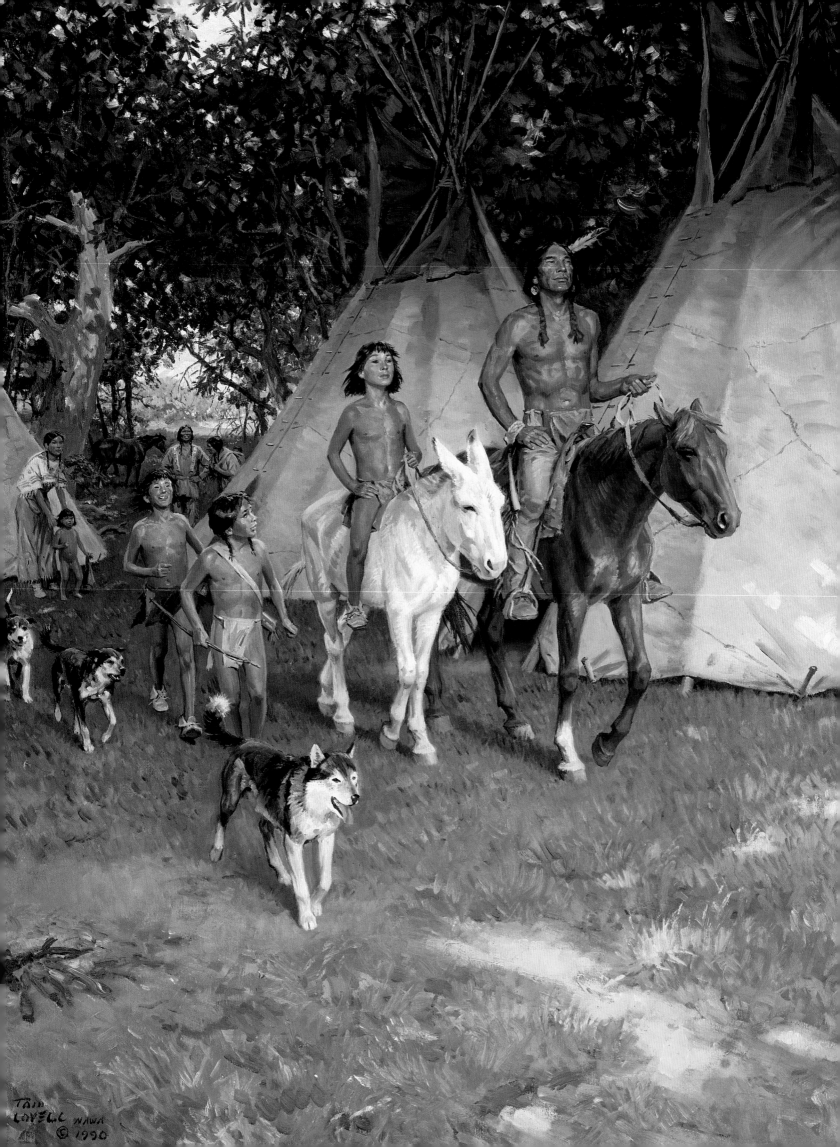

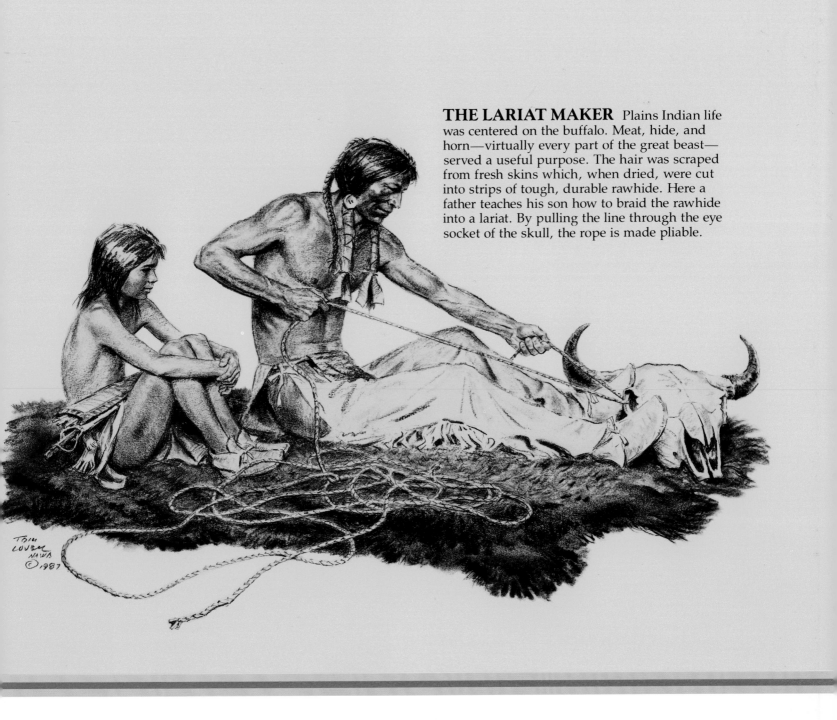

THE LARIAT MAKER Plains Indian life was centered on the buffalo. Meat, hide, and horn—virtually every part of the great beast—served a useful purpose. The hair was scraped from fresh skins which, when dried, were cut into strips of tough, durable rawhide. Here a father teaches his son how to braid the rawhide into a lariat. By pulling the line through the eye socket of the skull, the rope is made pliable.

THE GIFT

The acquisition of the horse had a tremendous impact on the life of the Plains Indian. Primitive nomads were transformed into highly skilled and efficient hunters and warriors. There has always been something special about the man on horseback, a quality of nobility which sets him apart from those who remain on foot.

Here is a scene of that time long ago when the Indian was lord of the Plains, and the great buffalo herds still roamed the prairies. In a Cheyenne camp, a father has made the gift to his son of a rare, white mule. They parade through camp displaying the wonderful gift and basking in the delight and envy their passing invokes. It is a moment of dignity and of pride, a step on the path to manhood for a young boy who revels in the accomplishments of his father and dreams of the day when he, too, shall ride forth for blood and honor.

THE FRIENDLY WILLOWS

It is a cold day on the frozen prairie, and danger is close at hand. A Sioux hunter and his young son grip their weapons and hide quietly behind a low stand of willows. Four Crow warriors, blood enemies of the Sioux, ride by in the snowy silence. The odds are stacked in favor of the Crows, and these are not men who take prisoners. The demands of a warrior's honor conflict sharply with a father's concern for his son's safety.

The Sioux boy's hands are steady on his small bow. He has been taught that bravery is the path to greatness, that it is a fine thing to die young in battle. He has heard the tales of courageous warriors and reaches down within himself for the strength to confront the reality of mortal danger.

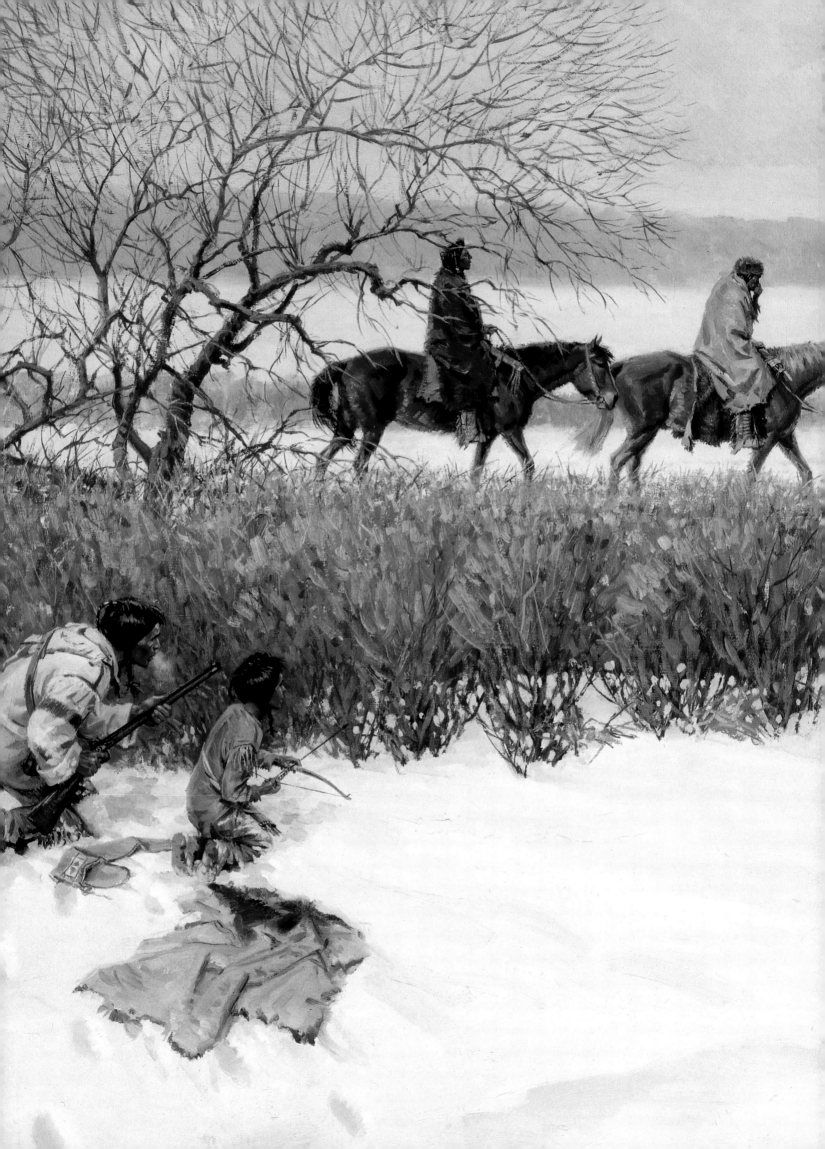

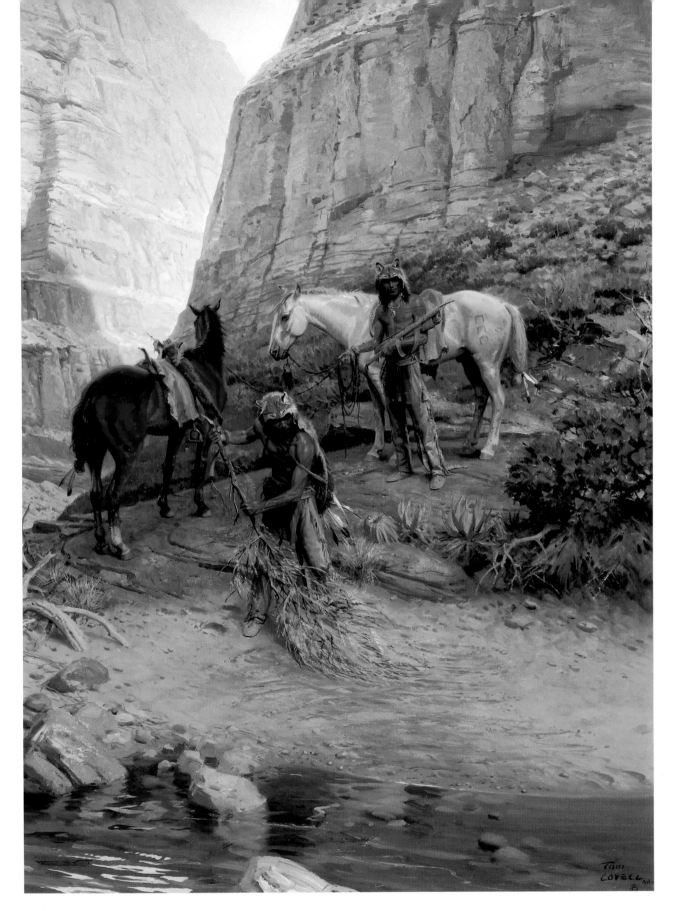

THE WOLF MEN

Warrior societies played an important role in the life of practically every Plains tribe. These societies were made up of warriors who shared common battle experiences. Each society had secret rituals and a particular symbol or emblem which identified their members. In this painting, the wolfskin headdress identifies warriors of the Comanche dog soldier society. These military societies guarded the camps during periods of intertribal raiding, preserved discipline during tribal hunts, provided leadership in war, conducted dances and ceremonies for the tribal gatherings, and passed on tribal history and folklore. Here, two dog soldiers, also known as wolf men among the Comanches, are covering the tracks of a war party which has crossed the river into enemy territory.

[33]

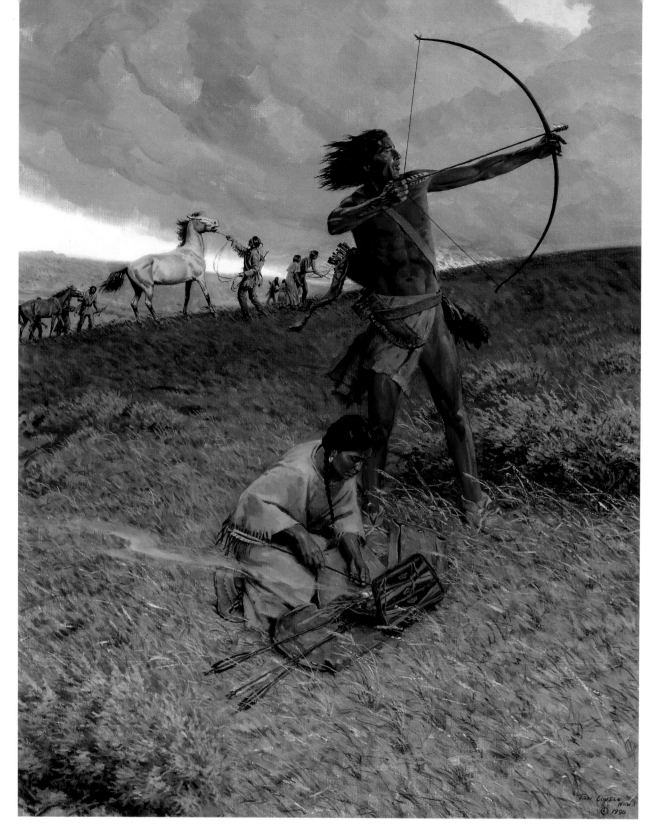

FIRE IN THE BUFFALO GRASS

Setting grass fires was a method of buffalo hunting that was in use long before Indians came into possession of Spanish horses. Flame-tipped arrows were shot in order to start fires on the flanks of a buffalo herd and stampede them towards a cliff. Ahead, others prepared to guide the herd into a "V" shaped funnel of rocks and brush that forced the buffalo off in a single spot. Such a tactic was employed less often once the Indian had horses.

COTTONWOOD GAZETTE ▶

Stolen horses and enemy scalps were measures of greatness among the warriors of the Great Plains. They were the trophies of battle, evidence of individual acts of bravery to be celebrated. In 1840, a party of Cheyennes on a horse stealing raid were attacked by Pawnees on the south fork of the Republican River. There were no survivors of the Cheyenne raiding party. The victorious Pawnees held a scalp dance near the battle site and recorded the event in pictographs on the trunk of a dead cottonwood tree. In this scene, a party of Sioux scouts reads about the fight. They will carry the tragic news to their Cheyenne allies. In the foreground are the ashes of the Pawnees' scalp dance fire.

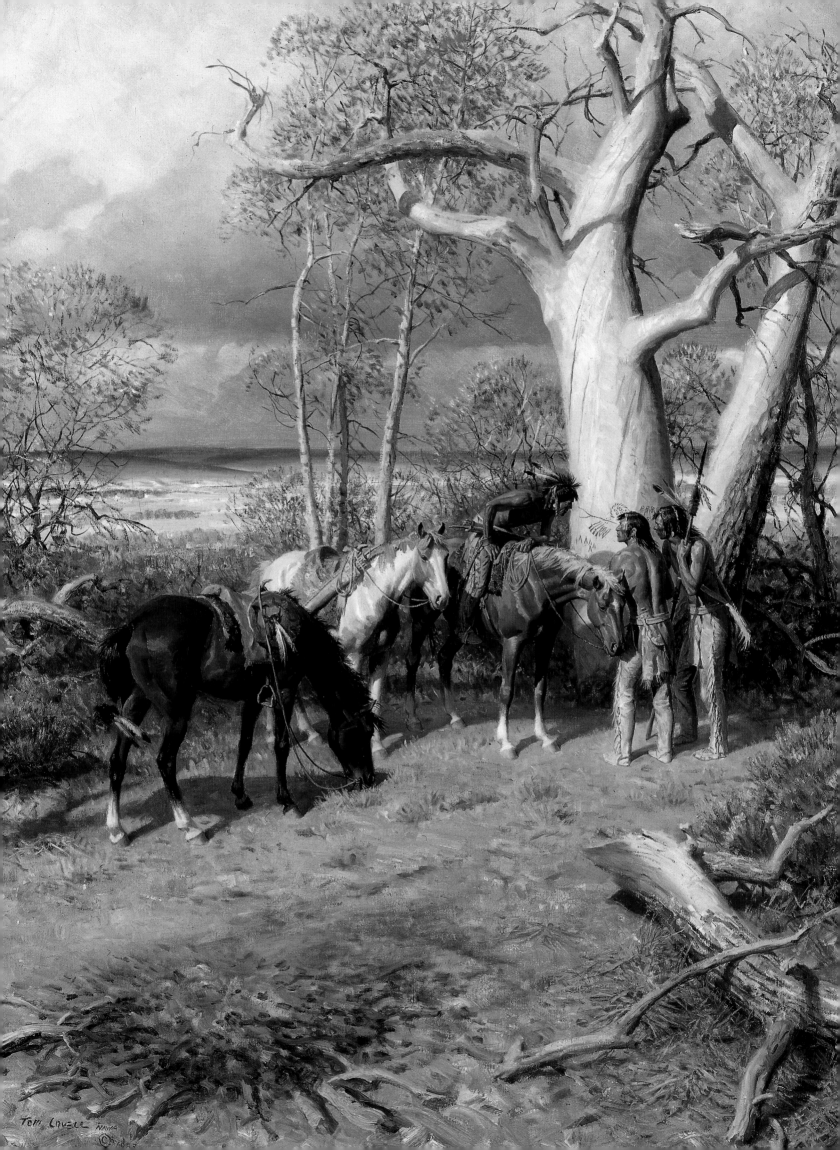

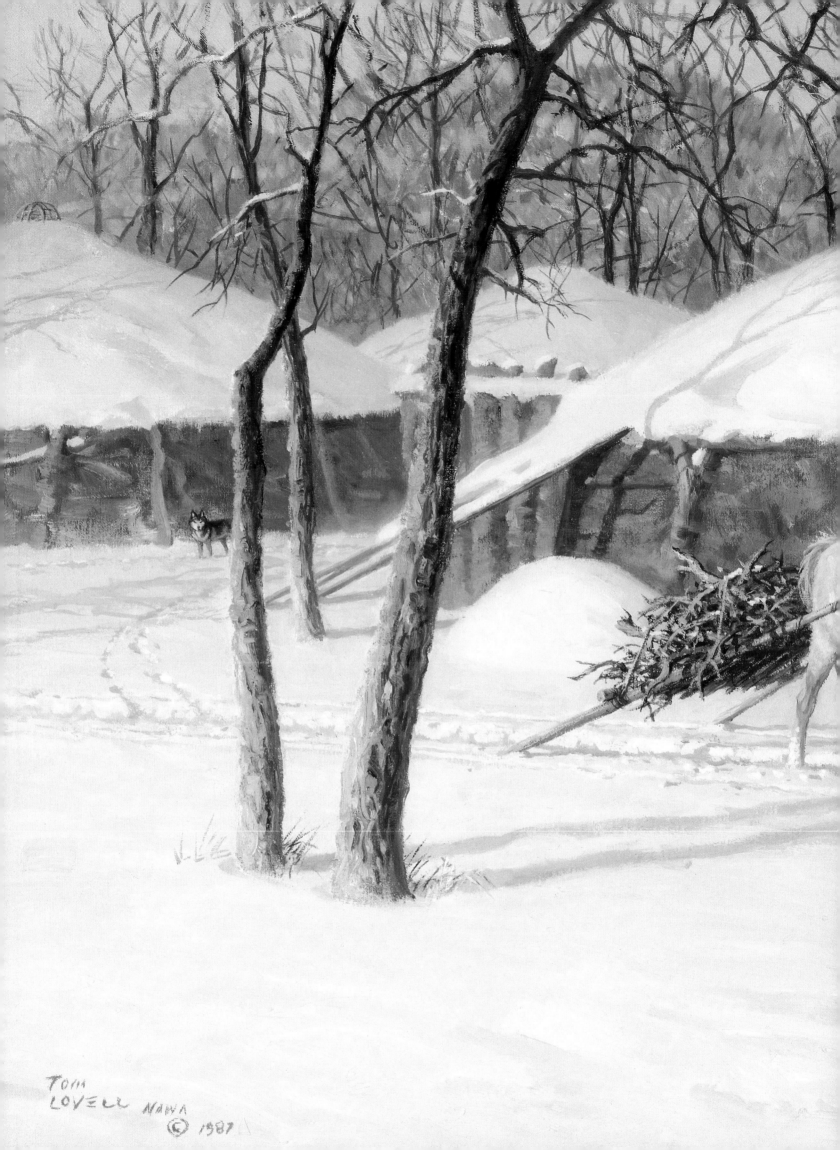

TOM
LOVELL NAWA
© 1987

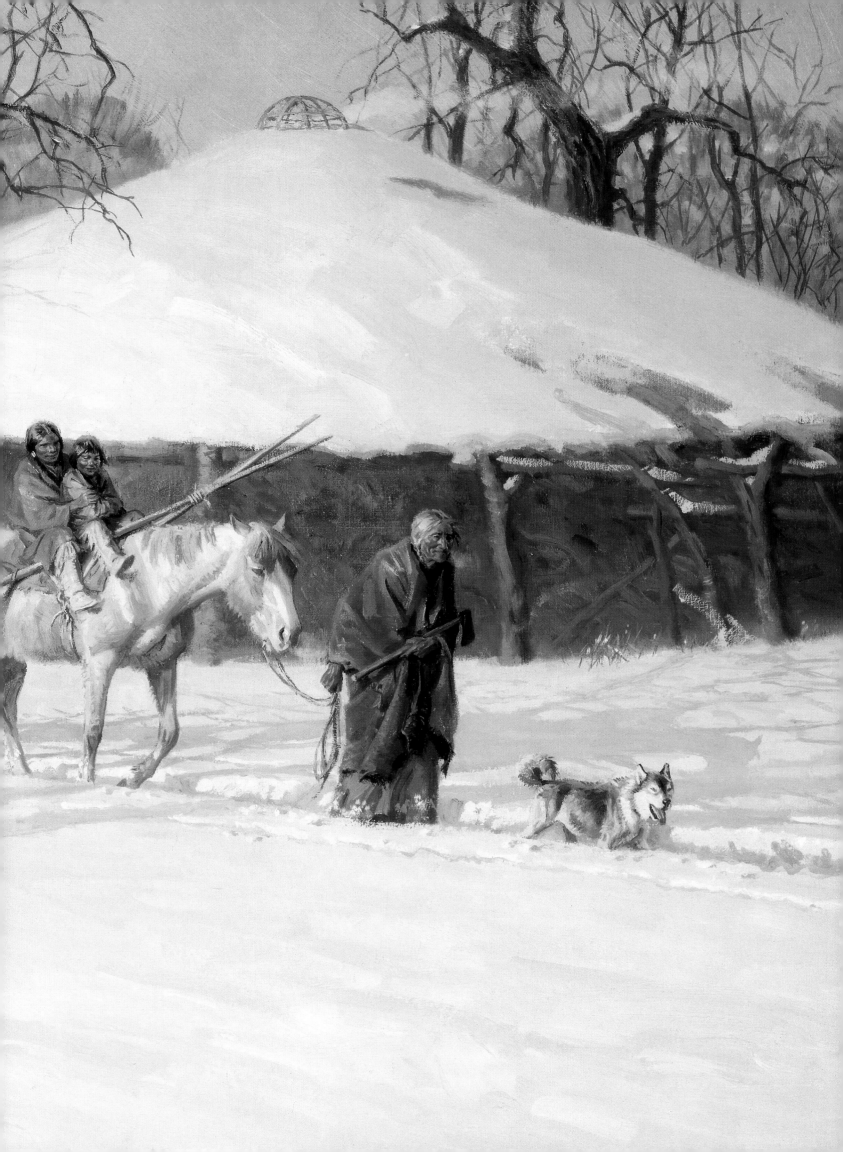

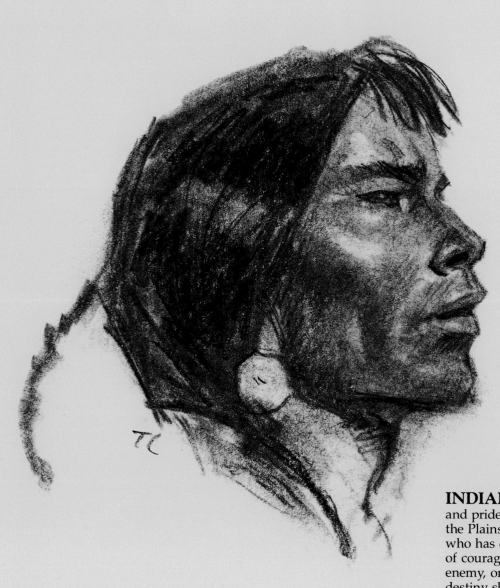

INDIAN PROFILE There is nobility and pride in the face of a young man of the Plains. This is the countenance of one who has distinguished himself with acts of courage and daring in the face of his enemy, or during the buffalo hunt. His destiny shines before him.

◀ THE HELPERS

The Mandans were a sedentary people who farmed and hunted along the upper Missouri River on the eastern edge of the Great Plains. Mandan women cultivated corn, squash, and beans in the fertile soil along the riverbanks, and the men made annual expeditions to hunt buffalo.

Early on a cold, winter morning, an old Mandan woman has gathered firewood and loaded it on a travois with the help of her grandchildren. The village is quiet; snow lies deep on the lodge roofs; and most families still sleep, huddled in warm, buffalo robes.

The once proud Mandan people would be ravaged by a series of epidemics as a result of contact with white men. In 1837 smallpox killed hundreds, leaving scarcely more than a hundred survivors of the entire Mandan nation.

FOUR TIMES TO THE SUN

The shield was one of a warrior's most prized possessions. He carried it into combat for spiritual as well as physical protection. It was the medicine represented by the symbols and trimmings on the shield itself, or on a buckskin cover, which was the real source of a warrior's confidence in its power. Each warrior's shield was decorated uniquely, according to directions received during vision quests.

In this scene a Cheyenne war party is preparing to engage the enemy. A warrior has removed his shield from its cover and raises it four times toward the sun. He asks that his medicine will be strong on this day and that the power of his shield will protect him.

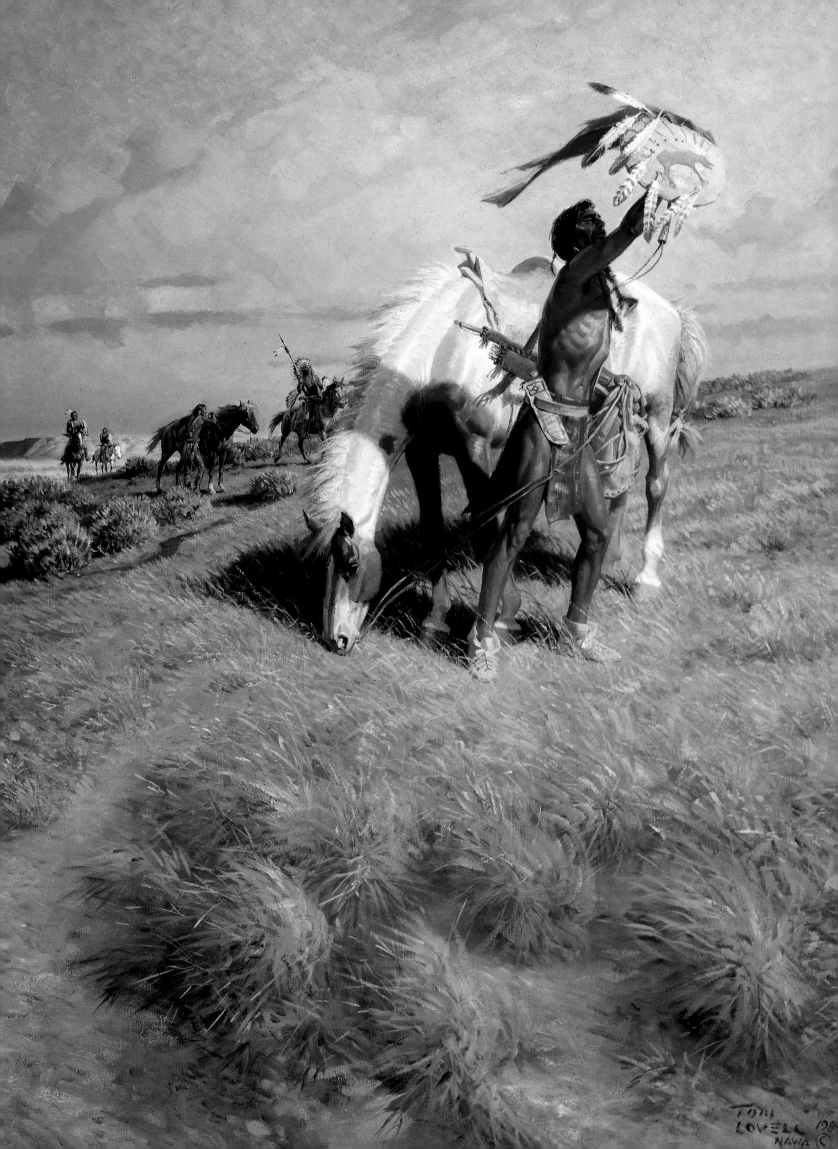

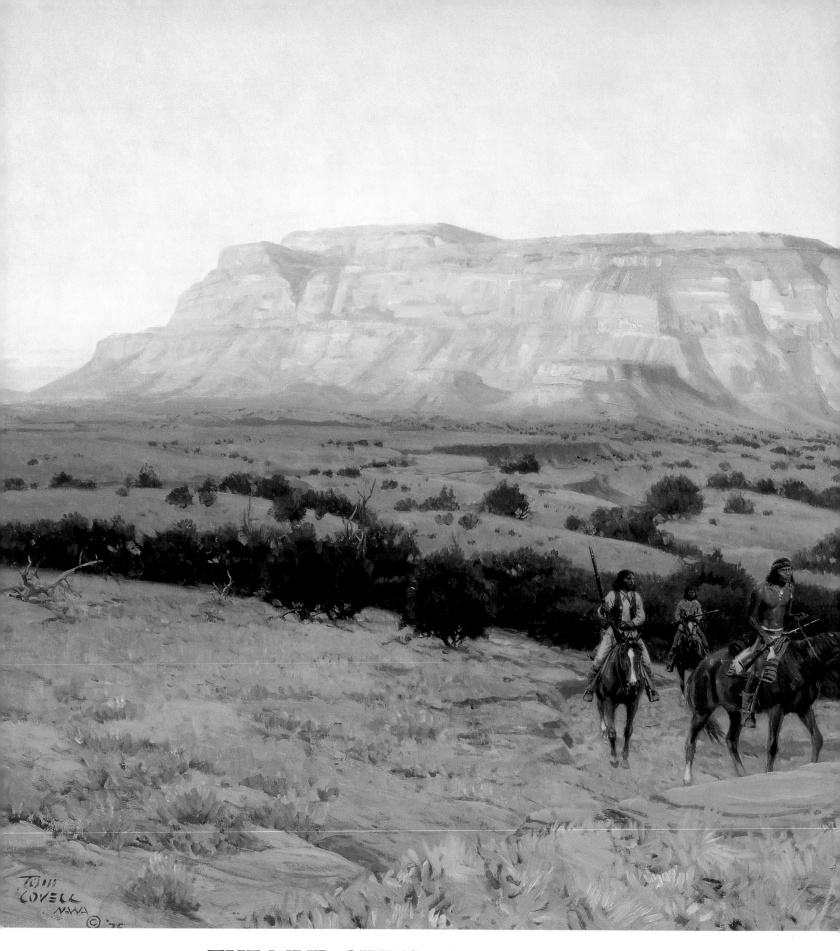

THE MUD OWL'S
WARNING

The Apaches were a fierce and warlike people. Most Indians of the Southwest were sedentary farmers and herdsmen. But the Apaches lived and died as warriors. They blazed a long and bloody trail from southern Arizona, across New Mexico, across the West Texas plains, and down into the mountains of northern Mexico. Among the various bands were the Jicarilla, Lipan, Mescalero, and Chiricahua. They

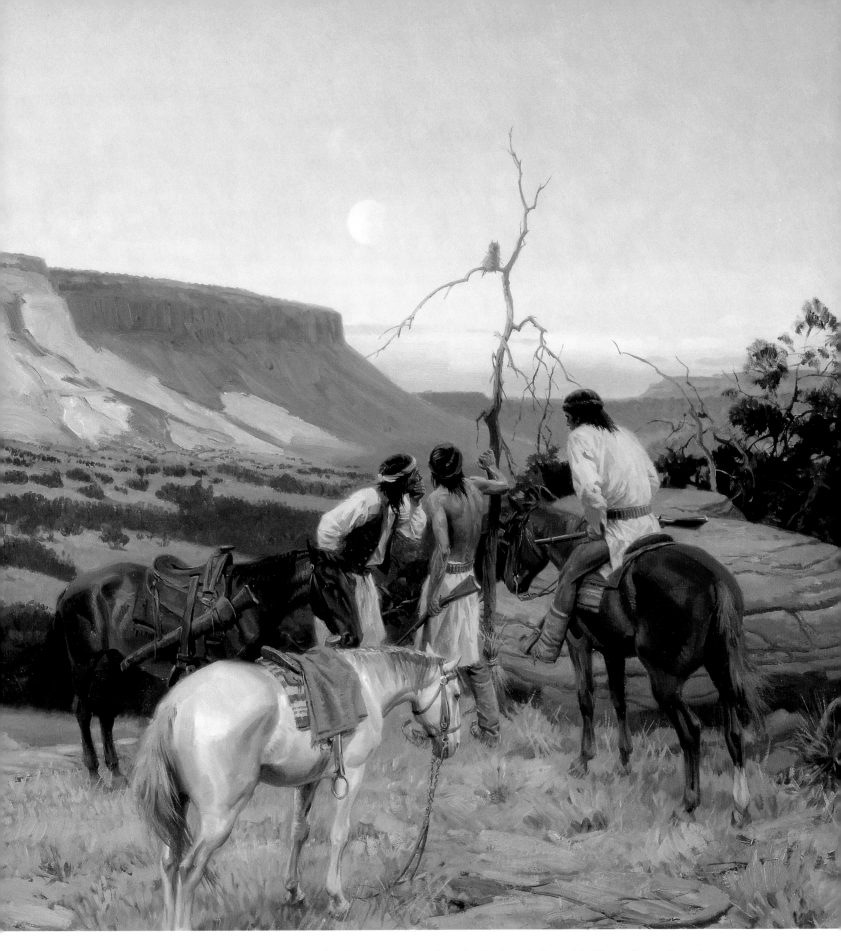

were at home in a rugged and desolate land, moving swiftly and silently against a bleak landscape to strike suddenly at the settlements of Pueblo tribes, Spaniards, and Americans.

Death was a major preoccupation for the Apache. The dead were buried quickly and their possessions burned. Mourners moved their camp away from the place of death. Spirits and ghosts dwelled every-where in the Apache's world. The owl was thought to be a messenger of death, a harbinger of disaster. When an Apache camp was struck by pestilence, mud effigies of the owl were placed along trails lead-ing to the camp as a warning. Here a group of war-riors, returning after days on the trail, find a mud owl and stop to ponder its meaning as the sun's last rays strike the distant mesa.

INDIAN TORSO The Plains Indian was truly nature's child. His was a life in harmony with his surroundings. He regarded the world with a deep and abiding reverence and was at peace with his brothers, the wolf and the eagle.

WALKING COYOTE AND THE BUFFALO ORPHANS

Among the stories of the Indians in northwestern Montana is one of a Pend Orielle man named Walking Coyote. He had married into the Flathead tribe which lived in the great plateau region on the western side of the Rocky Mountains. In 1872, Walking Coyote left the Flatheads and traveled east to the plains to hunt buffalo with the Blackfeet. He married again, this time to a woman of the Blackfeet.

The following year, Walking Coyote became homesick for the mountains. He set out on the journey back to Flathead country, taking along his new wife. He also brought eight buffalo calves that had been orphaned during the spring hunt. (Two would die en route.) This would be his peace offering to the Jesuit missionaries who were living among the Flatheads. The Jesuits took a dim view of Walking Coyote's bigamy.

Ostracized by the tribe and the Jesuits, Walking Coyote remained in the Flathead Valley and raised the buffalo orphans himself. Their progeny flourished in the protected valley and became the nucleus of the herd that exists today in the area designated as the National Bison Range. Walking Coyote is remembered as the one who saved the buffalo.

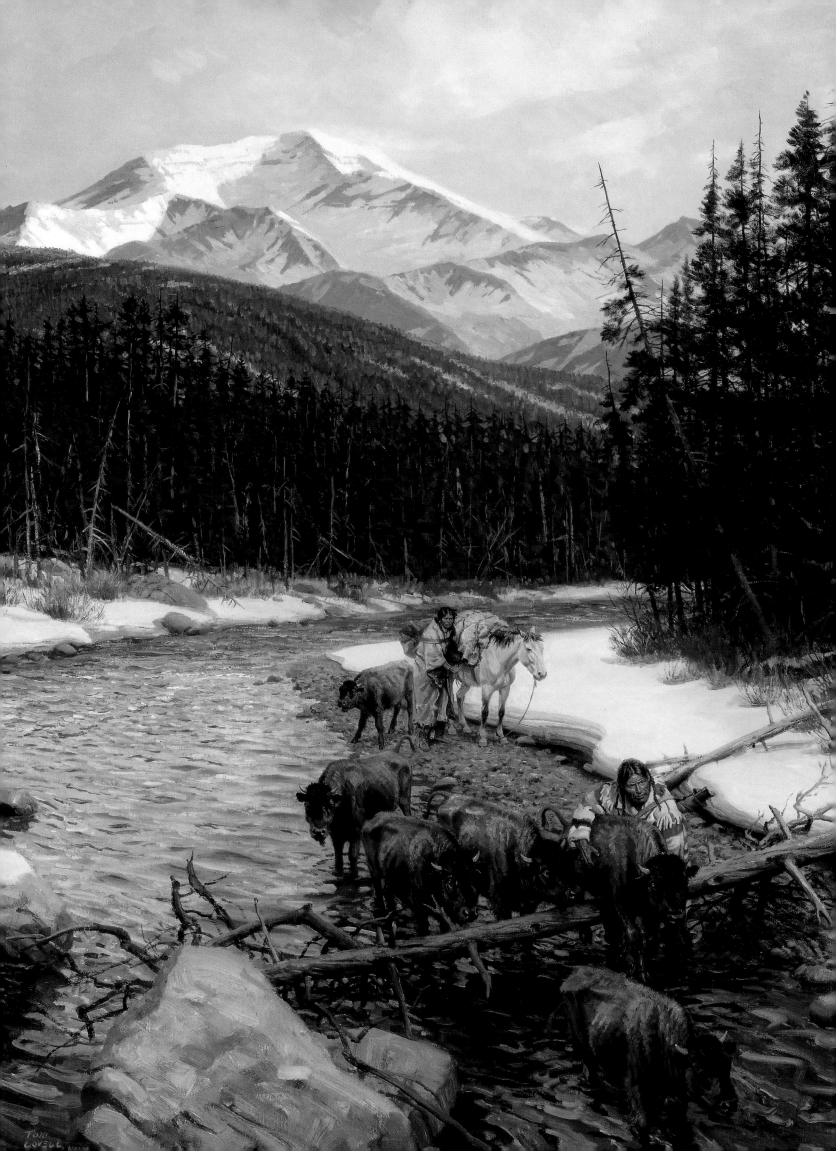

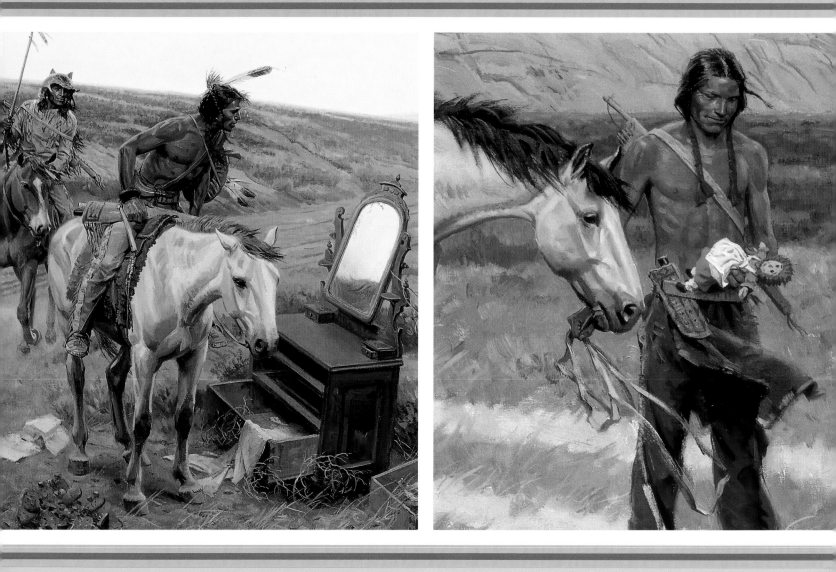

PART TWO
STRANGERS IN INDIAN COUNTRY

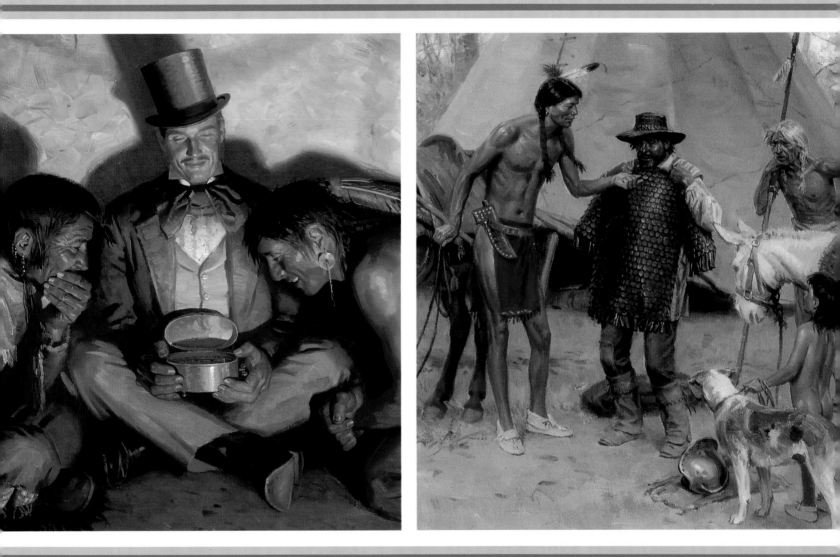

As a new century began,
men far removed from Indian country
negotiated across an ocean and set into motion
events that would threaten the survival
of the people of the buffalo range.

PART TWO
STRANGERS IN INDIAN COUNTRY

Few white men had ventured into the vast, unknown domain of the Plains Indian prior to the beginning of the nineteenth century. There was a Spanish presence on the southern fringes of the Plains, but it had an impact primarily on the sedentary Pueblo tribes of the Southwest and the intractable Apache.

Out on the broad expanse of the Great Plains, the Indian remained wild and free, secure in his prairie sanctuary. In the span of time since the acquisition of the horse, he had become more efficient as a buffalo hunter and more daring and deadly as a warrior. It was a time when life was better than it had ever been . . . or would ever be again.

As a new century began, men far removed from Indian country negotiated across an ocean and set in motion events which would threaten the very survival of the native people of the buffalo range. In 1803 the United States obtained from France, by the terms of the Louisiana Purchase, all the land between the Mississippi River and the Rocky Mountains, from the Gulf of Mexico to Canada. The Plains Indian's homeland had been bought and sold by men who had never even seen that for which they had bargained. And there was no thought or consideration given to the native population living in the area involved in the transaction.

From 1804 to 1806, a grand adventure was played out in an arduous trek up the Missouri River, out onto the Plains, over the barrier of the Rocky Mountains, to the shores of the Pacific Ocean, and back again. Meriwether Lewis and William Clark, accompanied by a small band of bold men and a Shoshoni woman named Sacajawea, traversed the interior wilderness, which was now claimed by the United States.

The official report of the Corps of Discovery expedition spoke in glowing terms of a wonderful country with fertile soil, flowing water, and abundant wildlife. As to their encounters with Indians, Lewis and Clark had, for the most part, found them to be friendly and hospitable. It was a story that captured the imagination and turned America's attention westward.

Along the frontier, in rough, river towns beside the Mississippi, the siren song of adventure and profit stirred the souls of men who craved wide, open spaces. Civilization had begun by now to crowd in on the free-spirited and hard-edged men who had blazed trails across the Appalachians and through the Cumberland Gap. Just as tales of golden cities had once lured Spaniards to the West, now stories of a bonanza of beaver pelts and other furs attracted that special breed who would come to be known as free trappers and mountain men.

Preceding the American adventurers, a small number of hardy French *voyageurs* had already ventured tentatively down from Canada into Plains Indian country. And down on the southern Plains, Spanish renegades called *comancheros* were already trading whiskey and guns to the Comanches for horses, cattle, and human captives taken from ranches along the frontiers of New Spain.

The free trappers and the mountain men tended to be sympathetic and understanding in their attitudes toward the Indians they encountered on their rambles to and from the western mountains. They shared with the Indian an intimacy with nature and gratitude for its bounty. Like the Indian, they, too, had a fierce sense of independence, prizing freedom above all else.

In small parties, or often alone, rugged, resourceful men, like Kit Carson and Jim Bridger, came in search of furs and adventure. Their presence did little to disturb the natural balance and order of Plains Indian life. They were solitary players in a brief drama, and after they were gone, not even their tracks were discernible.

In the wake of the mountain men came the traders, men of commerce in search of profit instead of freedom and adventure. They would begin to rend the fabric of Plains Indian culture. There was a ready, eager market for furs transported back down the Missouri from Indian country. Beaver pelts were of particular value for export to Europe, where they were made into top hats for continental gentlemen.

The prospect of profit brought both company men and independent entrepreneurs across the Plains to establish outposts for trading with the Indians. The simple manufactured goods

MORE THAN MEETS THE EYE

Success when it came for the white soldiers was most often due to the advice and counsel of Indian scouts. These were individuals who joined the whites in pursuit of their traditional enemies. The eyes of such men could see things that a white officer could not, even with the aid of his binoculars.

the traders offered in exchange for furs seemed wondrous to the Indian and were quickly incorporated into his material culture. Aside from the apparent harmlessness of glass beads and colorful cloth, the traders also brought guns and whiskey, both of which would have profound effect on traditional Indian life. The white men also brought their diseases: measles, diphtheria, and smallpox.

With the sudden ferocity of a prairie tornado, the Indian was buffeted by forces he did not understand and was ill-equipped to resist. The guns obtained from the white traders upset the delicate balance of power between neighboring tribes. Whiskey began to erode the Indian's fundamental concepts of pride and honor. Epidemics ravaged entire tribes, such as the Mandans, who were reduced in the early 1800s from a population of more than 3500 to a mere 125. Entire bands of once-proud hunters set up their camps around the trading posts to live like bears at a modern day garbage dump.

Intentional or not, the process of cultural transformation was abundantly evident scarcely more than a quarter century after Lewis and Clark. Anthropologists call this process acculturation and define it as the modification of a primitive culture resulting from contact with an advanced society. In the case of the Plains tribes, acculturation meant an elemental shift from traditional self-sufficiency to dependence on the white man and his trade goods.

The trader's metal knives, ax heads, and arrow points were clearly superior to the old stone tools for the purposes of both hunting and war. The rifle was a new emblem of power and distinction for those warriors who were able to obtain them. Glass trade beads took the place of quill and shell decorations on clothing. Mirrors, combs, pots and pans, blankets, bolts of colored fabric, and a variety of other products of industrial civilization quickly replaced the old Indian materials of horn, bone, and hide.

During the first three decades of the nineteenth century, white trappers, traders, and adventurers invaded the Plains Indian's domain. There was, thus far, no conscious intent on the part of the intruders to destroy the native Plains culture. Commercial exploitation was indeed central to the fur trade, but profitable ventures relied on maintaining amiable relationships with the Indians.

It was not yet evident to any significant number of Indians that the white man represented a genuine threat to their existence. In fact, most Indians were eager for each new surprise brought forth from the trader's packs. After coming in to the trading posts, or gathering for the annual spring rendezvous, most of the various tribal bands returned to their hunting grounds and camps to resume a life still structured on ancient beliefs and traditions.

[47]

This was a time that had about it the deathly calm which lies within the eye of a hurricane. But for the moment, the Indian still had about him the trappings of his full glory. Fortuitously, there were a few artists on the scene to record the appearance of people and cultures which were about to be irrevocably altered through white contact.

In 1832 the American painter George Catlin made the long journey up the Missouri from Saint Louis to the mouth of the far Yellowstone. The next year, in the company of a German prince, Swiss painter Karl Bodmer pushed across the Plains to the eastern slopes of the Rockies. In 1837, Alfred Jacob Miller joined the expedition of a Scottish sportsman and adventurer on a journey to the valley of the Green River in Wyoming, where Indians, traders, and mountain men came together to trade and celebrate. Catlin, Bodmer, Miller, and a handful of others had the rare and extraordinary artistic privilege of capturing images of a way of life poised on the brink of destruction and despair.

At this point the whites were but visitors in Indian country. The Indian was still the lord of the Plains. Even the government of the United States had recognized Indian sovereignty. The Northwest Ordinance enacted during Thomas Jefferson's administration in 1787 had declined:

> *The utmost good faith shall always be observed
> toward the Indians; their land and property shall
> never be taken from them without their consent;
> and in their property, rights, and liberty, they shall
> never be invaded or disturbed, unless in just and
> lawful wars authorized by Congress.*

Back east of the Mississippi, Indians had heard that same kind of rhetoric, only to be pushed off their land as the white population grew and pressed inland from the Atlantic seaboard. It seemed that the white man's concept of honor was as transitory as the smoke of a ceremonial pipe. Since the time when Cortez had landed at Vera Cruz, and the pilgrims at Plymouth Rock, the rights of the Indian were respected . . . but only until they came into conflict with the desires and designs of the white man.

During the decade of the 1840s, a tragic irony became apparent in the relationship between the Plains Indian and the white man. Horses and guns, along with iron arrowpoints and skinning knives, had transformed a primitive, nomadic people into a highly mobile and efficient society of hunters and warriors. And yet, the beneficent source of the materials from which greatness had been forged would also prove to contain the bitter seeds of ultimate dissolution.

By the 1840s, the beaver had become scarce as a result of the long years of intense trapping. Buffalo hides replaced beaver pelts as the medium of exchange in the commerce of the Plains. The Indian hunting parties would continue, as they always had, to kill buffalo for their own material needs. But now, with the implements of the white man, it became easy to kill and skin greater numbers in order to obtain hides with which to trade for more of the white man's goods. The availability of colored glass beads and raw whiskey was infinite; the number of buffalo was not. During the decade of the 1840s, it was conservatively estimated that 100,000 buffalo hides were being bartered each year. This represents a number of kills in addition to those taken for the Indian's own domestic requirements.

Still, though, it was a heady time of bold arrogance, when free and proud warriors counted their wealth in horses, and in the guns and colored blankets obtained in the hide trade. Few saw the subtle, yet accelerating, erosion of traditional patterns of Indian life on the Great Plains. The increased intensity of the white hunters' annual buffalo kill left moldering lumps of rotting carcasses and mounting piles of bones littering the Plains. It was a stark harbinger, a foreboding of desperation.

Early in the 1840s, the first wagon trains began to roll west across the Plains bound for the Pacific Northwest along the Oregon Trail. At first, the overlanders passed through Indian country without any danger, either perceived, or real. But as the extent of the westward exodus increased, the potential for conflict with the Indians grew proportionately. Before long, other bones would lie alongside those of the buffalo, to bleach on the lonely prairie beneath the cloudless, western skies.

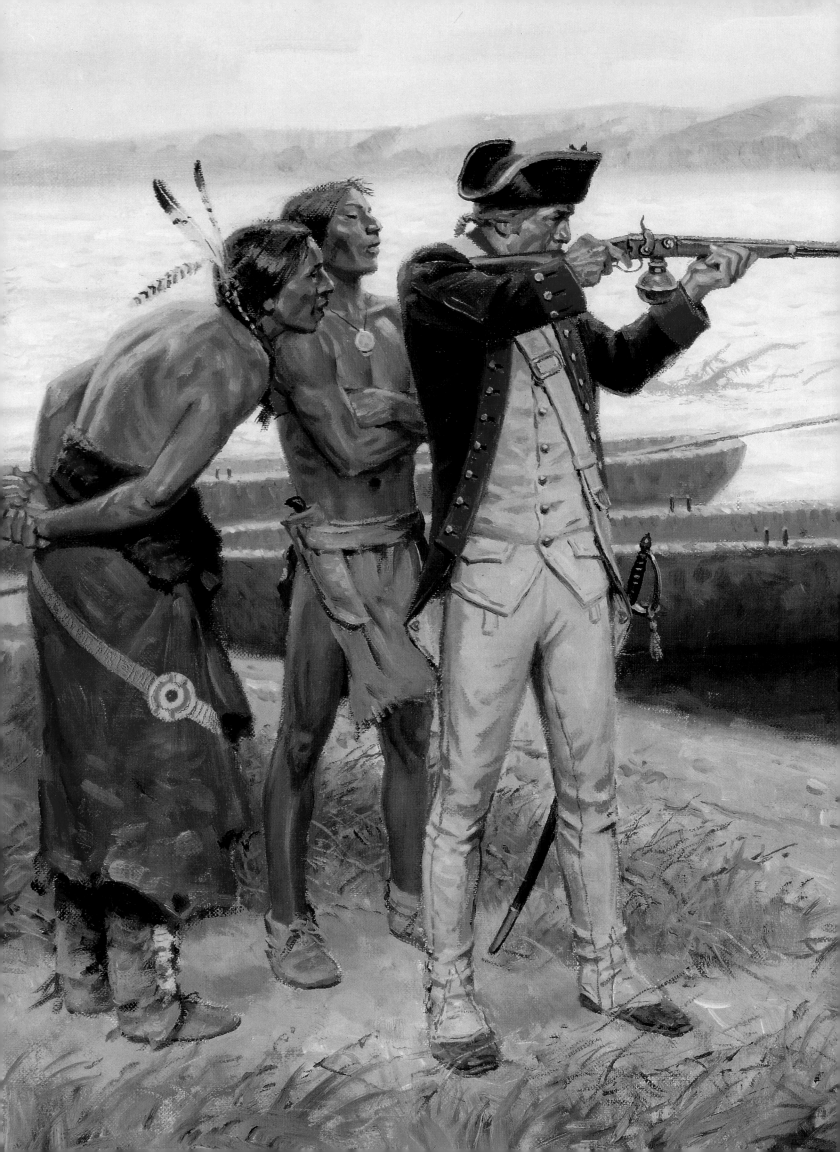

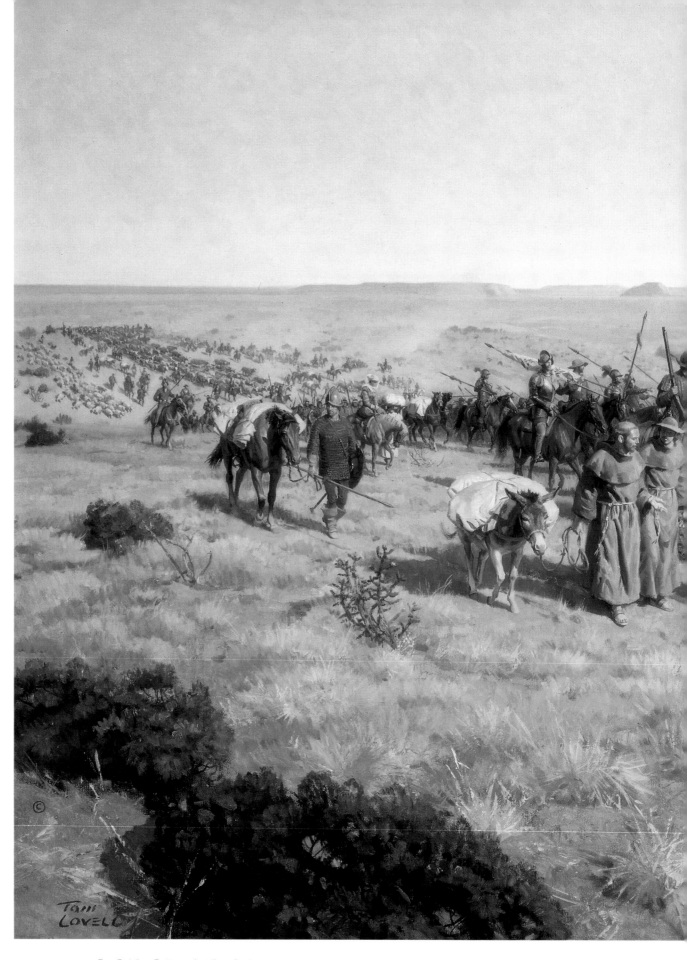

CORONADO'S EXPEDITION

In 1528, the Spanish explorer Alvar Nunez Cabeza de Vaca was shipwrecked on the Gulf Coast of Texas. He and a small group of survivors spent the next eight years traveling west across the complete breadth of a vast and unknown land, finally reaching Spanish outposts in lower California. During their journey they had heard stories told by Indians

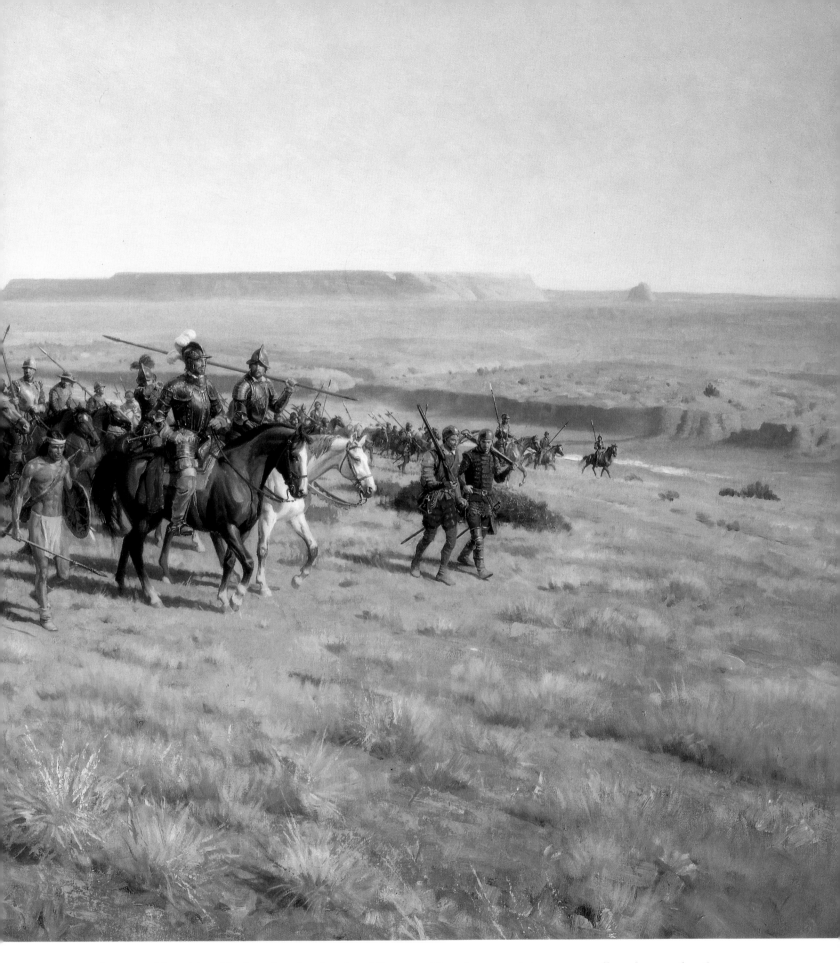

of seven golden cities. Having already plundered the fabulous wealth of the Aztecs and Incas, the Spanish *conquistadores* now rode north.

Francisco Vasquez de Coronado led the expedition which set out in 1540. He was in command of nearly 300 Spanish soldiers, a contingent of priests, and a thousand Mexican Indians. They brought with them cattle, sheep, and hogs, as well as horses for the armor-clad soldiers. Instead of cities of gold, Coronado found only the mud pueblos of New Mexico. He continued eastward out onto the Great Plains, but was finally forced to return to Mexico, empty-handed and in disgrace. But others would come, altering forever the native American's world.

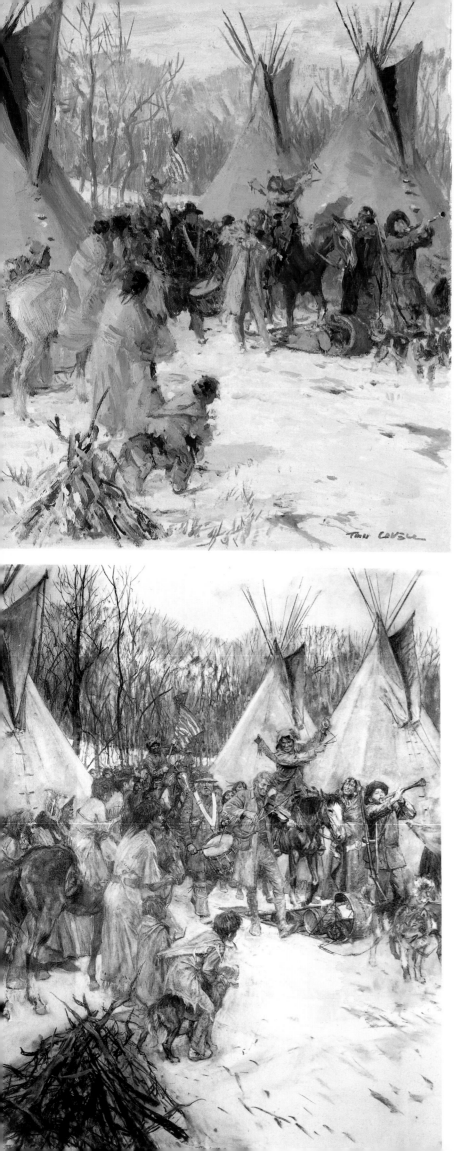

INVITATION TO TRADE

The inspiration for this painting came from the artist's reading of a journal kept by Charles Larpenteur, an employee of the American Fur Company on the upper Missouri River in 1844. At that time, trading in the Indian villages was forbidden by law. Commerce was restricted to the trading posts. Competition was intense, and rivals, such as the American Fur Company and the British Hudson's Bay Company, vied with each other to entice the Indians into their respective posts.

Larpenteur wrote: ". . .when some trouble was expected in bringing the chiefs to the fort a sled was brought out; having a small keg of liquor placed upon it to treat the gentlemen; a band of music was also in attendance. The instruments consisted of a clarinet, a drum, a violin, and a triangle . . . it was almost impossible for the Indians to refuse such an invitation."

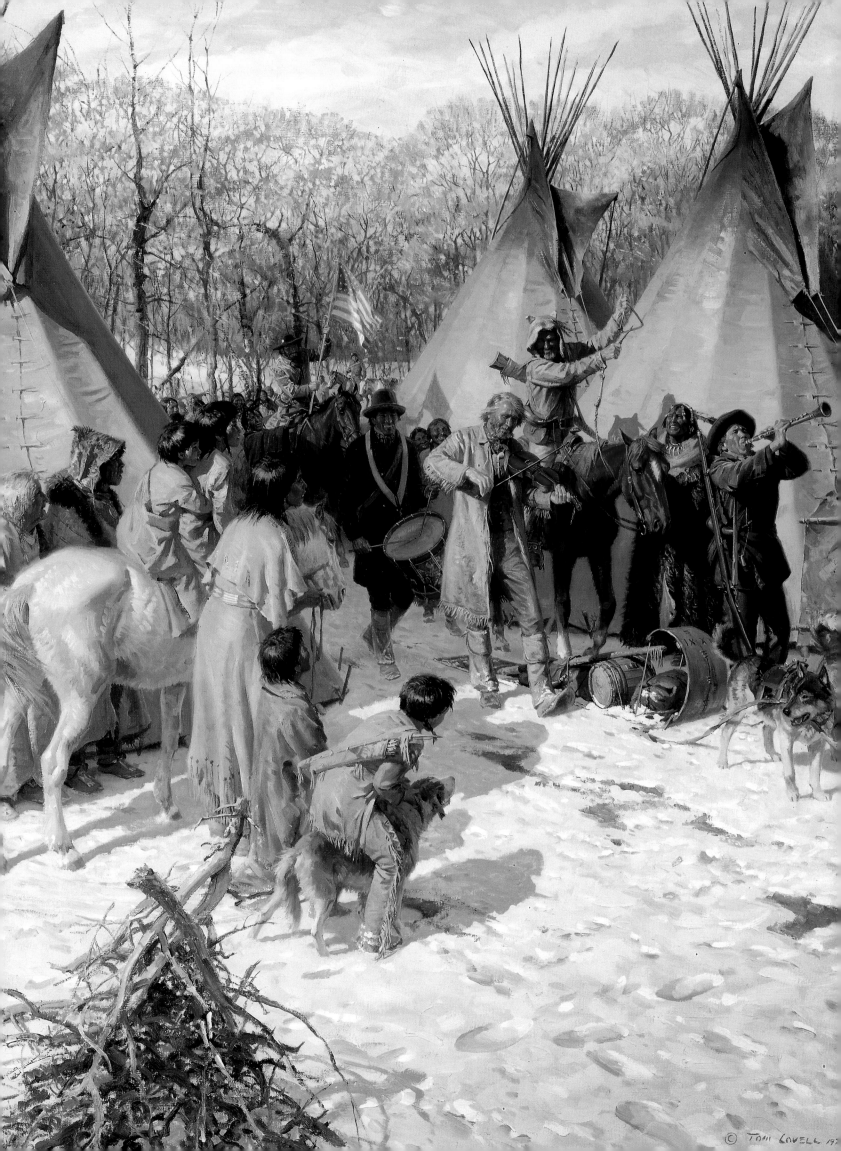

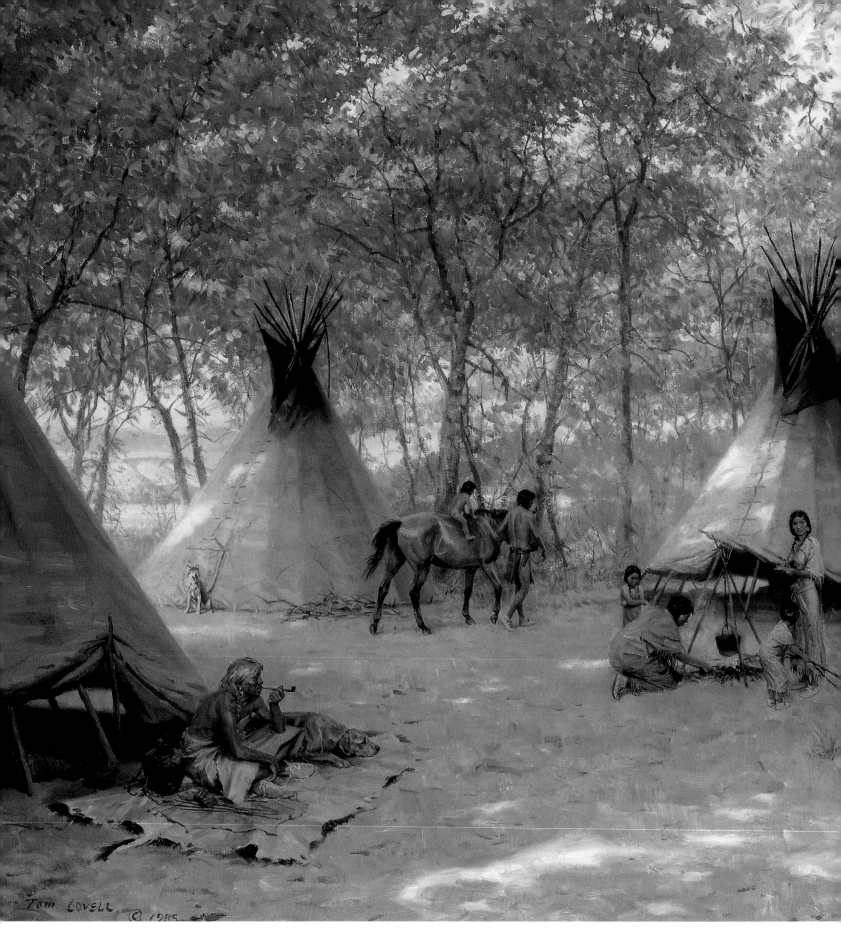

THE IRON SHIRT

The first *conquistadores* to venture north of the Rio Grande appeared fearsome indeed to the Indians they encountered. These bold strangers rode upon the backs of amazing animals the Indian had not seen before, and they wore clothing which arrows could not penetrate. They came for gold and God, but conquest proved a fleeting thing. Their Spanish dreams and armor-clad bones bleached under the hot southwestern sun.

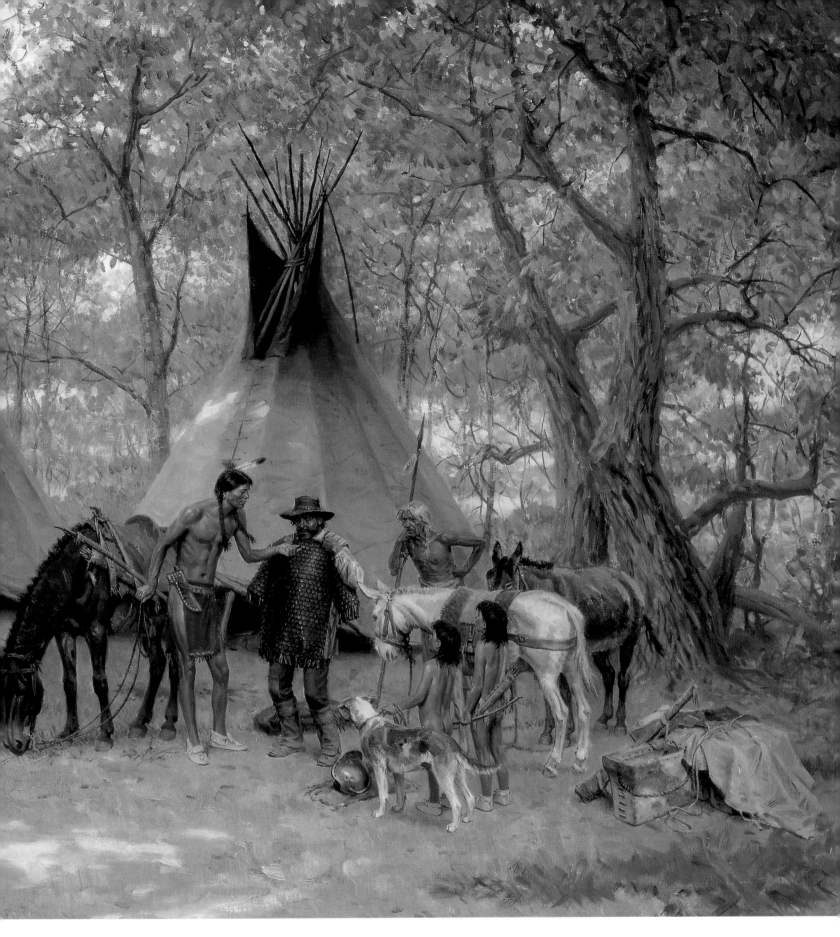

Here, in an Arapaho camp, a Mexican trader offers a shirt of iron scale armor in exchange for a white mule. The medicine of the iron shirt may prove to be stronger for the Arapaho than it was for the original owner. There is a story of a shirt, such as this one, which was found years later in the possession of a Cheyenne named Medicine Water, still the source of a warrior's pride, as it once was for another man, long ago and far away.

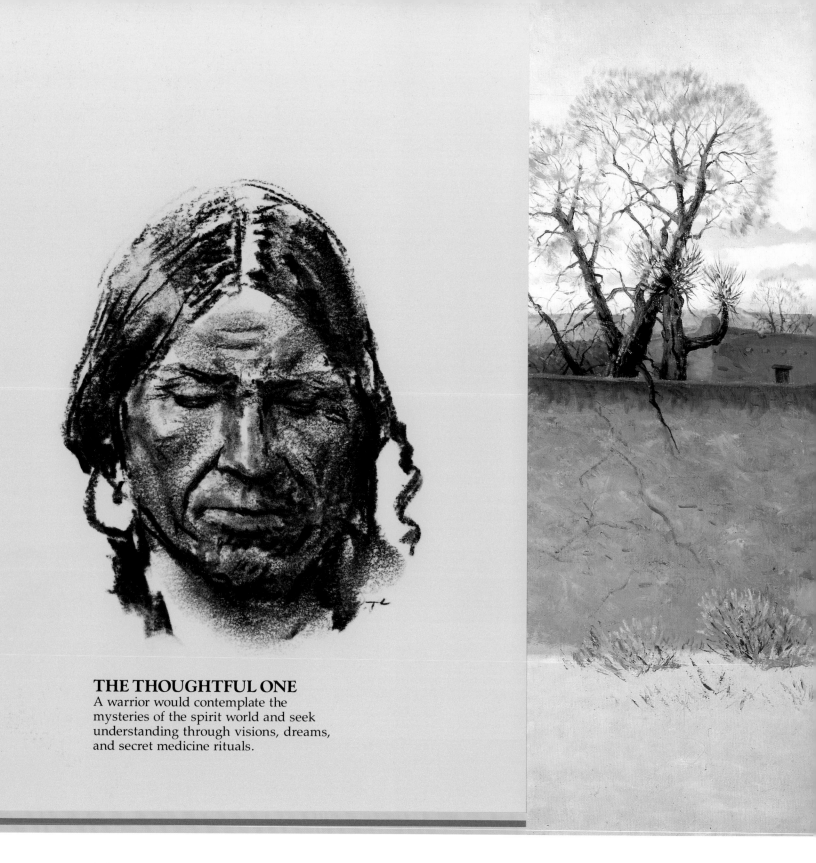

THE THOUGHTFUL ONE
A warrior would contemplate the mysteries of the spirit world and seek understanding through visions, dreams, and secret medicine rituals.

THE ROBE TRADERS

Sundown comes early on a winter evening along the trail to old Santa Fe. Two Jicarilla Apaches have approached the gates of a fortified *hacienda* and offer buffalo robes for trade. The men on the wall are reluctant to admit the Indians as the darkness gathers. Spaniards, Mexicans, and Americans had all come to regard the Apache with suspicion and dread. Others could be waiting in a nearby arroyo, ready to rush the gates as they swing open. The men inside notice additional robes on the two pack horses and debate among themselves whether or not to take a chance.

Just as the white men were inclined to exploit the Indians with worthless trinkets and cheap whiskey for valuable buffalo robes, so, too, were the Apaches ever ready to strike a blow against the foreign invaders. Suspicion and greed hang in the frosty, evening air.

Detail from
Preliminary Oil Sketch

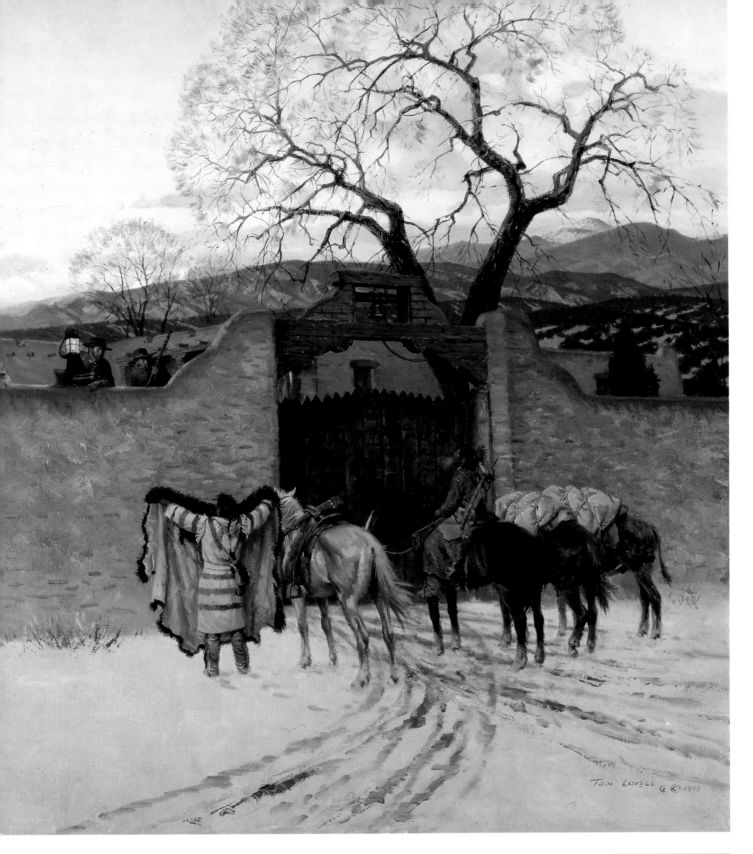

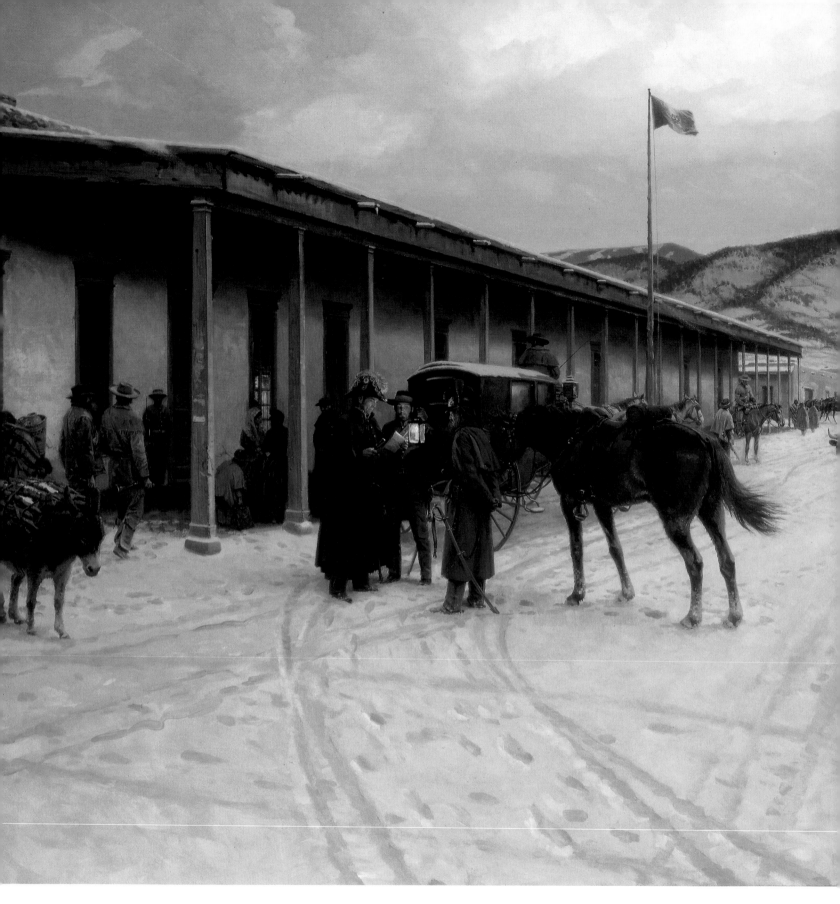

GOVERNOR'S PALACE, SANTA FE, 1840

By the year 1580 the Spaniards were determined to expand their empire into the American Southwest. Santa Fe became an early and important provincial capital. For almost two hundred and fifty years, Spanish soldiers and priests attempted to subjugate the Pueblo tribes. Violent revolts broke out in 1680 and again twenty years later. Spanish authority in the Southwest remained tenuous at best. In 1821 Mexico gained its independence from Spain, and an eagle and serpent flag was hoisted above the old

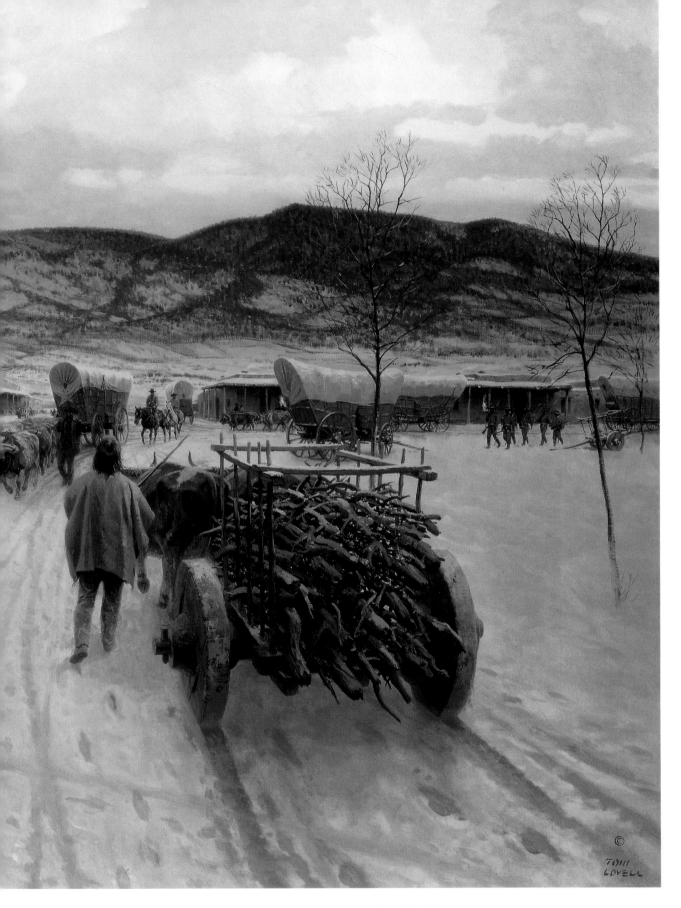

Governor's Palace in Santa Fe. Mexico's control of the Southwest territories proved to be even less effective than Spain's.

In 1846, as a consequence of the outbreak of war with Mexico, the United States took possession of present-day New Mexico and Arizona. The scene here is of a winter evening in 1846. Governor Manuel Armijo reads a dispatch by lantern light as a courier and his spent horse stand by. The war is not going well, and Mexico's hold on this place is slipping away.

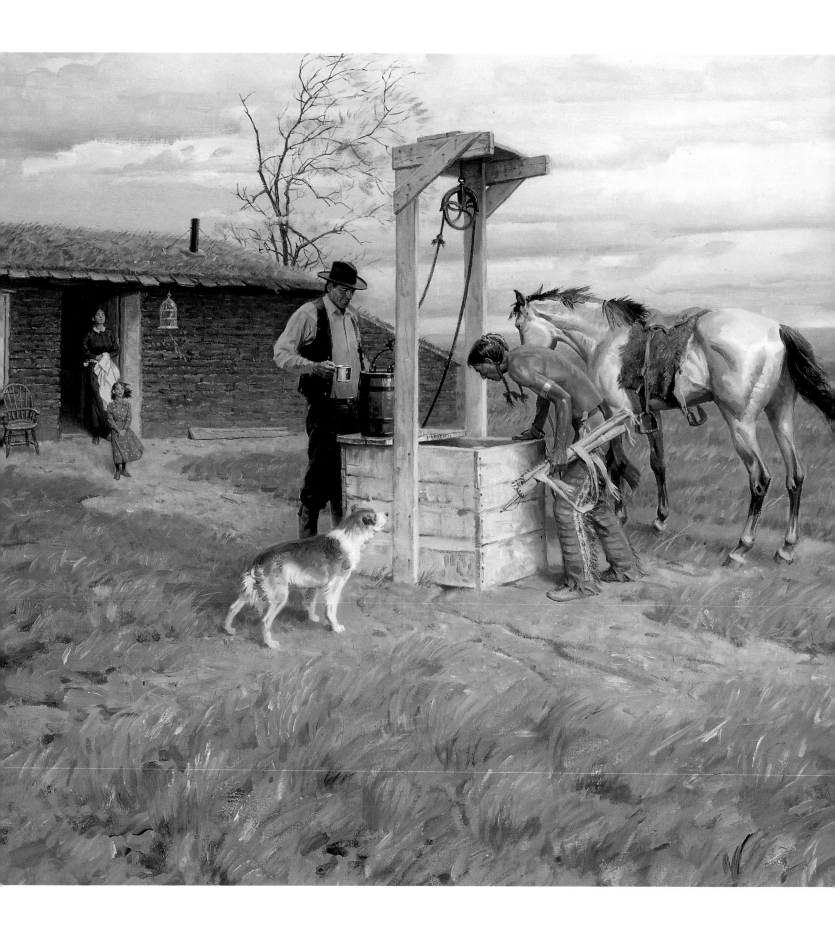

THE WATER HOLE

It was a time before the treachery and blood. A lone Indian could still ride up to a lonely, prairie homestead and receive a cautious welcome. The ways of the white man remained a puzzle to the Indian. It was a strange and magical thing that this man kept his water in a hole in the ground that was enclosed in a wooden box. And his lodge was a marvel too, built, it seemed, out of blocks cut from the prairie itself. These people did not seem to belong here.

Tensions would increase as time passed. More and more of these strange men would bring their families to settle in the heart of traditional Indian hunting grounds. Friction was inevitable. When the violence finally flared, there would no longer be moments such as this, when men from different worlds could share a cup of cool water.

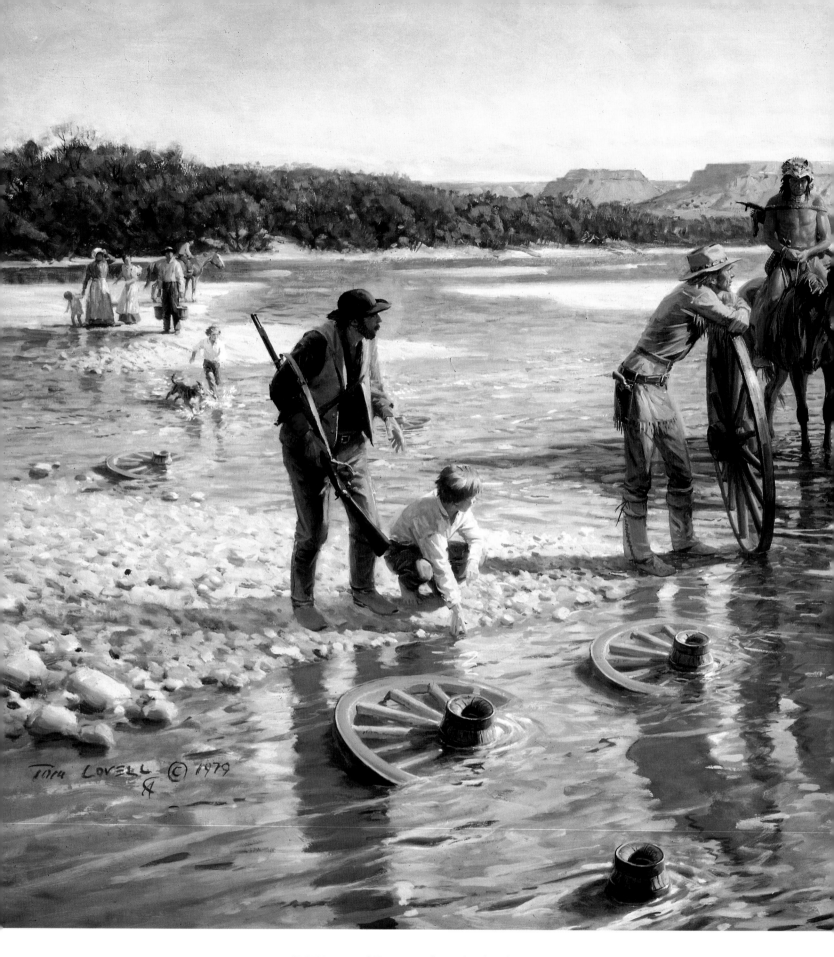

THE WHEEL SOAKERS

Wagon trails to the fertile valleys of the Pacific Northwest, and to the California gold fields, lay directly through the heart of Indian country. Overland immigrants posed no real threat to the Plains Indians in the early stages of white America's move westward. They were only passing through. The Indians were curious about the travelers, but hesitant in their approaches. The whites were most often suspicious and distrustful.

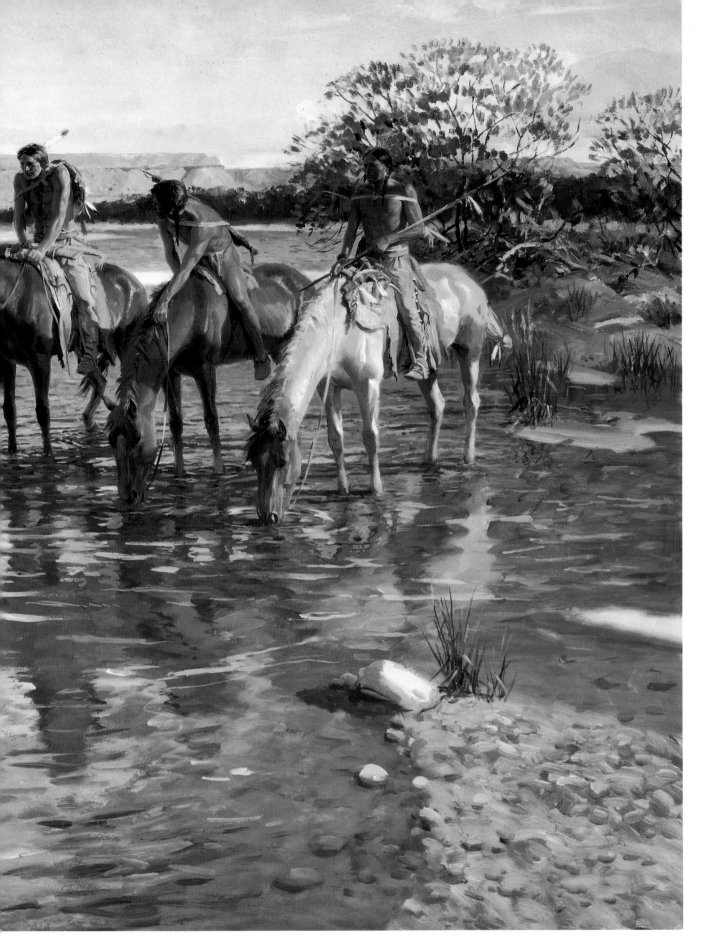

A party of immigrants have paused in their journey to soak the wheels of their wagon. This prevented the wheels from shrinking and dislodging the iron rims. Four Comanches have ridden up to witness this strange procedure. One white man grasps a rifle, the other wears a pistol on his hip. Bows and arrows are slung across the backs of the Comanches, and one bears a lance. But there will be no violence today, and a young boy will cherish a vivid memory.

THE JUMP SUIT Newcomers to the frontier trading posts of the Upper Missouri were amazed by the strange appearance of the men they encountered. One new arrival in the far West remarked that many of these frontiersmen seemed poised for action. Their buckskin leggings, which often became baggy at the knees when wet, dried that way, giving the appearance that the wearer was about to jump.

MR. BODMER'S MUSIC BOX

Karl Bodmer, a native Swiss, was trained as an artist in Paris. At twenty-three he came to America with the German naturalist Maximilian, Prince of Wied, for an expedition to the far West. The party left Saint Louis in April of 1833, journeying up the Missouri by steamboat. From Fort Union, the party went by keelboat to Fort McKenzie, the American Fur Company's outpost at the eastern edge of the Rocky Mountains. Bodmer painted a wide range of subjects, from Indian portraits to wildlife and landscapes. Eighty-two of his paintings were reproduced in Maximilian's two-volume narrative of the expedition, *Journey into the Interior of North America*, which was published in 1839.

On the year-long western adventure, Bodmer carried a small, mechanical music box with which he entertained his Indian hosts. The Indians were delighted by the music and considered it good medicine. Here, in a Mandan lodge, Bodmer shares the pleasure of his new friends.

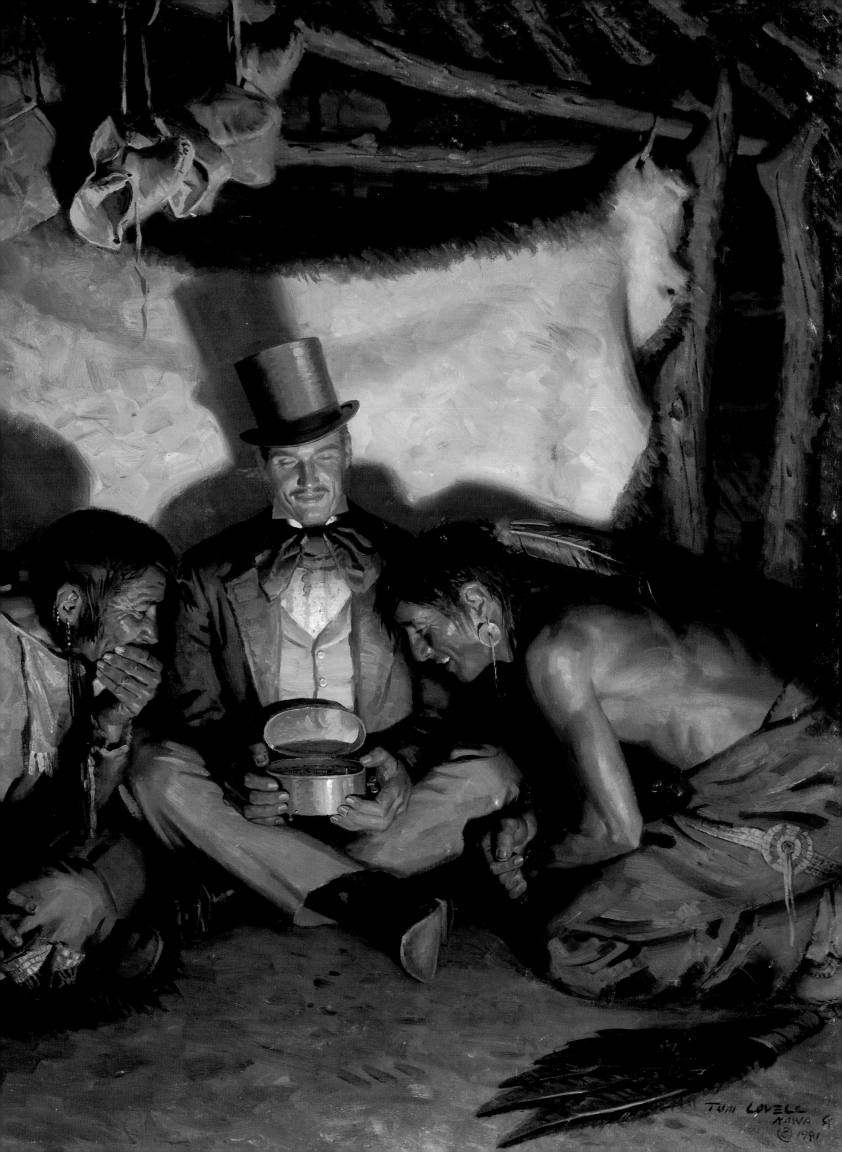

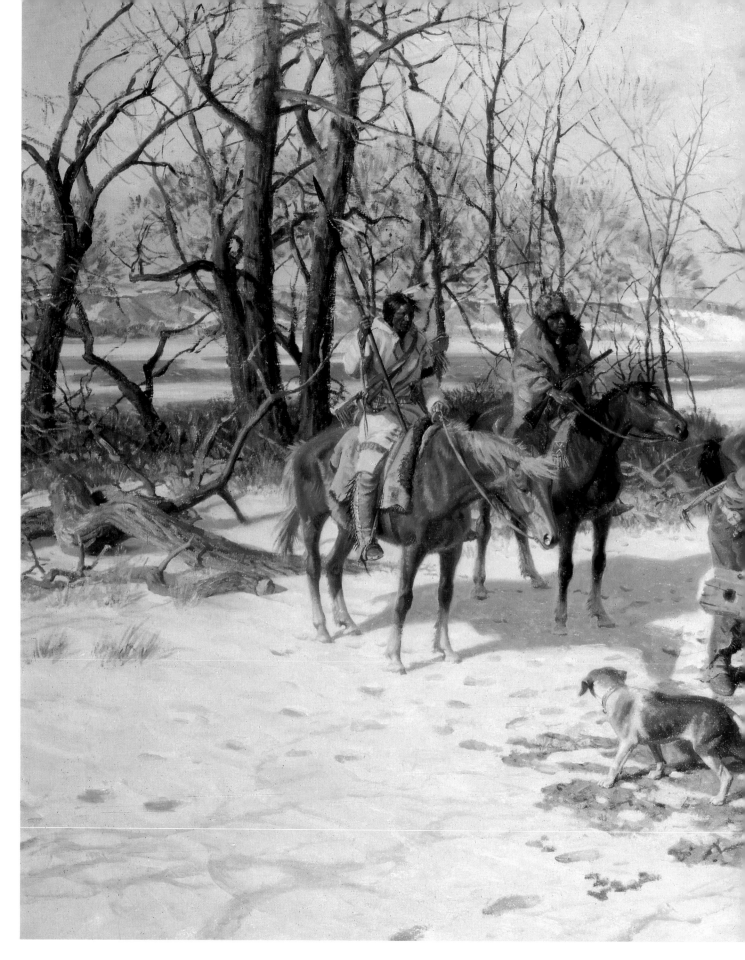

CARSON'S BOAT YARD

Christopher "Kit" Carson was a bold adventurer whose exploits became legend in the Old West. He was among the first of the mountain men to set traps along the beaver streams of the far western wilderness in the 1820s. For fifteen years he wandered the wild country beyond the headwaters of the Mis-

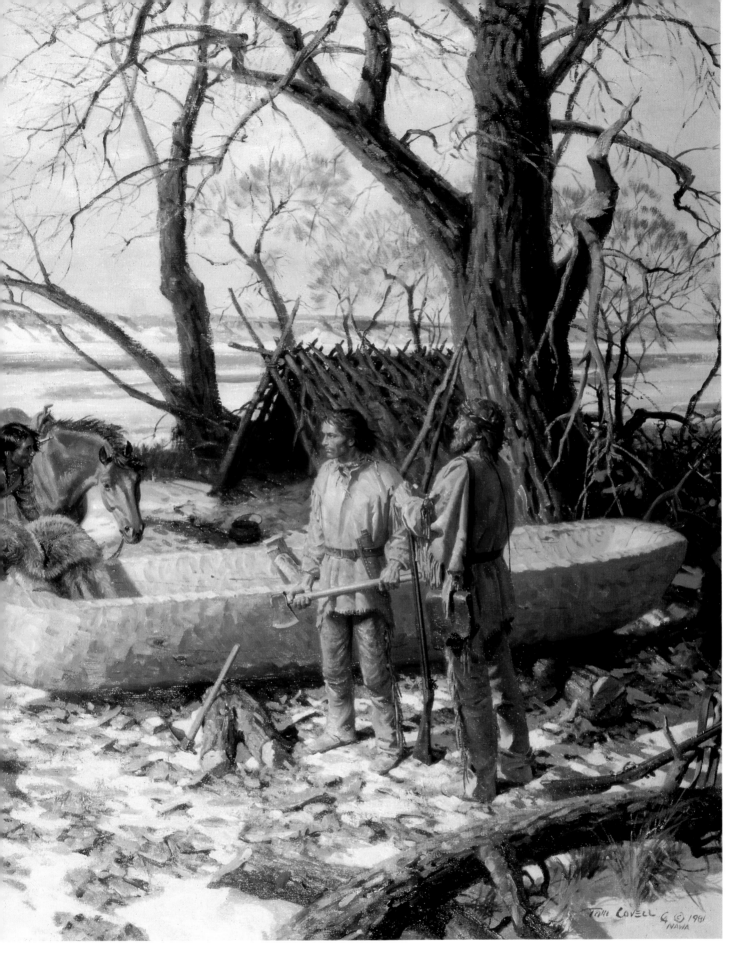

souri, relishing a life of danger and loneliness. He was a familiar figure at the great rendezvous in the Green River Valley of Wyoming. Later, he supplied meat to the employees at Bent's Fort down in Colorado, and in the mid-1860s, he led a force of New Mexico volunteers in successful campaigns against the Navajo and Kiowa. In his autobiography, Carson mentioned a campsite where dugout canoes were constructed to transport furs back down the river in the glory days of the fur trade. This is that camp. Three Sioux have come to trade a wolf pelt as Carson and a companion are at work on a canoe.

THE HANDWARMER

It is a cold, winter day on the Great Plains. Two Sioux hunters in search of fresh meat for their village have been drawn to a thin thread of smoke mysteriously rising out of a snowdrift. They discover the stovepipe of a white home-steader's sod house. Someone must be home tending the fire.

The hunters warm their hands in the rising heat and wonder at this strange house which could not be broken down and hauled on a travois when buffalo hunting began in the spring. Inside, perhaps a small family huddles close to the stove, alarmed by the sounds coming from the roof.

But the hunters are not displaying weapons, only curiosity. In the days before the blood-shed began, it was possible that the white fam-ily might even invite the Indians in to visit and accept a fresh-killed rabbit for some bread and a cup of hot coffee. Friendship and hospitality were still possible on this day when the wind howled across the buffalo range.

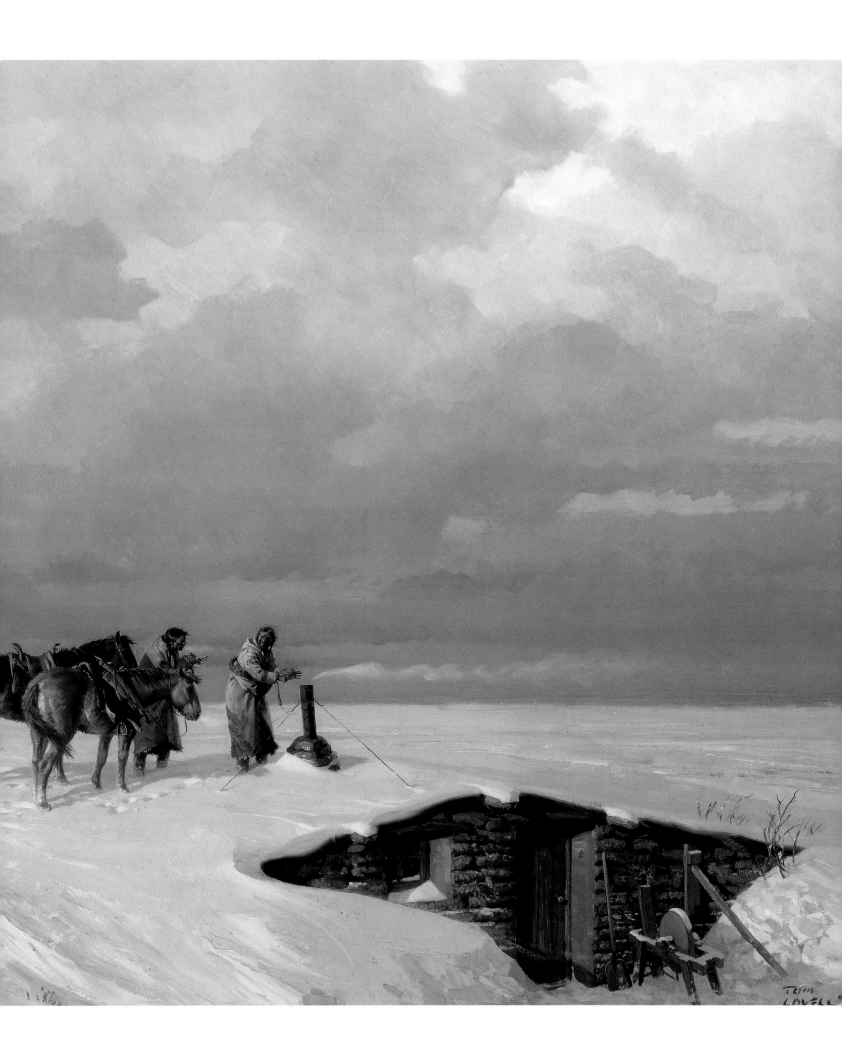

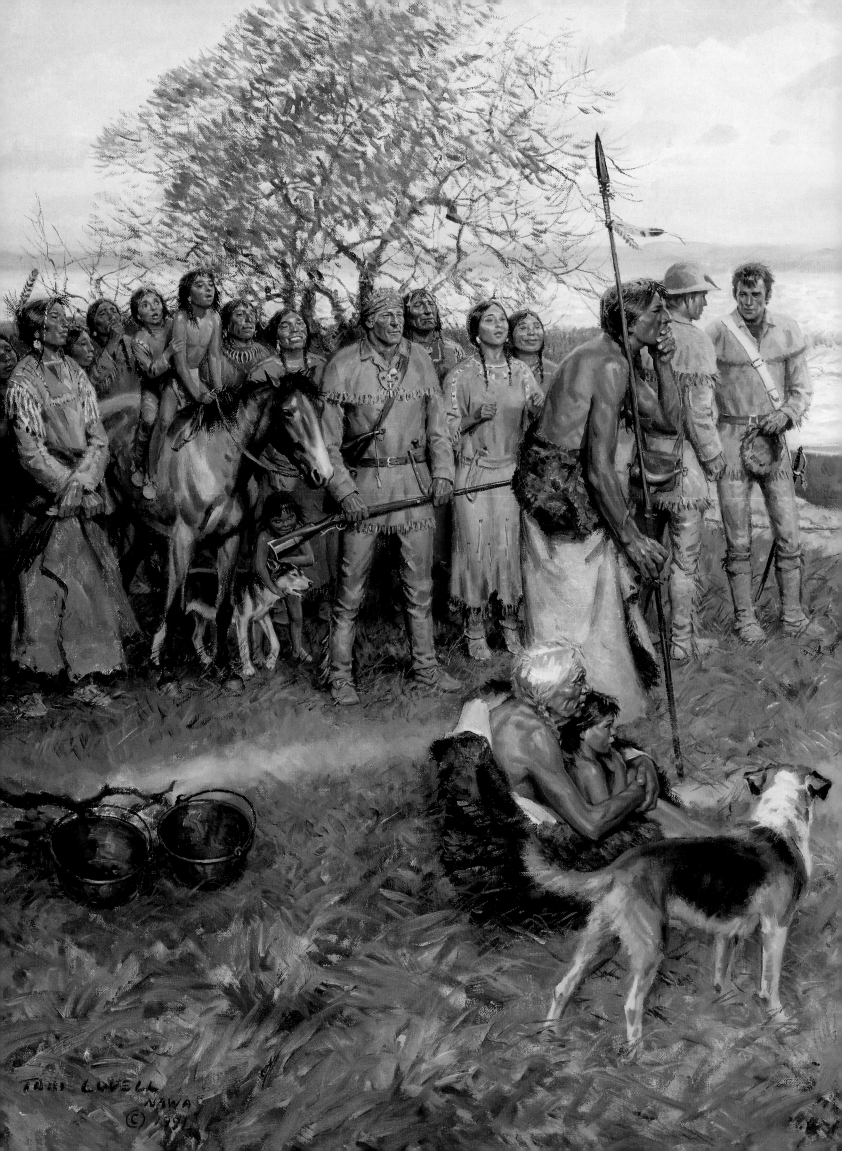

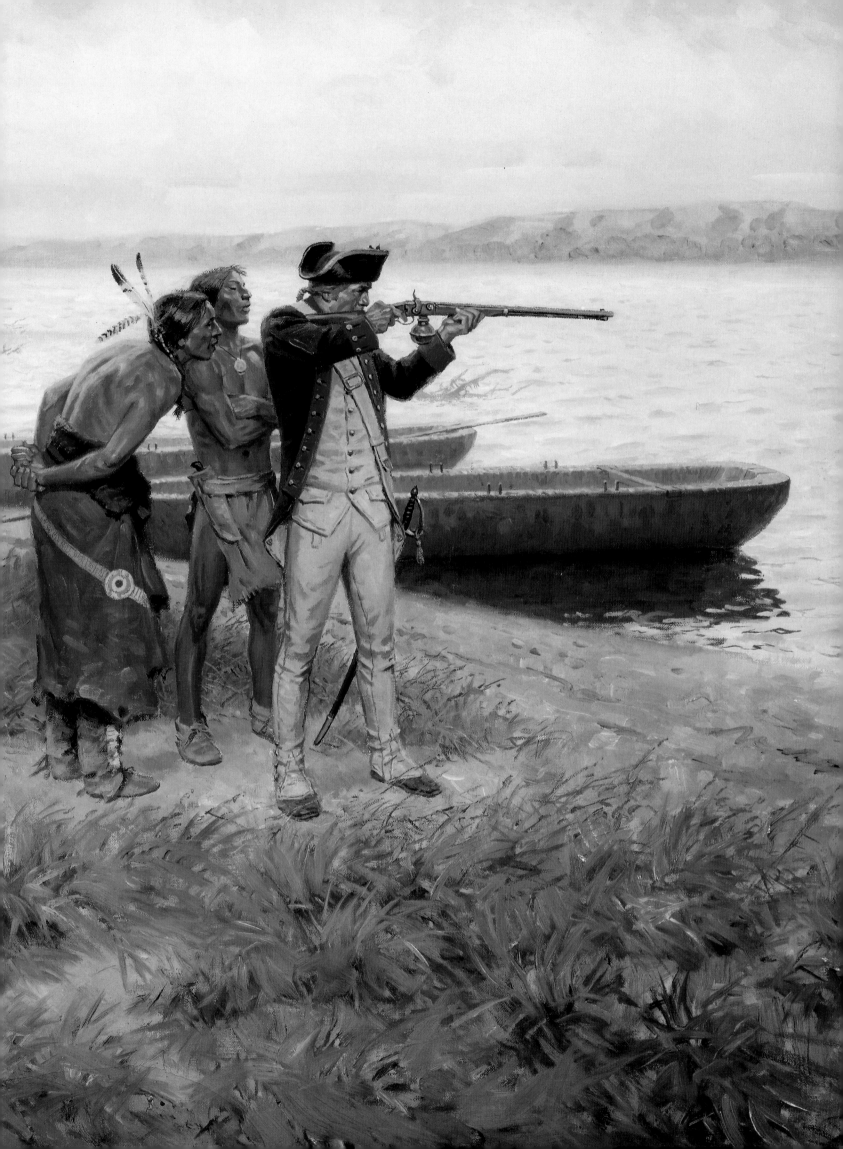

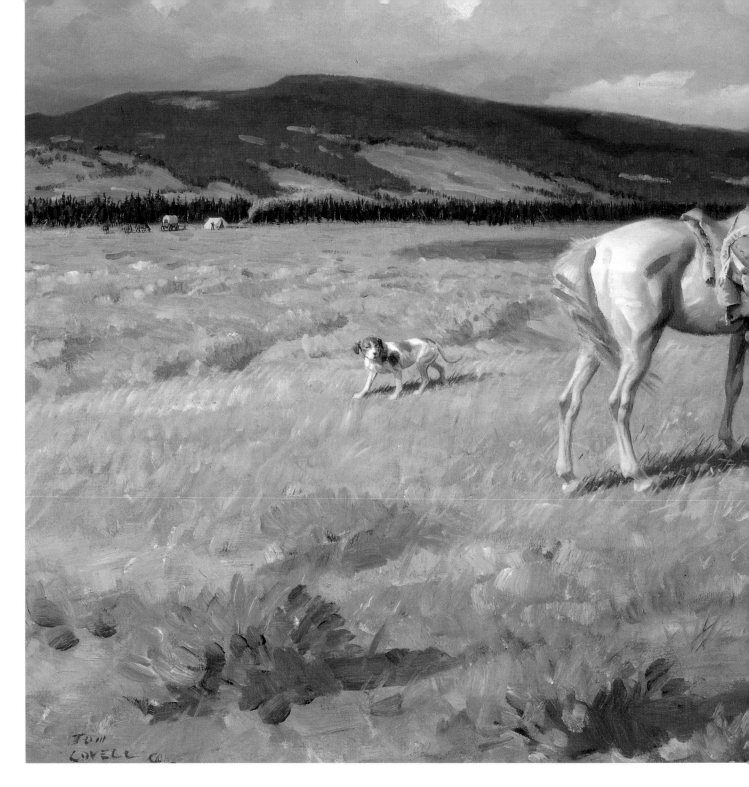

◄ CAPTAIN CLARK AND THE AIR GUN

Most Indians living along the twisting course of the upper Missouri River had not seen white men prior to the Lewis and Clark expedition of 1804–06. A few scruffy French *voyageurs* had come down from Canada to trade with villages on the northeastern edge of the Plains. But the arrival of the Lewis and Clark party was the first time a significant number of Indians came in contact with this tribe of men who appeared so different from themselves. Great excitement was created by the arrival of these strange

visitors from the East. The manner of dress of the expedition commanders was most unusual, and they brought with them things which inspired awe.

Part of the mission of the Corps of Discovery was to make friends of the native people encountered on the long journey to the Pacific. Here, Captain Clark, in full dress uniform, entertains a band of Indians with a demonstration of a rifle which fires multiple times from the power of a compressed air flask attached beneath the breech.

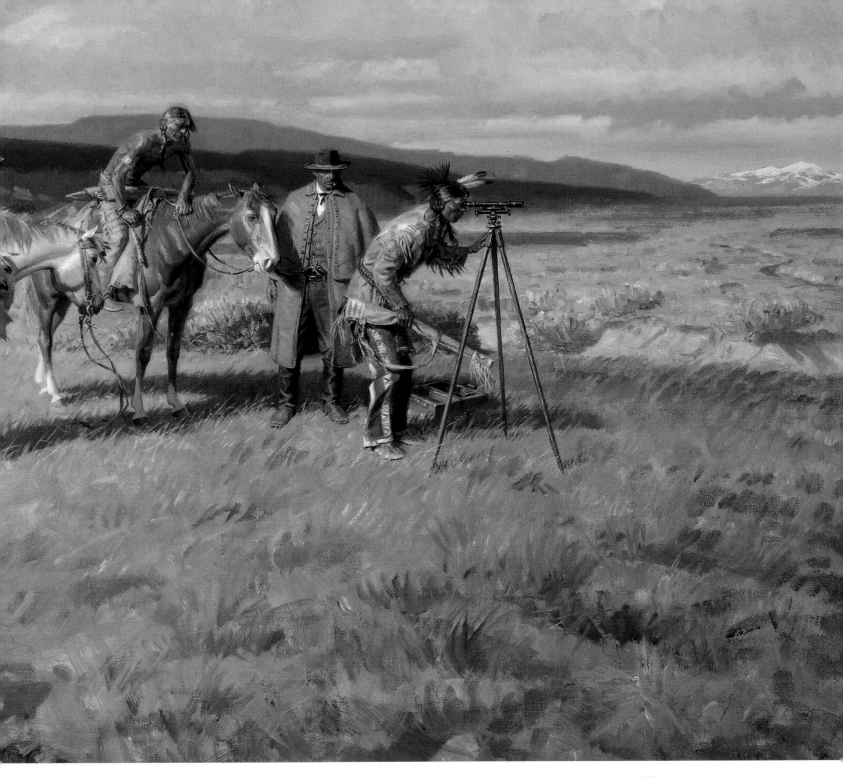

THE SURVEYOR

There seemed no end to the white man's marvels. Here two buffalo scouts stop to see what this man is doing out here with this strange contraption. Is it a weapon? The big man assures them it is not, and one Indian dismounts, indicating trust by keeping his rifle in its case. The Indian peers through the magical device and decides this is yet another example of the white man's strong medicine. The surveyor realizes he is outnumbered and that his camp is far off, back by the trees along the river, beneath the distant hills. His pistol is stuck in his belt where the Indians can see it. When the railroad pushed west from Dodge City in 1869, surveying parties moved out in advance of the construction gangs. The Indians did not yet perceive the threat the railroad would present to the traditional patterns of life.

Preliminary Charcoal Sketch

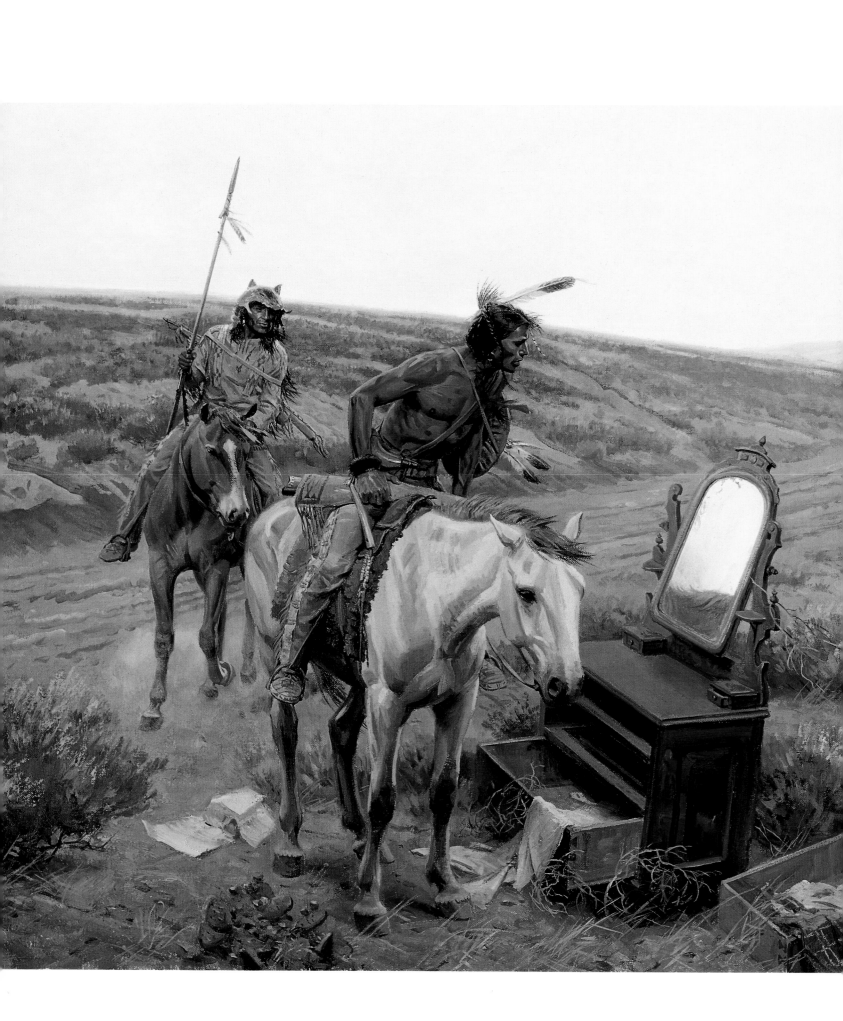

THE HEIRLOOM

It has been estimated that more than ten thousand wagons rolled across the western Plains along the Oregon Trail during the decade of the 1840s. They were bound for the lush, green valleys of the Pacific Northwest. Hardship and hunger rode alongside the overland immigrants. Sickness eroded the body, and despair broke the spirit. A family's dreams dimmed a little more each day as the sun rose again on an endless expanse of prairie. Hope was abandoned along the trail; and with the weakening of the team horses, so were cherished items which had been intended for new homes and new lives in the promised land.

A Sioux warrior regards his reflection in the mirror of a dresser which has been thrown out to lighten a wagon's load. Somewhere, farther up the trail, a pioneer woman mourns its loss . . . and keeps moving west.

*Preliminary
Charcoal Sketch*

THE LOST RAG DOLL

Wagon tracks have become a permanent feature of the prairie landscape in the 1840s as increasing numbers of white immigrants travel the Oregon Trail. From the shelter of the hills, Indians observe the exodus and wonder where these people come from, and where they go. In the lodges of the chiefs, old men sit around council fires and talk of the white trespassers who are disturbing the buffalo. Near Independence Rock, a Cheyenne brave rides

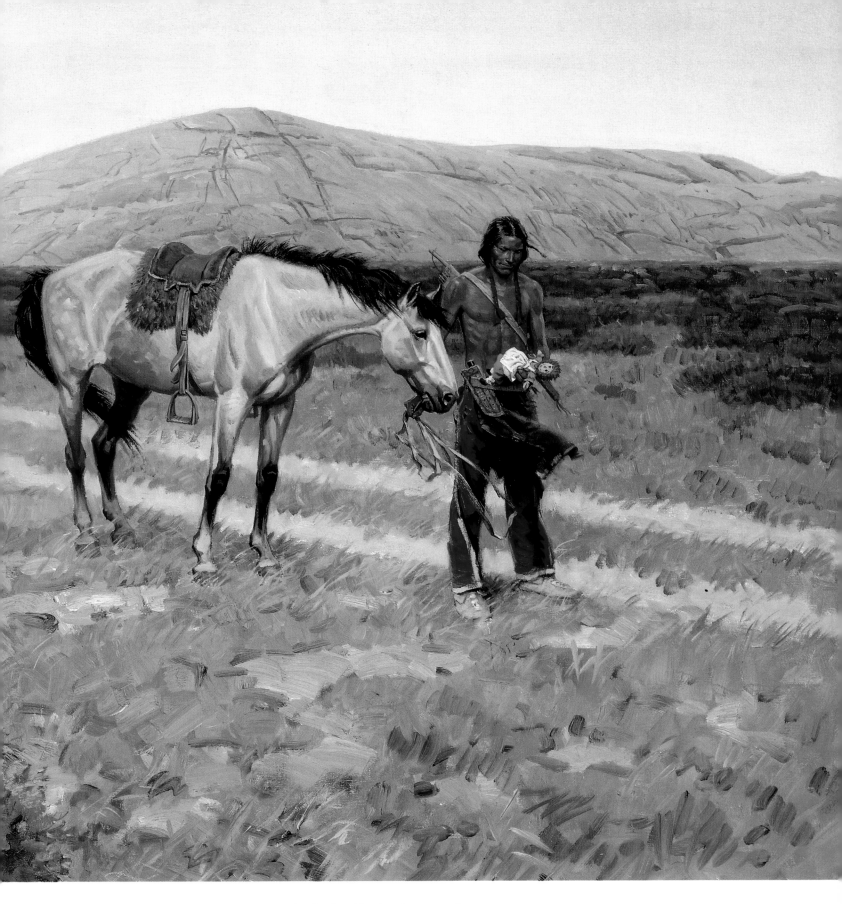

down to investigate a bright spot of color beside the dusty track. He finds a child's doll, a plaything not so different from one made of buckskin that belongs to his own daughter. He thinks that maybe these prairie travelers are not a truly terrible people as some have said. Cold hearts would not make redheaded dolls for little girls to play with. Perhaps the warnings of the shaman have been wrong, and the wagons may continue to pass in peace.

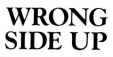

WRONG SIDE UP

What manner of men were these white people who would do such a thing to the buffalo range? The plow proved to be a deadly weapon which set in motion a sequence of destruction. Crops were planted where the buffalo had grazed; soon the great herds would be gone. Without the buffalo, the Indian was doomed. And in the end, the white farmers would abandon these places to

drought and erosion, the genesis of the dust bowl days. Buffalo, Indians, homesteaders . . . all blown away in the rising dust clouds because the land had been turned wrong side up.

The scars are still upon the land, and deepest yet in the hearts of the descendants of Plains Indians who had understood the delicate balance of nature on the range of the buffalo.

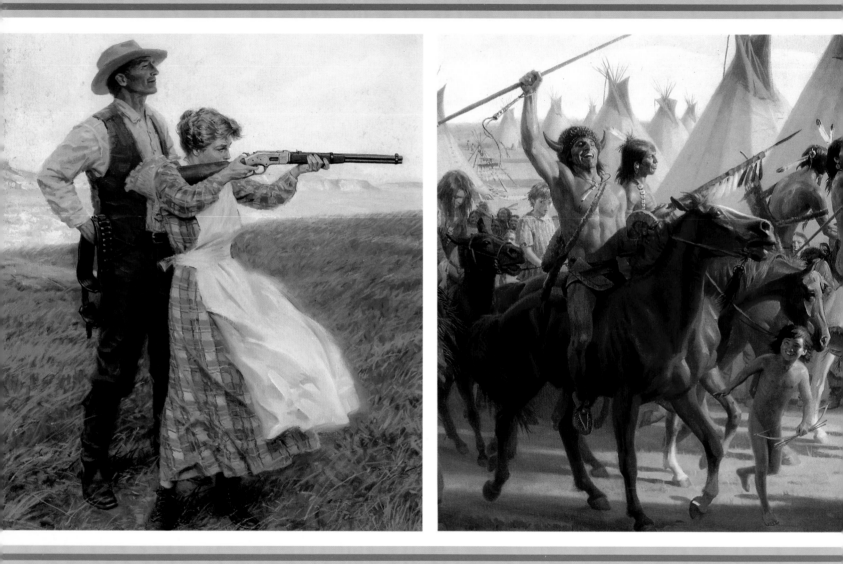

BLOOD ON THE PLAINS

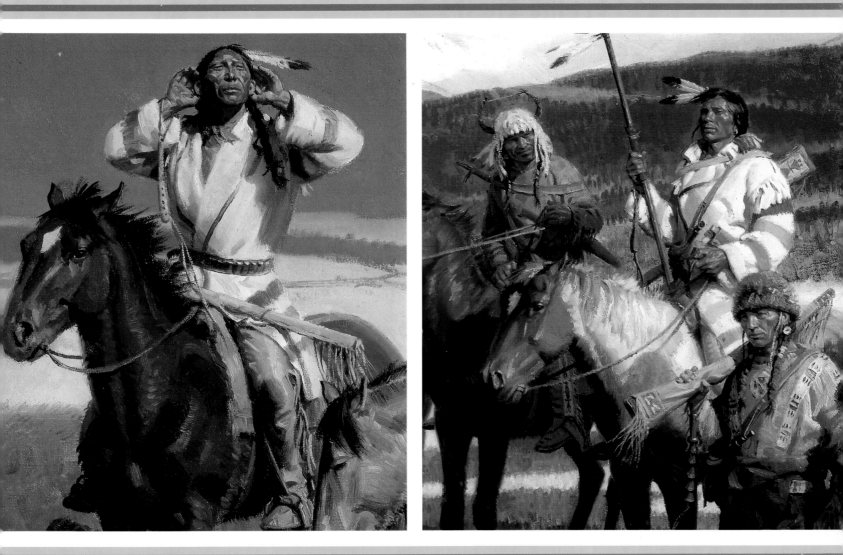

It was clear to the Indian that
the treaties they had signed were meaningless.
Whites and Indians viewed each other
with deepening suspicion and kept
their weapons close at hand.

PART THREE

BLOOD ON THE PLAINS

Back at the beginning of the nineteenth century, the Plains Indian had regarded the few white men he encountered with bemused curiosity. Close behind Lewis and Clark came the trappers and traders. The Indian was inclined to be open and friendly toward them and their trading enterprises. Then, the wagons began to roll along the Oregon Trail, and a string of forts was built as blue-coated soldiers began to appear in Indian country. The old men of the tribes became apprehensive.

The discovery of gold in California at mid-century accelerated westward overland migration. In anticipation of trouble, the white man's government attempted to forestall the outbreak of violence by entering into treaties with the various tribes. The Indians were to guarantee safe passage for the whites traveling through their territory, and to restrict their movements to specific areas that were separate and distinct from that of other tribes. In exchange, the Indians would receive annual payments in the form of the trade goods on which they had become dependent. In the fall of 1851, eight northern tribes accepted such an arrangement at Fort Laramie in Wyoming. Two years later, several southern tribes would make similar deals.

Eager at the prospect of an annual allotment of trade goods, the Indians paid scant attention to the implications of the territorial restrictions contained in the treaties. Here was the genesis of the reservation concept.

By now the great western buffalo herds were beginning to show the effect of a decade of intensified hunting. The white overland immigrants were also killing significant numbers of buffalo, too, and disrupting the normal patterns of herd movements. This made it necessary for the Indian hunting parties to roam outside the specified territories.

As additional military outposts were established on the Plains, pioneer families who had started out for Oregon began to feel more secure. They recognized the potential for farming and stock raising on the prairies, and many cut their journey short to settle on the land which the government had promised would always belong to the Indian.

Gold strikes in Colorado, Montana, and the Dakotas further exacerbated the situation. White men were by now becoming a permanent presence in Indian country. It was clear to the Indian that the treaties they had signed were meaningless. Whites and Indians viewed each other with deepening suspicion and kept their weapons close at hand.

A fundamental shift had occurred in the white men's intentions toward the Plains Indian and his land. No longer did they come to trade, or to seek a path across the prairies to some distant destination. Now the whites would have this land for their own: to dig in the hills for gold, to plow up the buffalo grass for farming, and to build towns.

A rationale for the expropriation of Indian land and sovereignty was already in place. It was a cultural and territorial imperative called manifest destiny. This was a doctrine based in America's white European Christian background which gave priority to the purposes of *civilized* people over those of native *savages*. The Great Plains belonged to white America. Thomas Jefferson had bought them from France. The Indians had come with the deal. If they wanted to stay, they would have to be lifted out of their ignorance and transformed into peaceful, Christian farmers: to become dark-skinned white men.

In the lodges of the Sioux and the Cheyenne, old men sought help from the Great Mystery Power and performed ancient medicine rituals. Young men sang war songs and made their hearts hard against the whites. Vision seekers saw hazy reflections of blood and smoke. The thunder of violence finally began to roll across the Great Plains on a day in 1854. A Sioux hunter killed a settler's stray cow in the area around Fort Laramie. A contingent of thirty soldiers, under the command of Lt. John L. Grattan, rode boldly into the Sioux camp and demanded the surrender of the culprit. The Sioux refused, and Grattan ordered his men to fire on the camp. A single white soldier was able to make it back to Fort Laramie to tell of the fight.

The fragile peace was broken. From the sacred Black Hills of Dakota, to Palo Duro Canyon down on the Llano Estacado, war cries and bugle calls would echo across the Great Plains for the next thirty years.

Part of the ultimate tragedy was that the Indian did not understand the true nature of the conflict. He thought of the whites as just another tribe of people: strange and different indeed, but guided in war by principles of bravery, honor, and good medicine which were common to all the Plains tribes. The Indian never fathomed the depth of the white man's belief in his own racial and moral superiority which would, if necessary, justify the total and complete extermination of native Americans.

Sporadic violence came to be a part of life on the Plains during the 1850s. The Indian still had the advantage of numbers, as well as a knowledge of the country. They also had the

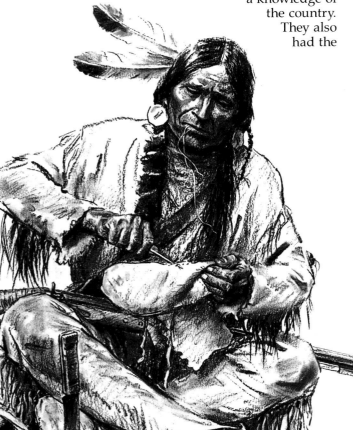

strength of a righteous cause: the defense of their homeland. Solitary travelers and isolated settlers on the buffalo range came to know fear.

At the outbreak of the Civil War, frontier hostilities remained unabated. The government in Washington was unable to provide enough troops to pursue punitive expeditions against the Indians, or to offer anything but minimal defense for immigrant parties and settlers. Irregular forces were formed by the whites in an attempt to provide for mutual protection. The most famous of these, the Texas Rangers, challenged the fierce Comanche on the southern Plains in constant and bloody conflict.

Further north, in Colorado Territory, white irregulars went on the offensive, burning villages and killing at random. The Cheyennes struck back in June, 1864, with the massacre of a white family near the settlement of Denver. In retaliation, on a cold, November morning, a volunteer force attacked the camp of a peaceful band of Cheyennes at Sand Creek. They killed two hundred men, women, and children. The rest of the Cheyenne Nation, along with their Sioux and Arapaho allies, would no longer tolerate those among them who talked of peace.

Up on the northern Plains, the Sioux, under the leadership of Chief Red Cloud, carried the war to the whites with increased ferocity. The army had sought to gain treaty concessions in 1866 to build forts along the Bozeman Trail, which stretched directly through Sioux hunting lands protected by prior treaties. Red Cloud's warriors would not bargain. Before the year was out, Sioux and Cheyenne fury was unleashed across Montana, Wyoming, and the Dakotas. One hundred and fifty whites died along the route, which came to be known as the Bloody Bozeman. By now, the white government's preoccupation with the Civil War was behind them. There were plenty of battle-hardened troops available to pursue the war in the West. But it was not just the introduction of additional soldiers that would result in the increase of frontier violence.

New waves of immigrants and settlers fled a depressed and war-weary East in search of a new start in the West. Cowboys trailed great herds of longhorn cattle up from Texas to carve out a ranching empire in the heart of the buffalo range. The railroad also began building across the Plains, killing still more buffalo to feed the construction crews.

The once-mighty herds that had sustained the Plains Indian were dwindling fast. It is estimated that there were approximately sixty million buffalo at the beginning of the nineteenth century. By 1870, that number had declined to around thirteen million. Professional hide hunters descended upon the prairies in the 1870s with deadly efficient Sharps rifles to complete the bloody job. By 1900, there were fewer than a thousand buffalo left. It was the slaughter of the buffalo, even more than inevitable defeat in battle, which dealt the killing blow to traditional Plains Indian life. The great herds were gone forever, and starvation stalked the Plains.

The unrelenting advance of white civilization rolled on. In the fall of 1874, troops under Colonel Ranald McKenzie rode down into Palo Duro Canyon, in the Texas Panhandle, and attacked a large encampment of Comanche, Kiowa, and southern Cheyenne. This battle broke the back of Indian resistance on the southern Plains.

Up north, in the Black Hills of Dakota, prospectors swarmed at the reports of a new gold strike. This was sacred ground to the northern tribes and was reserved to them by terms of treaty. In the late spring of 1876, more than 10,000 Sioux and Cheyenne came together for the sun dance ceremony and to hear Crazy Horse and Sitting Bull call for all-out war.

On June 25, Lieutenant Colonel George Armstrong Custer and 225 men of the Seventh Cavalry approached the Indian camp along the Little Bighorn River in eastern Montana. Before sundown that day, the scalps of Custer and his men hung in the sprawling camp beside the Little Bighorn, and war drums throbbed with the rhythm of victory. The defeat of Custer sealed the fate of the northern tribes of the Great Plains. Now the white man's army would doggedly pursue them unto surrender or death.

A year after Little Bighorn yet another epic drama was played out on the northern Plains. Chief Joseph led 700 Nez Percé men, women, and children from their Oregon homeland, across the mountains, and out onto the Plains. Fighting pursuing soldiers every step of a 1700-mile trek, the Nez Percé were finally brought to bay near the Canadian border in northern Montana. Of the 700 who had started out in Oregon, 431 were left. The survivors were starving, cold, and dispirited. Joseph surrendered to Colonel Nelson A. Miles saying: *Hear me my chiefs. I am tired; my heart is sick and sad. From where the sun now stands, I will fight no more forever.*

It is difficult to imagine the abject hopelessness of reservation life for a people who had been proud and free. In despair, the Indian struggled to keep hope alive. In 1889 a Paiute from the high deserts of Nevada reported he had received a vision: the Indian dead would rise, the buffalo would return, and the whites would disappear. In order to bring this about, the Paiute called for passivity and a new ceremonial dance. Word of the ghost dance spread quickly across the Plains.

By the following year, the Sioux had adopted the ghost dance. The reservation agents and soldiers saw it as a security threat and accused Sitting Bull of inciting revolt in the guise of religion. In mid-December he was shot dead by Indian police who had been sent to arrest him. In panic, Indians began to flee the reservation. On December 29, 1890, Chief Big Foot and a band of about 350 Sioux resisted attempts by Seventh Cavalry troops to return them to the reservation. The soldiers of Custer's old regiment shot down half of the band, including Big Foot, and rode off, leaving the bodies where they had fallen. Three days later, New Year's Day, 1891, the soldiers returned. They pried loose the bodies that had become frozen to the ground and dumped them into a common burial trench close by the icy waters of Wounded Knee Creek.

Wounded Knee marked the bitter end of the struggle for control of the Great Plains. Henceforth, for the Indian there was only sadness and resignation. It is a tragedy that continues to haunt the American conscience.

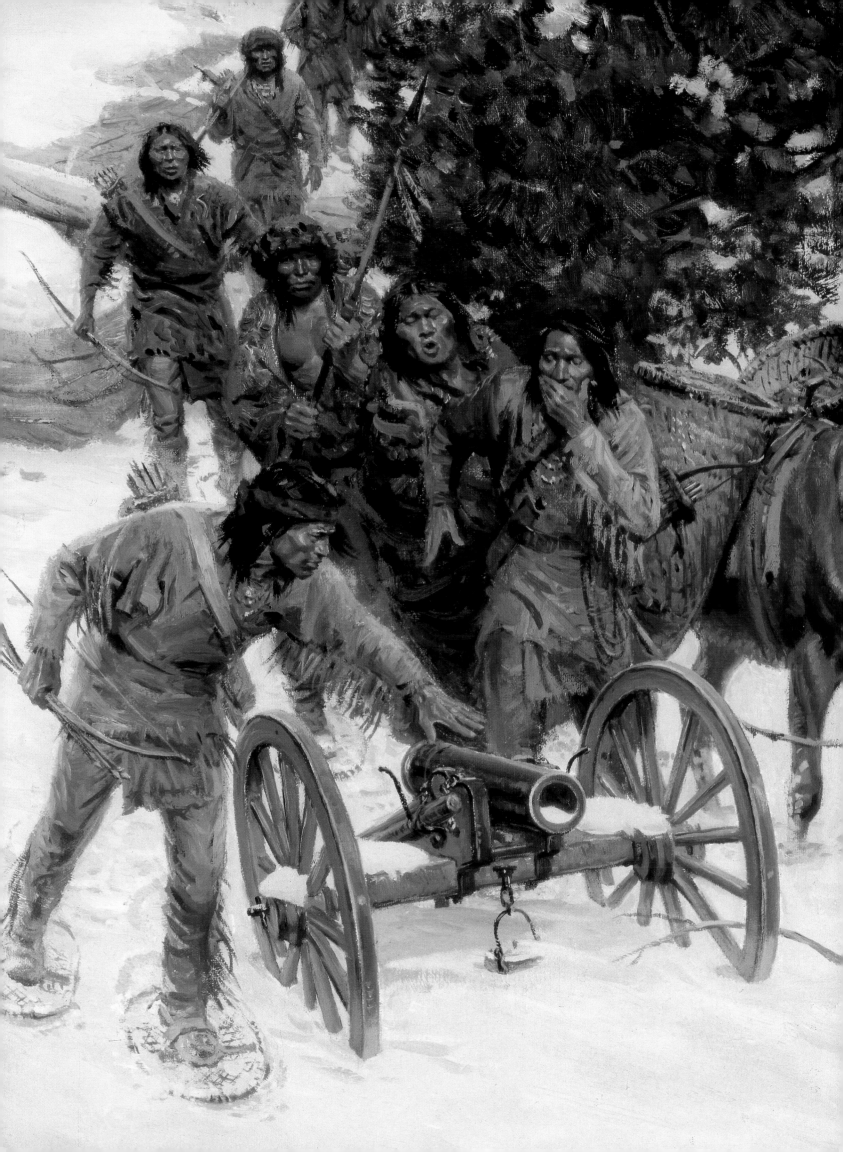

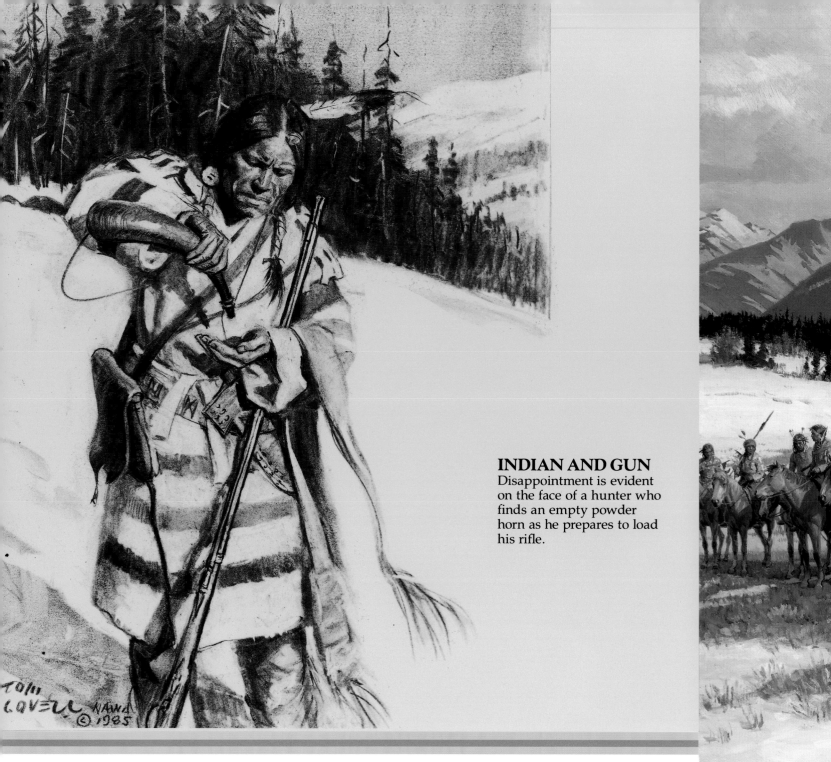

INDIAN AND GUN
Disappointment is evident
on the face of a hunter who
finds an empty powder
horn as he prepares to load
his rifle.

BLACKFEET WALL

The Lewis and Clark expedition had reached the shores of the
Pacific and had begun the trek back across the continent. In July,
1806, Captain Lewis and three members of the party split off from
the expedition to explore the area around the mouth of the Yellow-
stone. They met a Piegan hunting party and shared a camp for the
night. The Piegans were a band of the Blackfeet tribe, a people of a
proud warrior heritage. Toward dawn, the Piegans attempted to
steal a rifle and the horses of Lewis' party. A fight broke out, and
two Piegans were killed.

After that fatal morning on the Yellowstone, the Blackfeet would
forever consider the white man to be their enemy. In the 1830s,
Eagle's Rib, a Piegan Blackfeet war chief, would boast to artist
George Catlin that he had taken the scalps of eight white trappers.
This formidable row of mounted warriors symbolizes the Black-
feet's determination to defend their homeland against the white
invaders.

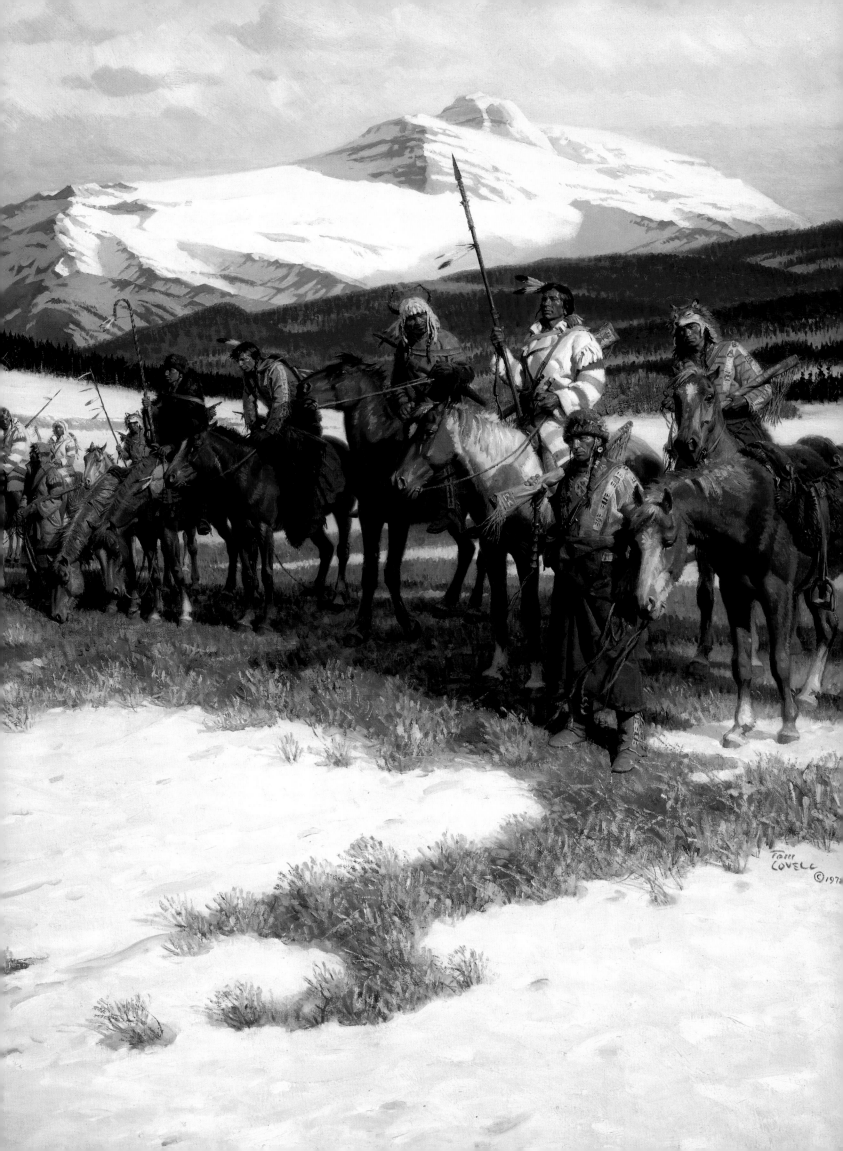

PAWNEE SCOUT

The Pawnees were willing to serve as scouts for the white man's army in its campaigns against their old enemies, the Sioux and Cheyenne. In retribution, a large force of Sioux attacked a Pawnee hunting party in 1873. One hundred and fifty Pawnees were killed, including their leader, Sky Chief, who had been responsible for the scouting agreement with the U.S. Army.

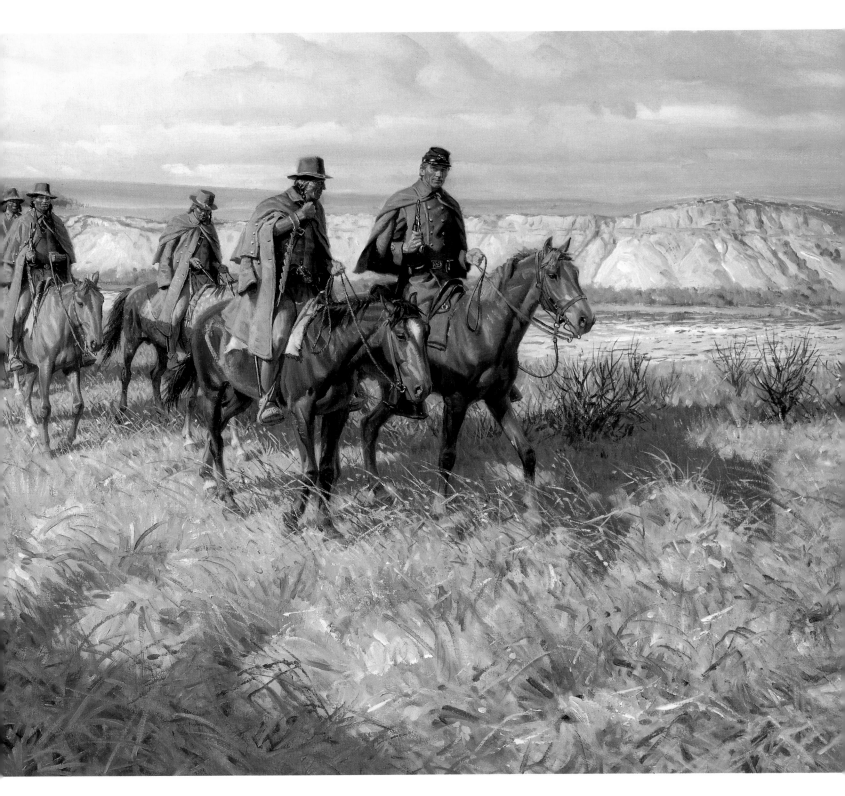

CAPTAIN MURIE'S PAWNEES

Sky Chief, a leader among the Pawnees, was willing to make friends with the white men. He provided warriors to scout for the Cavalry, and others to serve as guards for railroad construction crews. This alliance would not only diminish the threat from the Pawnees' traditional enemies, but might also result in treaty advantages once the Indian wars were over.

In 1867, the Cheyennes launched a series of attacks on Union Pacific crews. The U.S. Cavalry was arrayed on a wide front, and sufficient forces were not available to pursue the Cheyenne raiders. A resourceful Army captain turned out his Pawnee scouts, stripped down to breechcloths and ready to fight. They disguised themselves in Army coats and hats, leading the Cheyenne to believe that this was an inferior force of ill-prepared white soldiers. Throwing off their coats, the Pawnees were able to rout the Cheyennes with the element of surprise.

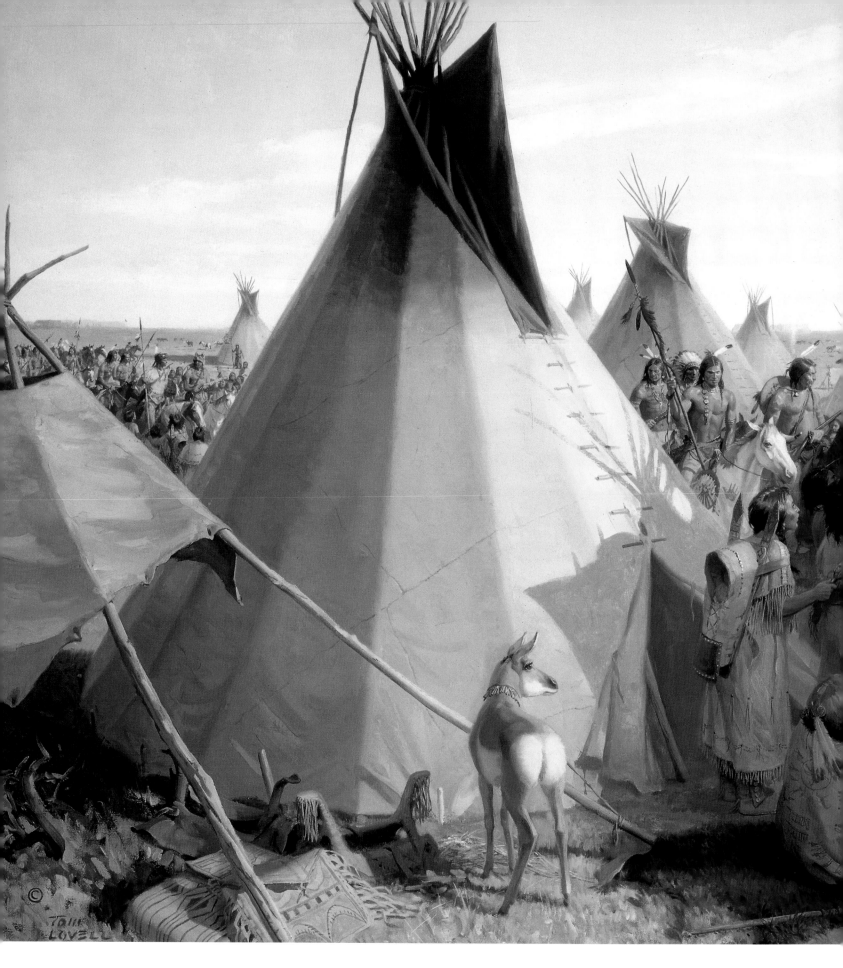

COMANCHE MOON

The Comanche warrior was the undisputed lord of the southern Plains. He repelled attempts by Spain to establish a southwestern empire and was victorious in intertribal warfare with the Arapaho and southern Cheyenne. Even the indomitable Apache was no match for the fierce Comanche. Theirs was

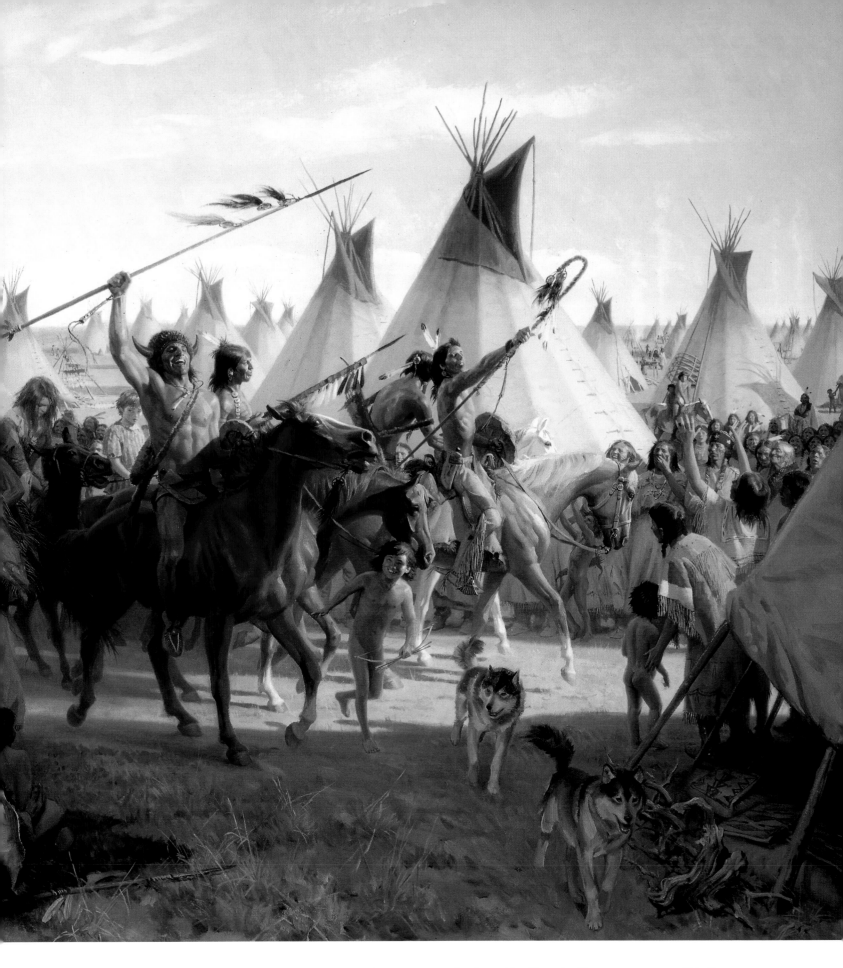

a fearsome and bloody heritage of horses and war. In 1836, the Republic of Texas was founded on the eastern edge of Comanche territory. The isolated farms and ranches west of San Antonio became the targets of Comanche raiding parties. The period of the full phase of the moon seemed to be a favored time for the raids. Frontier Texans came to call it the Comanche moon and would, on the bright nights, sleep uneasily, with guns close at hand. The blood and violence would continue until 1875, when Quanah, the last great Comanche war chief, finally surrendered.

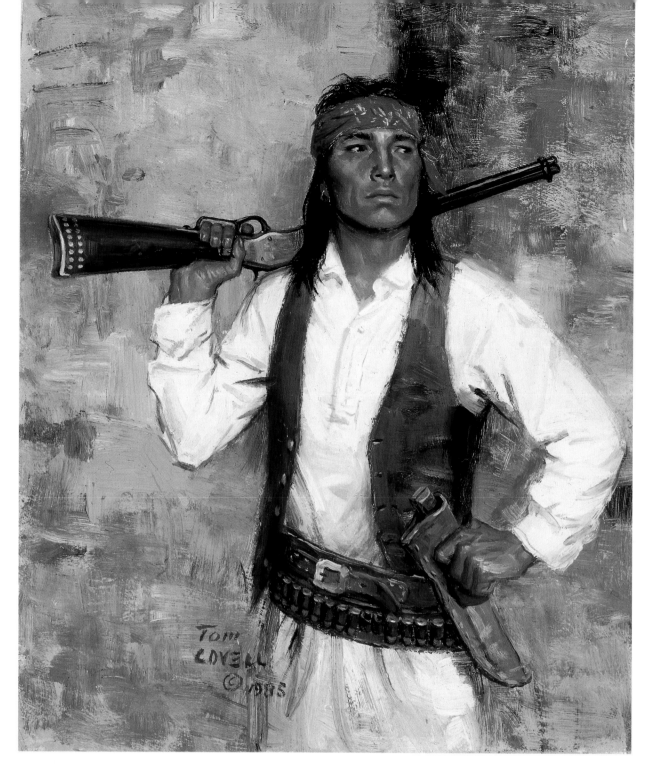

CHIRICAHUA
SCOUT

This Apache wears the red headband of a scout
for the Army. He was capable of covering more
than fifty miles a day on foot, through country
where a horse could not go, and where only
the Apache knew the location of water. It is
doubtful that the Army would have survived
in the desolate land had it not been for the
services rendered by the Apache scouts. After
the final surrender of Geronimo's remaining
warriors, the scouts were shipped off to federal
prisons in Florida. They had served the white
soldiers against their own people and were
promised freedom. Like other government
promises, that promise was broken.

LISTENING FOR
THE DRUMS ▶

On an early morning in November, 1864, several hun-
dred Colorado volunteers attacked a peaceful band of
Cheyennes at their camp on Sand Creek. Two hundred
Indians were killed, most of them women and children.
This massacre brought a swift and violent response
from the Indians of the central Plains. Cheyenne,
Sioux, and Arapaho war parties attacked and killed
whites where and when they found them. Throughout
the long, winter nights, drums throbbed in camps
along the South Platte as warriors sang songs of re-
venge and put on war paint. The camps were moved
frequently to avoid discovery by Army patrols. Scouts
looking for the new location of their camp would stop
and listen from the hills for the sound of drums, which
would guide them through the winter darkness.

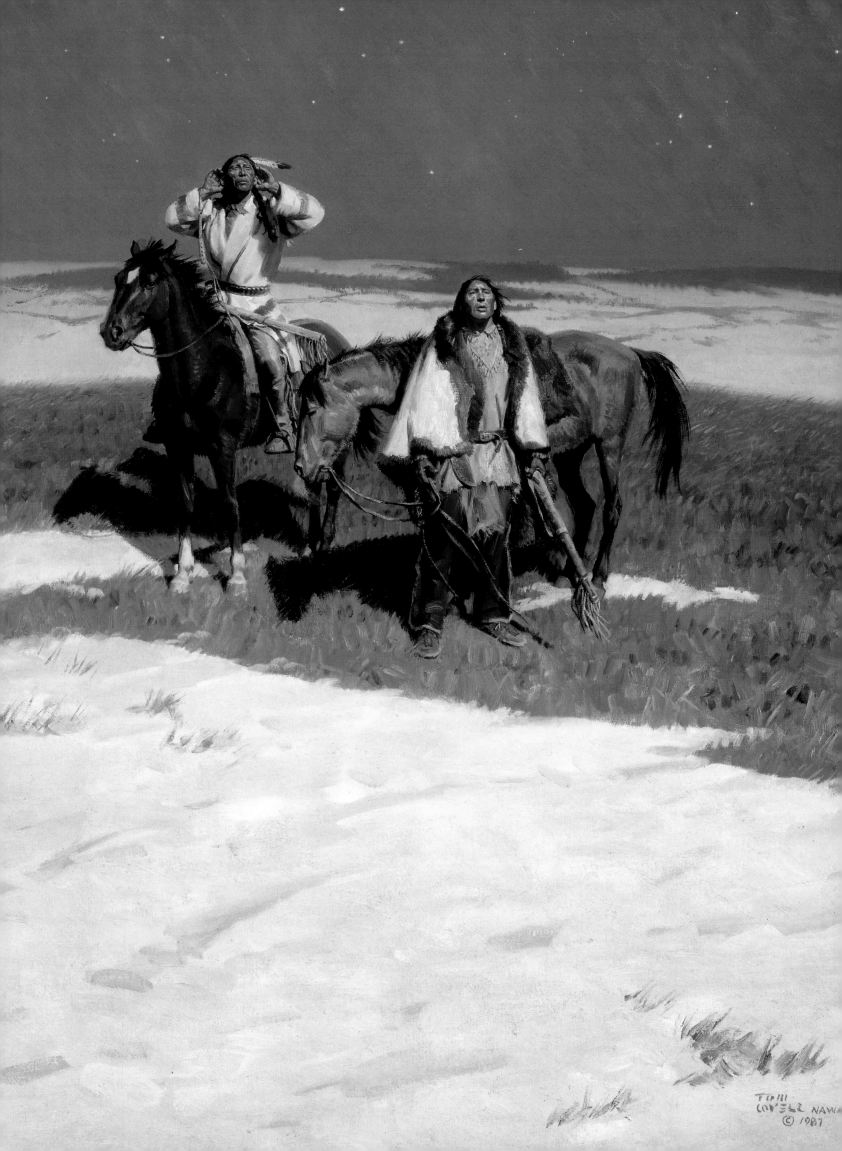

FIVE MILES AHEAD OF THE COLUMN

Sporadic violence between whites and Indians increased in the decade of the 1850s. Treaties were abrogated as white settlers and miners laid claims to the land of the buffalo range. Reprisals followed, and all-out war seemed a certainty. U.S. Army troops no longer moved with impunity across Indian country.

On the northern Plains, Pawnees and Crows were enlisted by the Army as scouts, as were white frontiersmen who had particular knowledge of the hostile tribes and the country. Here, two scouts have accompanied an officer in advance of the main force. They survey the open terrain in search of enemy movements before showing themselves. The toll of dead soldiers has mounted over the last few months, and a good officer has learned not to underestimate his adversary. Lieutenant John L. Grattan and his entire column of thirty men were wiped out in a fight near Fort Laramie in 1854. Henceforth, the blue-coated columns would proceed with caution in enemy territory.

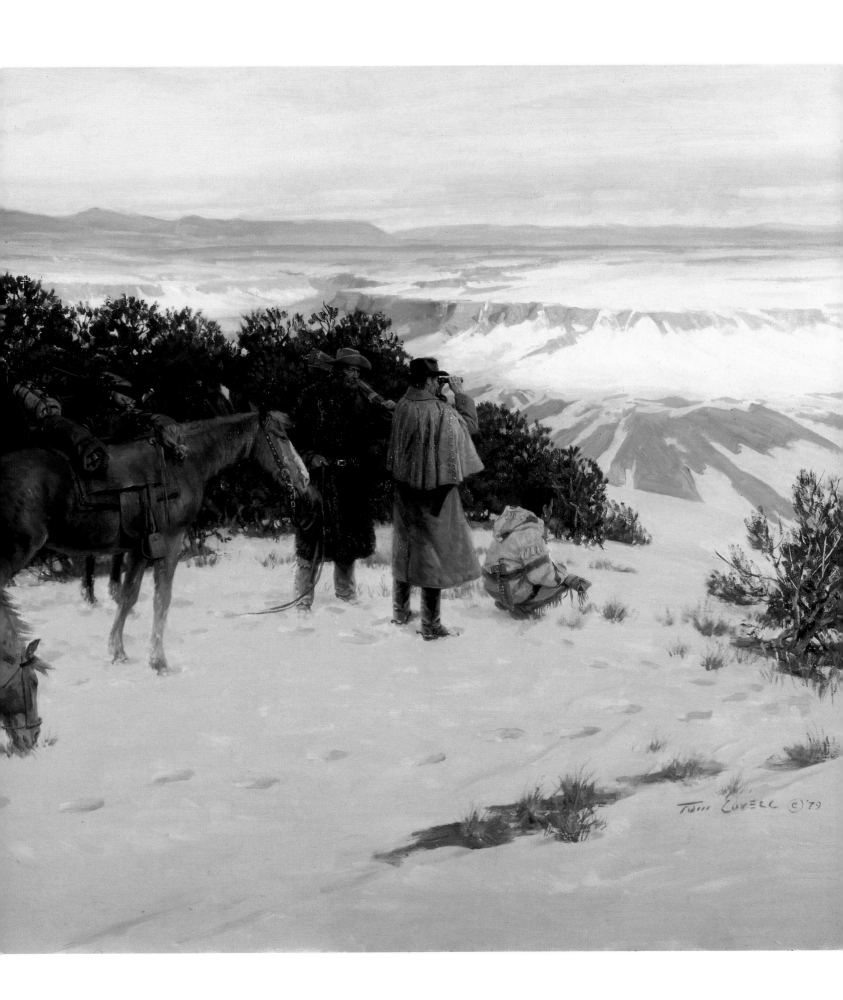

COOLING THE BIG 50

In the 1870s, buffalo hides were selling in the range of three dollars apiece. A small party of professional hide hunters could shoot and skin as many as two hundred buffalo on a good day. The gun of choice was the heavy-barreled, fifty-caliber Sharps rifle. From a location downwind, a hunter was able to shoot from long range without causing the herd to stampede. The kill would continue until it became necessary to cool down the over-heated rifle barrel with water.

PONY TRACKS AND EMPTY SADDLES

The element of surprise was a major weapon in the arsenal of the Apache. They struck their enemies in lightning-swift raids and withdrew as suddenly. If pursued, they prepared ambushes in narrow, rocky canyons to deal a second deadly blow. In this scene, the rear guard has reported such a pursuing force. Some warriors drop off at strategic points along the canyon, while others continue on with the horses, leaving tracks which will make it appear that the raiders are still in retreat. The enemy of the Apache would learn to fear places like this, where steep rock walls blocked out the sun, and death waited in the shadows. One such place came to be known as Apache Pass, a narrow six-mile-long canyon between the Dragoon and Chiricahua mountains in southeastern Arizona. Spaniards, Mexicans, and Americans learned about guerrilla warfare, the hard way, on the dim trail that led through Apache Pass.

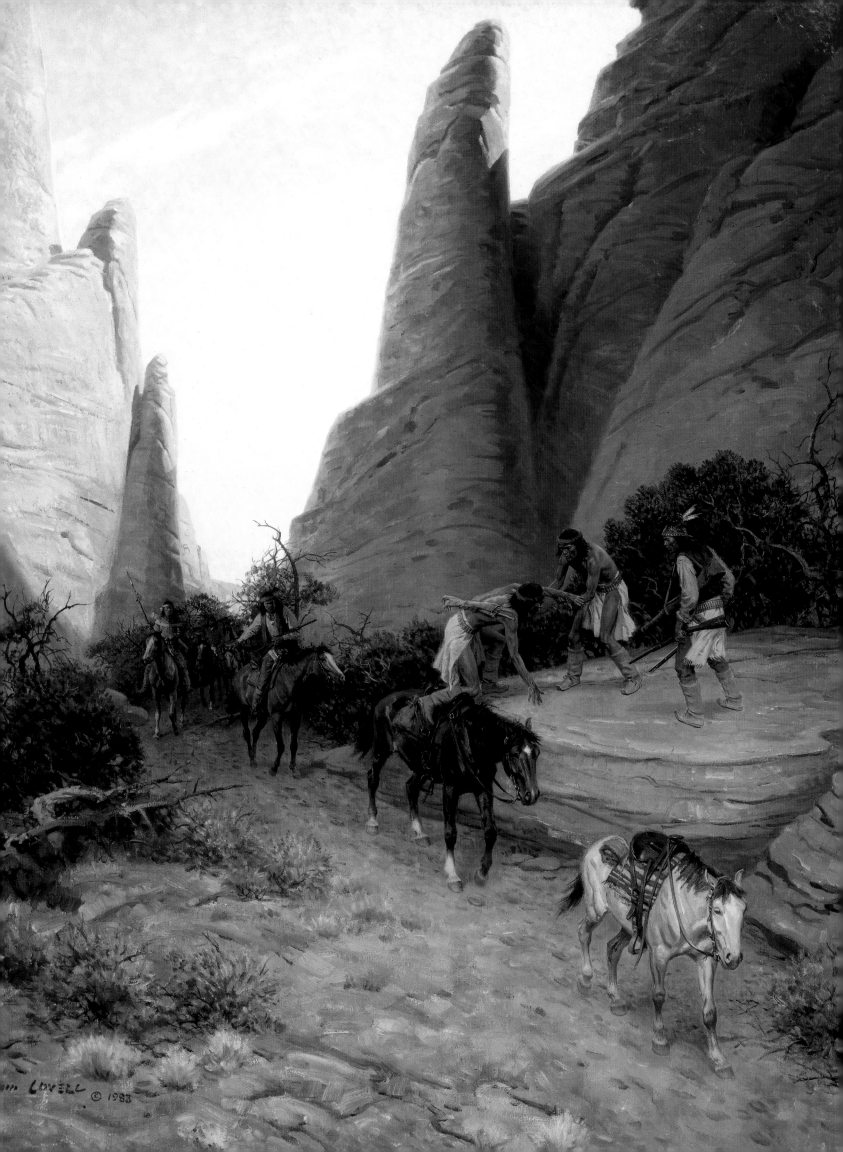

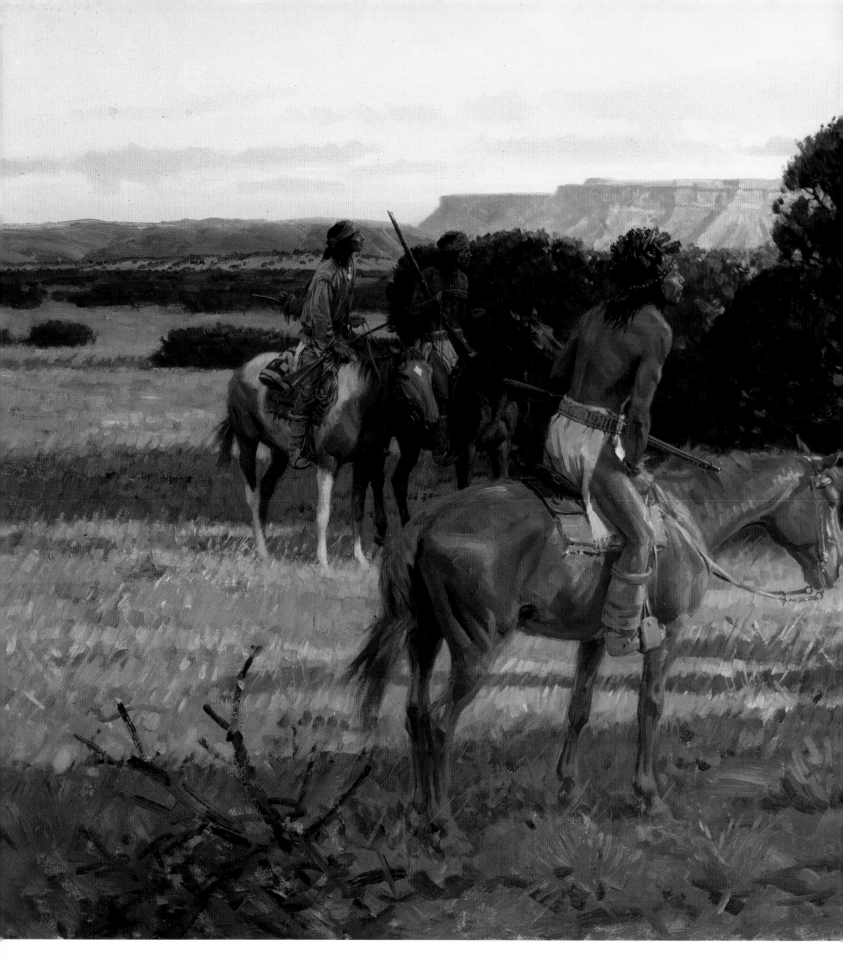

THE DECEIVER

Traditional military training and strategy were no match for the unconventional guerrilla tactics of the wild Apache. Battle-scarred veterans of the Apache wars, from the merciless Jose Carrasco, of Sonora, to the American generals, George Crook and Nelson A. Miles, came to admit reluctantly their respect for the

devils of the desert. They realized that there was an intuitive quality to the Apache concept of war. Like the wolf, an Apache knew instinctively when to fight and when to flee, where to hide, and how to travel fast and far across terrain unknown to the enemy.

In this scene, Apache raiders are attempting to lure a cavalry patrol into an ambush with the help of a souvenir from an earlier victory. Swift and certain death awaits the soldiers who respond to the deceptive clarion call. Shadows deepen as the sun drops below the surrounding mesas. Life and death hang in the balance as darkness descends.

CHEYENNE DOG ROPE Among the Cheyenne, the warrior society known as the dog soldiers was comprised of individuals whose courage and daring had been proven in battle. The dog soldiers were not only leaders in warfare, but also performed a police function on special occasions, such as sun dance ceremonies, or buffalo hunts. The dog soldiers maintained a lodge within a Cheyenne village which was the site of private and public functions, not unlike an exclusive men's club in white society.

Although every dog soldier had demonstrated his bravery, particularly valiant warriors were accorded the special recognition of wearing a long, buffalo-skin sash which hung from the shoulders to the ground. In battle, a warrior who wore the sash, or dog rope, would inspire his warriors by dismounting in the midst of battle and driving his lance or a wooden peg through the end of the sash. Here he would stand to face the enemy unless another dog soldier released him by pulling up the lance or peg, or with a ceremonial tap of a quirt.

RAMRODS AND BUFFALO CHIPS

A tour of duty on the western frontier was an adventure few soldiers were prepared for. Recruits from eastern cities and midwest farms found themselves thrown together in a strange and empty land. Life was tough for the common soldier, and tough, too, were the men he had come to fight. Close order drills and parade ground formations were of little use when facing an enemy who struck suddenly, and then melted away into a landscape of shadow and mirage. The best officers and troops were those who could adjust to the situation as they found it. Army regulations had not always provided for the reality of survival on the Plains. Every good officer knows that hot meals are essential to the morale of his men. Cold bivouacs take the edge off a fighting spirit. In a land where trees are scarce, resourceful infantry men use their rifle ramrods to collect dried buffalo dung to fuel the evening cook fires.

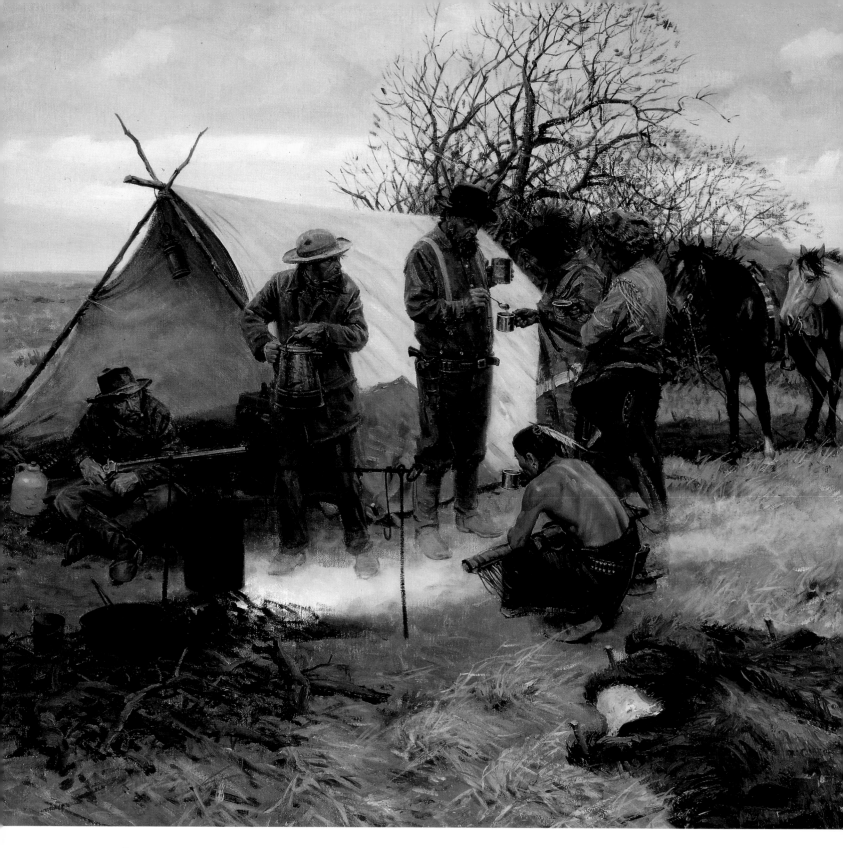

SUGAR IN THE COFFEE

By the 1870s buffalo were becoming scarce on the northern Plains. The hide hunters turned their attention southward, to the Texas Panhandle. This was Comanche country, but in spite of treaty guarantees, the government made no attempt to keep the hide hunters out. The wholesale slaughter of the great southern herd was in full swing by 1873. The Comanches resented the intruders, but did not fully grasp the implications of this terrible, bloody business. There had always been buffalo. Surely a few white men could not change that. For a brief time, they tolerated this renegade bunch.

On a cold, Panhandle morning, three warriors have ridden boldly into a hide hunter's camp. It is an uneasy moment, and the man sitting in front of the tent nervously fingers the trigger of his Sharps rifle. His partners offer coffee and sugar from their meager supplies, scant recompense for the buffalo hides curing in the foreground. The buffalo will soon be gone, and so, too, the free life of the Comanche.

Preliminary Oil Sketch

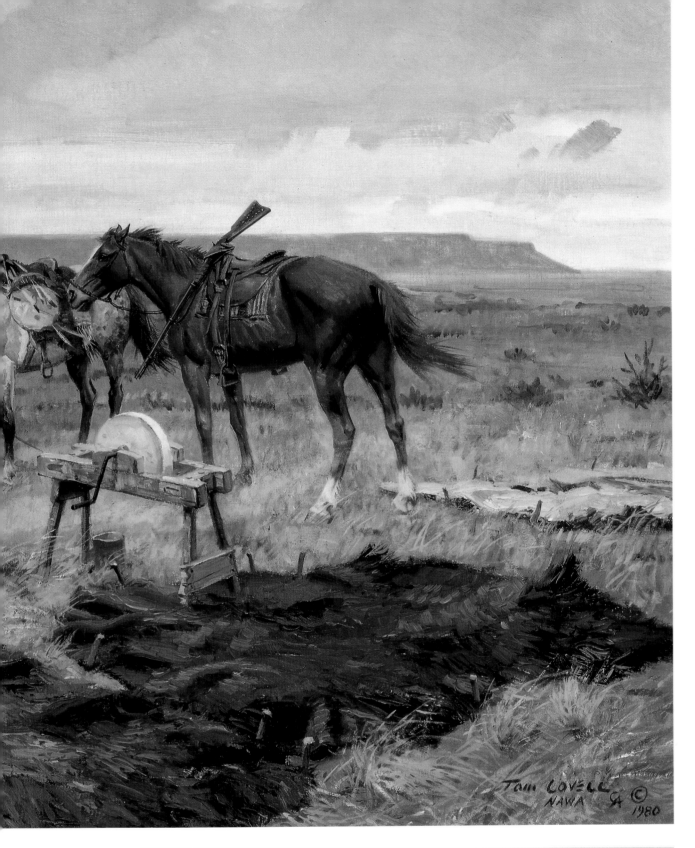

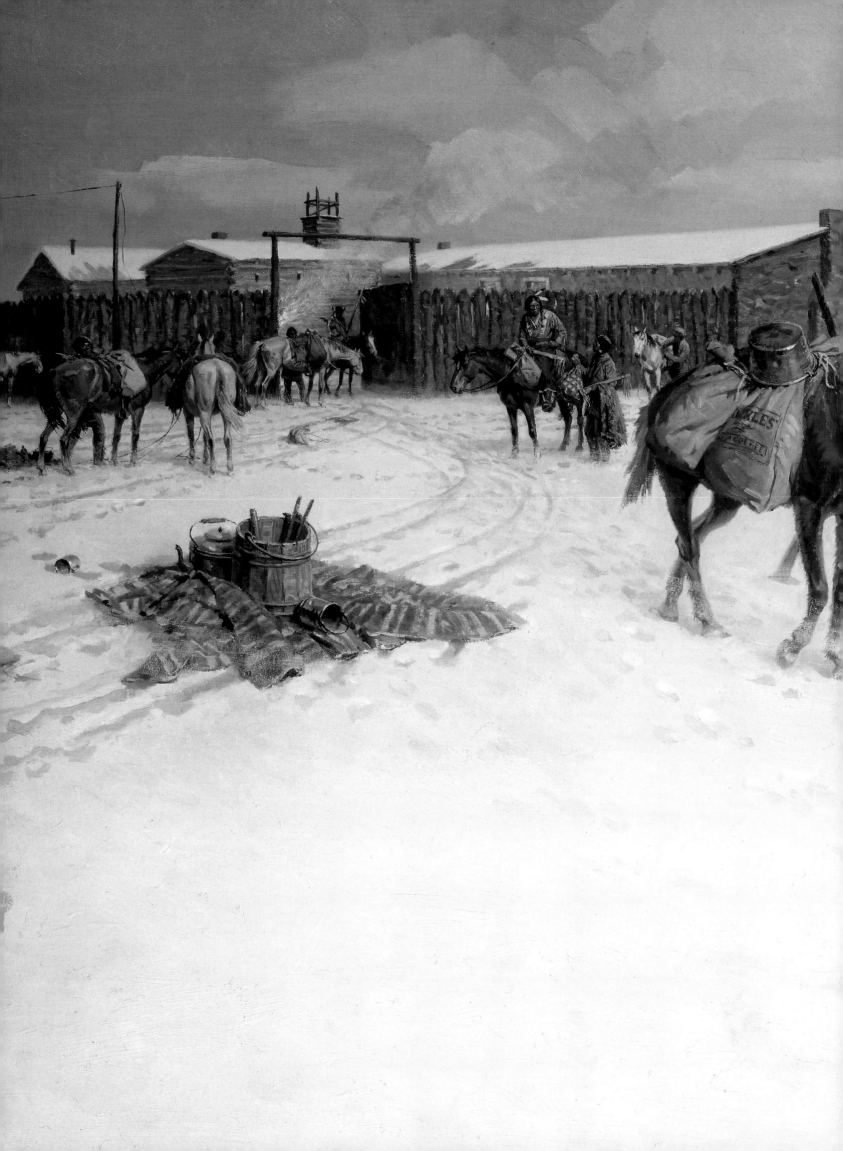

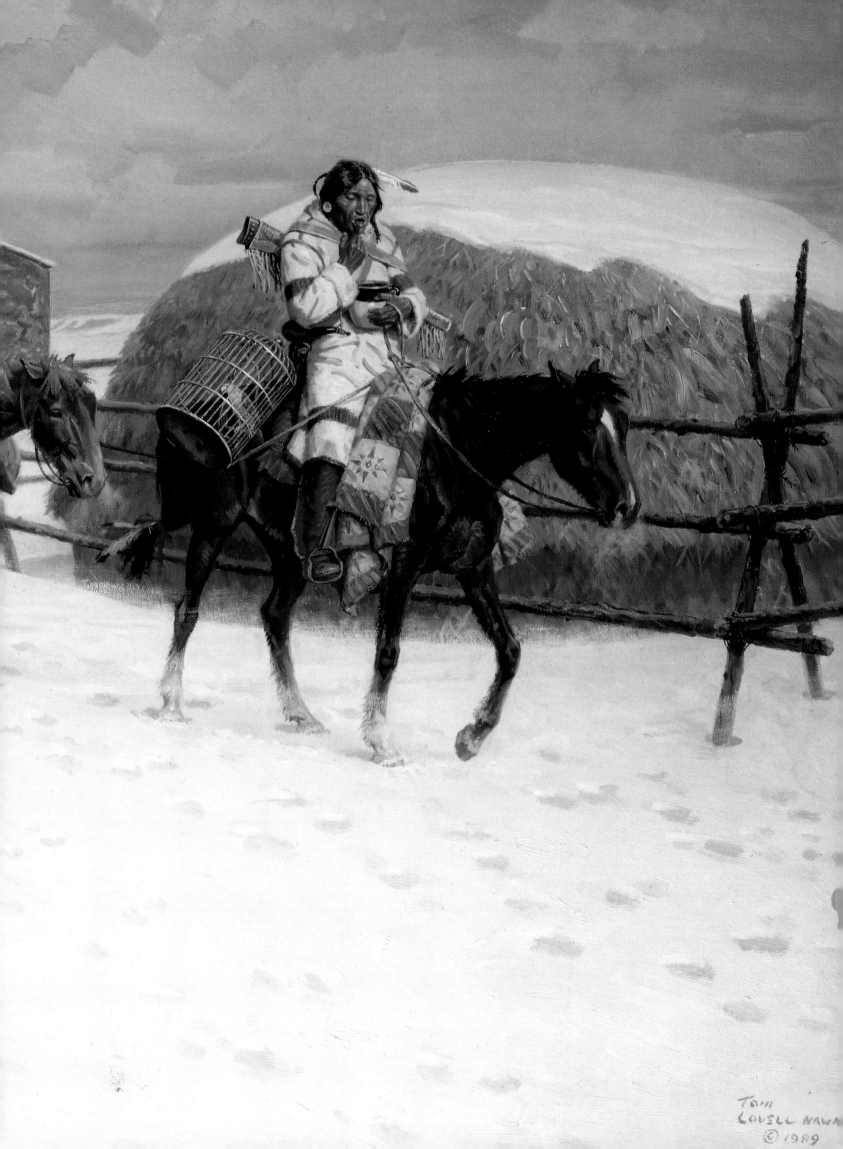

APACHE From the Dragoon and Mogollon ranges of the north, down onto the Sonoran desert below the Sierra Madres, men of grim determination and remarkable endurance resisted all who dared intrude into the Apache domain. Warfare was the Apache's birthright, and his bloody exploits still loom large in the early, violent history of the American Southwest. They expected and gave no quarter in battle, cutthroat marauders in a wild and desolate land.

◀ DRY GOODS AND MOLASSES

After the Sand Creek Massacre in November, 1864, the Cheyennes struck back hard in raids along the South Platte River. They destroyed telegraph lines and cut the stagecoach route to Denver. Outlying homesteads and stage stations were abandoned, as whites fled in panic.

On a cold, Colorado day, a Cheyenne war party has looted and set fire to an abandoned stage station. There will be no white deaths today to avenge

Black Kettle's people who fell at Sand Creek. Flames begin to rise against a gray sky that promises more snow by morning. The war party divides the plunder and prepares to ride away. There will be joy in the lodges of the Cheyennes on this night. No warriors have fallen in battle, and the party is returning with many wonderful things left behind by the whites. With a caged parrot riding along, a warrior takes his first taste of molasses. This has been a good day.

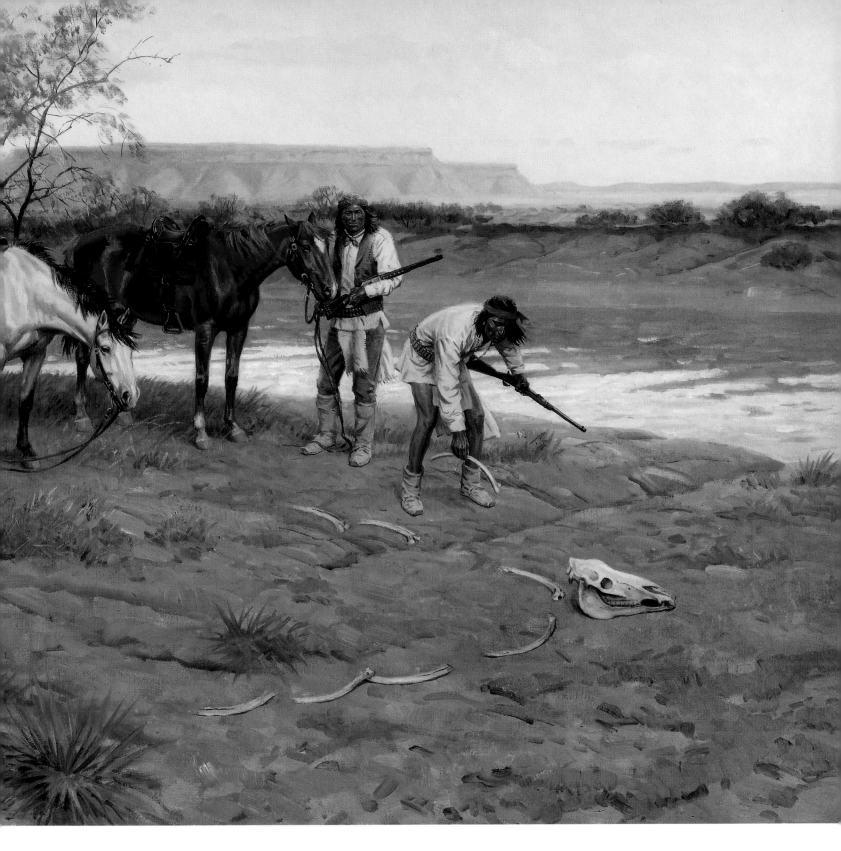

APACHE TRAIL SIGN

Cochise, Mangas Colorados, and Geronimo are names that conjured images of death and destruction, and evoked undimmed memories of dread and terror in the hearts of those who dared challenge Apache sovereignty in the old Southwest. It seemed that there had never been a time when the Apaches were not at war. The Pueblo tribes had felt their sting—so, too, the Spanish and their Mexican heirs. The cream of the United States Army could claim victory only after centuries of attrition had reduced the ferocious and wily warriors to an unrepentant handful. The rough, wild country of mountains and deserts seemed an ally of the Apache.

Here, two Apache scouts are preparing a message from the bones and skull of a horse. It may be a signal for their own band, indicating the direction in which they are to proceed; or, it could be a deception to throw a pursuing enemy off the trail. White soldiers would attach little significance to the subtle story told by the bones.

CAMELS IN TEXAS

On March 3, 1855, Congress appropriated $30,000, as requested by Secretary of War Jefferson Davis, to purchase camels for use by the Army. It was Davis' belief that the camels would solve the difficult problem of transporting supplies across the arid borderland from Texas to California. Thirty-three camels, purchased at various Mediterranean ports, were unloaded on the Texas coast, at Indianola, in April,

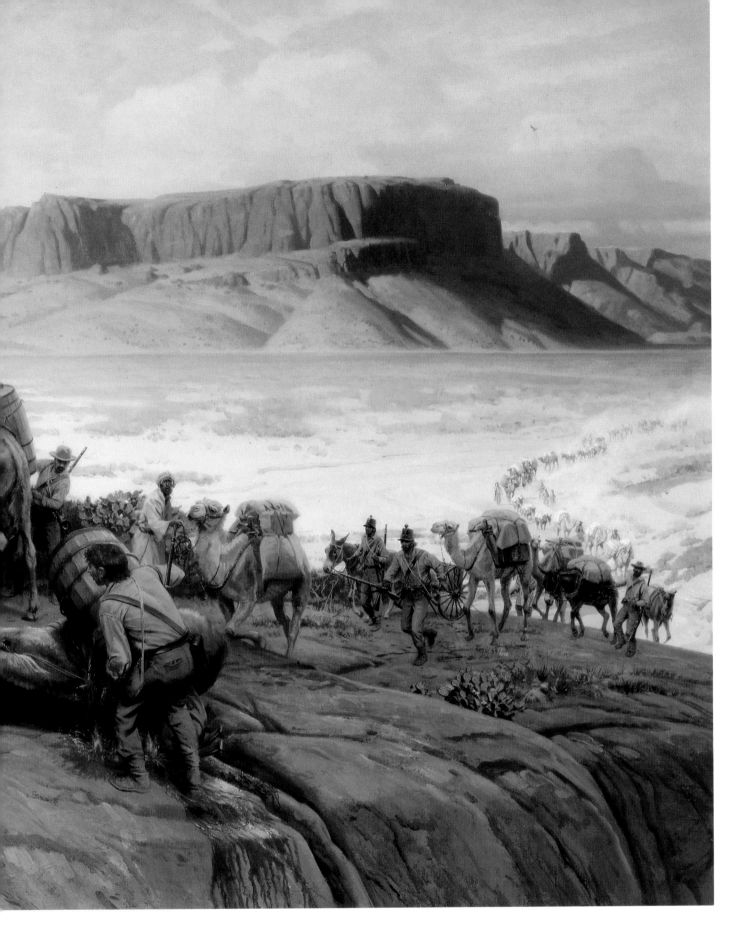

1856. The camels were trailed inland to Camp Verde, a small post west of San Antonio. In the months that followed, the camels were matched against Army mules in field exercises at several frontier outposts. This scene is of a trial run from Fort Davis in the rugged Trans-Pecos region of far West Texas.

Jefferson Davis' camels performed well for the Army. Lieutenant Edward F. Beale crossed the rugged Trans-Pecos country of West Texas and went on to lay out a wagon route from Fort Defiance, New Mexico, to the California border. The camels traveled faster, carried heavier loads, and maintained their strength far better than horses and mules. Before the Army could proceed with the camel program, the Civil War broke out and military concerns shifted.

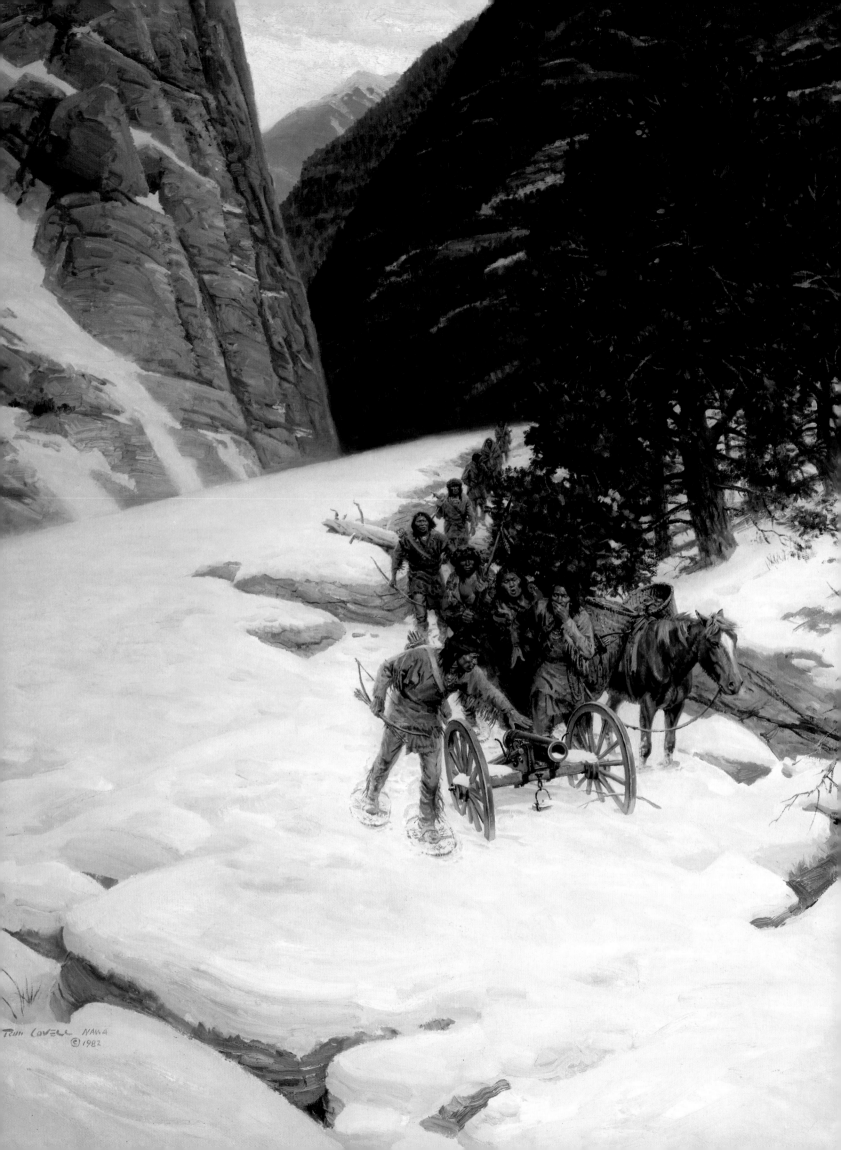

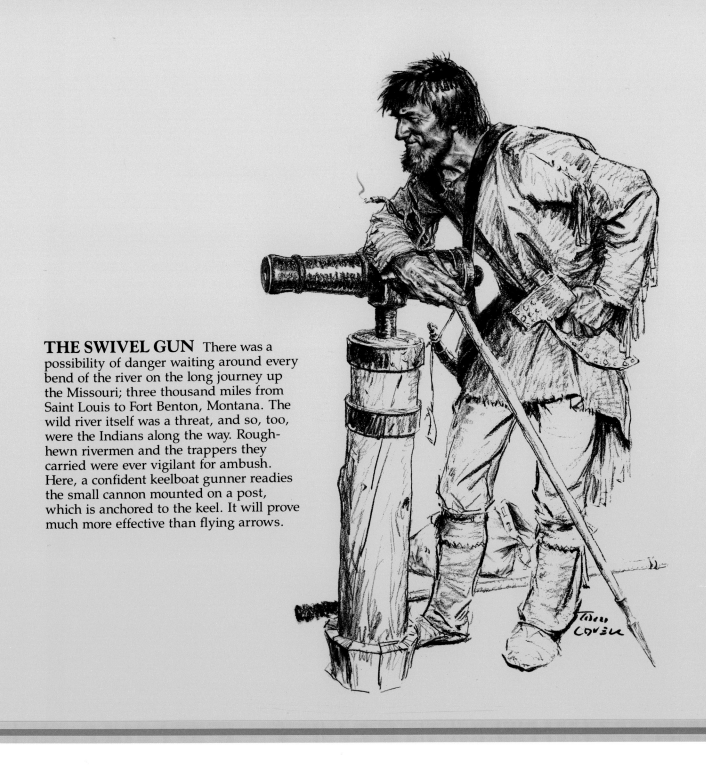

THE SWIVEL GUN There was a possibility of danger waiting around every bend of the river on the long journey up the Missouri; three thousand miles from Saint Louis to Fort Benton, Montana. The wild river itself was a threat, and so, too, were the Indians along the way. Rough-hewn rivermen and the trappers they carried were ever vigilant for ambush. Here, a confident keelboat gunner readies the small cannon mounted on a post, which is anchored to the keel. It will prove much more effective than flying arrows.

CAPTAIN FREMONT'S HOWITZER

It is a matter of official record that Captain John Fremont carried a small howitzer during his U.S. Army expedition into the California mountains. He was forced to abandon it in a high Sierra pass in January, 1844. It was a rugged, lonely place, where the snow lay deep, and frigid winds howled between the rocky cliffs. Men and horses were taxed to their limits by the harsh weather and terrain. When it became necessary to lighten the loads, the howitzer was an obvious choice. After nearly a century and a half, no one has reported the discovery of Fremont's abandoned artillery piece.

Perhaps an Indian hunting party passed this same way, on the trail through the high, windy pass. They are amazed and alarmed by this alien object sitting in the snow. It does not belong here and must be some sort of omen . . . but good, or bad? Most probably the Indians would have left it alone.

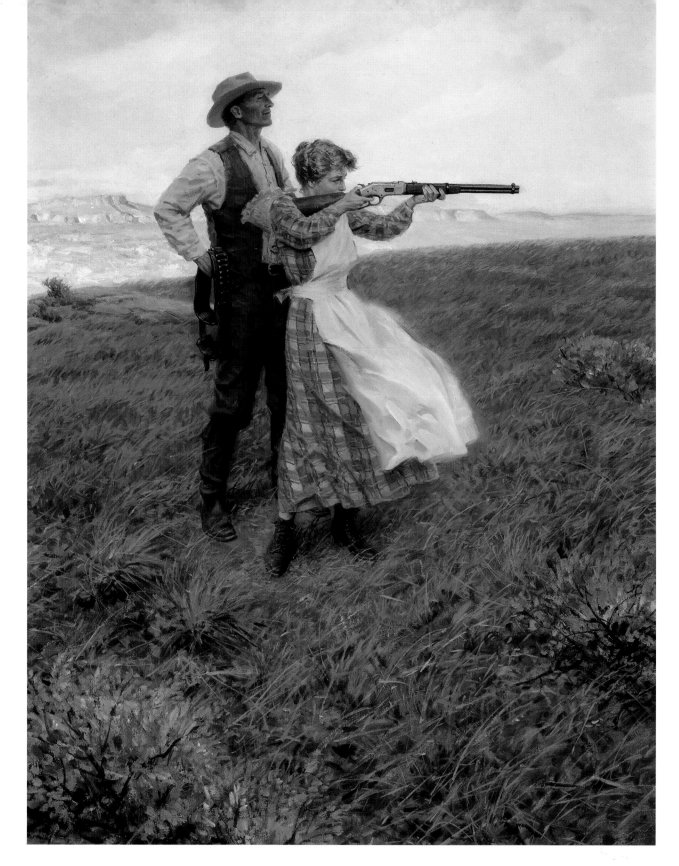

TARGET PRACTICE

Life on a prairie homestead was hard for the early settlers, and particularly so for the women. Mothers and daughters carried out domestic chores under the most primitive of conditions, while fathers and sons plowed up patches of buffalo grass for crops, tended herds of livestock, and hunted in the hills for wild game. Renegades, both red and white, roamed the Plains, and danger was ever close at hand. A woman's marksmanship often saved her frontier family.

FIRES ON THE OREGON TRAIL ▶

As the pressures of white encroachment increased on the northern Plains, the Indians responded with open hostility. Attacks on overland immigrants and railroad construction crews increased. Following in the wake of work parties, Indians burned down the poles that carried the white man's messages on humming wires. While it is unlikely that the Indians understood the function of the telegraph, they did know that the poles and wires were alien to the open prairies.

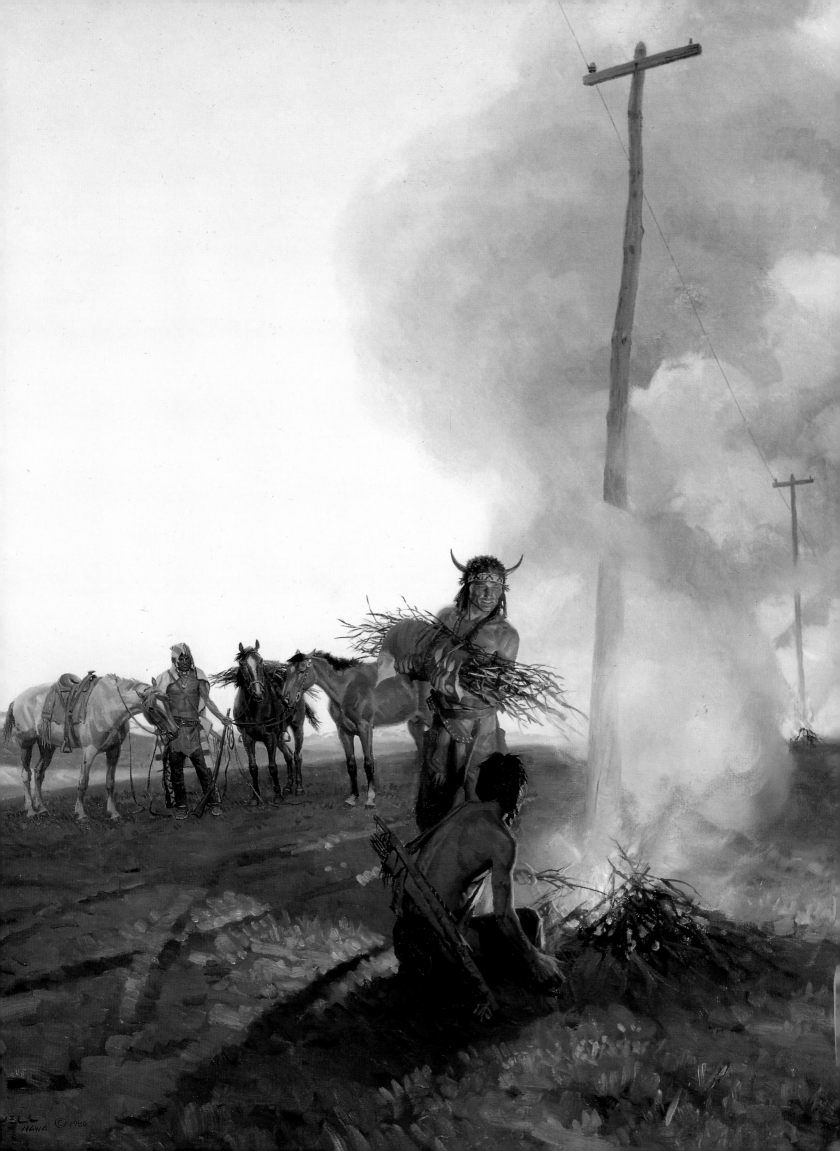

PART FOUR
THE CIVIL WAR

Neither side expected a long war.
Northerners were determined to prevent
the breakup of the nation. It took four years, in one
of the bloodiest wars in a century,
to settle the issue.

PART FOUR
THE CIVIL WAR

As a growing population pressed inexorably westward, it continued to cause racial confrontations with the Indians, who were being driven into continuous retreat.

However, the westward expansion also carried with it the internal racial conflict over slavery. Although introduced to America almost from the beginning of white settlement on the continent, slavery eventually was generally confined to the Southern, agricultural states. While the practice was opposed in the Northern states, there was an equivalent number of Southern states which supported slavery. This political equilibrium could be maintained east of the Mississippi, but the balance was threatened because Western territories were being settled by proponents of both sides of the issue. A growing Northern abolitionist movement resisted attempts to expand slavery into any of the Western territories as they applied for statehood. Southern states saw a danger to their cause unless they could obtain an equal number of slave supporting states.

As voting deadlines for statehood drew near, fighting broke out in several border states. In 1855 and 1856, "bloody Kansas" was torn by factional fighting that took many lives. Compromises of 1820, 1833, and 1850 to prevent disunion had each failed; by 1860 several of the Southern states threatened to secede from the Union if the Republican candidate for president, Abraham Lincoln, were elected. Although Lincoln's personal position was remarkably conciliatory and accepting of the Southern states' rights, partisan Southern sentiment perceived his election as a threat to their equality under the Union. Lincoln was the narrow victor on November 6, 1860, and was inaugurated on March 4, 1861.

On April 12, 1861, Southern batteries fired on the federal Fort Sumter, in South Carolina, forced its surrender after two days of shelling, and the Civil War was under way.

Neither side expected a long war. The Confederate states had quickly formed a government and expected to have a fully viable economy through cotton, tobacco, and other farming exports. The North had the advantage of an expanding industrial development and a larger population. Northerners were determined to prevent the breakup of the nation.

It took four years, in one of the bloodiest wars in a century, to settle the issue. It was, perhaps, the most defining time in the course of American history. At no other juncture has such a rift in the core morals, beliefs and policies of the Union resulted in a fracturing of the nation on the magnitude of the Civil War. The crisis was our own, as was the course of its resolution. And once resolved, it would determine the ethical, social, and economic ties that bind the country together today.

Bull Run, Richmond, Shiloh, Antietam, Fredericksburg marked the see-saw nature of the war's early years. With the thought of an easy victory quickly fading into memory, both sides geared up for what would become the most technologically advanced war of its day. Telegraph wires sped information on troop size, locations, and movements more effectively than ever before. Aerial reconnaissance came into being with the observation balloon. Ironclads spelled the end of the wooden-hulled navy. Rifled barrels, telescopic sights, and breech-loaded weapons quickly showed their effectiveness on the battlefield at terrible human cost.

Both Lincoln and Davis believed that Vicksburg, Mississippi, was a key to the defeat or survival of the South. Passage on the Mississippi River was effectively controlled by the Confederate batteries positioned on the heights of Vicksburg. Their command of this part of the river prevented Union forces in control of the southern portion of the river to link up with those to the north. Preparations for a Union fleet to run this blockade were made for months, and on the night of April 16, 1863, a large flotilla of ships, under the command of Rear Admiral David Porter, successfully ran the gauntlet of fire to supply Grant's troops and opened up the length of the river. In a bold series of maneuvers, Grant surrounded and cut off the city.

In response to a growing Union stranglehold on Vicksburg in spring 1863, Lee felt an incursion into the North would both force Grant to abandon his siege and, if lucky, win the war. This was Lee's second invasion of the North, at Gettysburg, Pennsylvania. Gettysburg was not necessarily the turning

LINCOLN SKETCH Many of the figures in Lovell's paintings began as sketches, like this one of Lincoln. An attempt is made to relate the figures' poses to the overall picture idea but also to relate the figures naturally to each other. Although not described in history books or official documents, it is surely likely that Lincoln, as Commander in Chief, would have watched a demonstration of the new Sharps rifle, and Lovell has chosen such an incident in which to depict the President.

point of the Civil War (some historians consider the earlier battle at Antietam to have been the key defeat for the Confederacy), but it certainly marked the furthest and most dangerous Southern incursion into the North. General Lee had made an audacious gamble. At Gettysburg, Pennsylvania, he nearly succeeded. By the second day of the battle, the attacking Rebels had driven the Union forces from their positions at Seminary Ridge and mounted an all-out frontal attack on the Union troops on Cemetery Hill.

The operation, under the command of General Longstreet, was a suicidal one, which required the troops to cross a stream in an open area. The dug-in Union troops subjected them to intense fire, and the assault was repulsed with terrible losses. Lovell's painting, "Second Day at Gettysburg," depicts Berdan's Sharpshooters, who were equipped with new breech-loading Sharps rifles that could shoot five times in a minute, opening fire at this critical juncture of the advancing troops' vulnerability.

On the battlefield, over three million Northerners and Southerners took up arms in defense of their respective causes. They were led by some of the finest military minds that the 19th century was to produce. They were also led by some of the worst. By its end, more than 600,000 would not return home. Whether host to the horrific onslaught of the battling armies, or home to men that fought, no portion of the country was spared the savage resource of the war.

The Battle of the Crater was an inexcusable Union blunder. For a month, the besieging Northern army had been secretly tunneling under the fortified Confederate works at Petersburg, Virginia.

By filling the labyrinths of the tunnel with 8,000 lbs. of gunpowder, the Union commander planned to set it off and breach the Confederate defenses.

On the morning of July 30, 1864, at 4:44 A.M., the munitions were ignited. There was a tremendous explosion that created a huge crater 135 feet long, 97 feet wide and 30 feet deep. The surviving Rebel defenders panicked and fled in disarray.

The Union soldiers, sensing a quick and easy victory, charged headlong through the lines and into the crater. However, after a short interval, the defending troops re-grouped and realized that the Union soldiers were trapped by the steep sides of the crater. Rebel fire inflicted great losses as the Union troops tried to scramble out of the hole. The fiasco was compounded as reinforcement troops, including a Black division, were pushed forward into the same trap. What should have been a breakthrough victory was turned into a Union rout and ended efforts by General Grant to take Petersburg by direct attack.

The role of Blacks in fighting during the Civil War has generally not been adequately presented. Yet, as the war progressed, many free men and recently freed or escaped slaves

volunteered for the Union cause. Such soldiers were usually formed into segregated companies and seldom were allowed into combat. When engaged, however, they fought bravely and effectively. Southerners were deeply resentful of such troops and showed them no mercy.

The Union attack on the Battery at Fort Wagner, near Charleston, was a joint assault by sea and land on July 18, 1863. After a day's heavy bombardment by naval gunboats, a storming party of several Federal regiments, including the Massachusetts Fifty-fourth (Black) led by Colonel Shaw, charged across 200 yards of beach toward the Wagner bastion. They were immediately attacked by intensive fire from the entrenched Rebel garrison and powerful shellfire from the guns of Battery Gregg and Fort Sumter.

In this first use of Black infantry in combat, the troops acquitted themselves courageously under fire, crossing a deep water-filled ditch and climbing to the edge of the Confederate parapet, where they engaged in hand-to-hand combat against overpowering odds. Colonel Shaw was killed, and the regiment was forced to fall back, sustaining fifty percent casualties. Several additional regiments were also driven back, and the Union troops were finally ordered to retire.

With the seemingly endless resources, the tide of the war began to swing in the North's favor. The war of attrition had begun to take its toll on the South. During the latter part of the war, when the South was nearing the end of its manpower resources, a young contingent of students at the Virginia Military Institute was drafted into emergency service for the Battle of New Market. With the Union troops advancing on a weakened position, the young boys were positioned to plug the gap in the lines. They not only held, but counterattacked, reclaiming lost ground and holding the lines.

But even valiant acts such as this could not change the course the war was taking. By the spring of 1865, the dwindling Confederate armies were being mauled mercilessly by Union generals. Sherman invaded and devastated Georgia and the Carolinas. Sheridan defeated the Confederate army at Five Forks, and Grant's army held siege lines at Petersburg. When Lee could no longer defend Richmond and Petersburg, he withdrew in a circle to the south in an attempt to join his small remaining army of 25,000 men with that of General Johnson in North Carolina. Recognizing this objective, Grant maneuvered to cut Lee off.

Realizing that his position was impossible, Lee accepted General Grant's overture for surrender. The two men concluded the documents at the McLain residence in the small town of Appomattox Courthouse on April 9th. Grant's terms were generous. He respected Lee as a soldier and allowed Lee's troops to surrender with honor. Soon thereafter, on April 18th, Generals Sherman and Johnson met and also signed an agreement to cease fighting. Except for a few scattered skirmishes, the war was finally over.

Many artists, writers, and photographers covered the war for a public anxious for news. Matthew Brady trained a staff of photographers, who carried their equipment to the battle sites, developing their wet plates in portable darkrooms. Artists, such as Alfred R. Waud, Winslow Homer, Edwin Forbes, and A. C. Redwood, made drawings of battles and maneuvers which were dispatched to magazines and newspapers to be transcribed by other artists onto wood-engraved blocks and rushed to print. While accurate to a degree, these drawings were joint efforts, subject to errors in interpretation and, at best, information could be only crudely presented by wood engravings.

Painting various aspects of the Civil War has been a special challenge to Tom Lovell, who brings an historian's outlook to picture making. Although guided by pictorial reference contained in photos and drawings of the events, he has needed to find the hard facts from additional sources, such as the Smithsonian Institute, museums, records of eyewitness accounts, topographical maps, architectural renderings and blueprints, as well as the examination of various firearms, ammunition, and military equipment. He has then searched for an appropriate viewpoint to present an action that represented it as a whole and not as an unrelated incident.

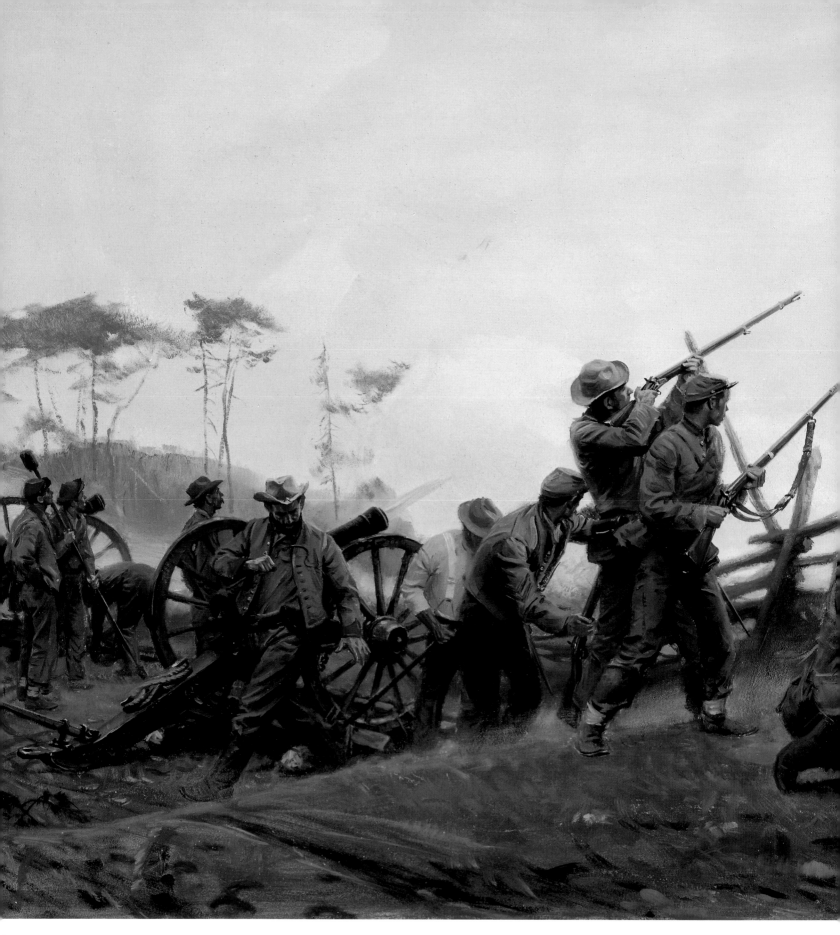

PROFESSOR LOWE'S BALLOON

Each war draws upon the newest technologies available to it. Both sides in the Civil War benefited from the ongoing industrial revolution, but the North, where most of the major manufacturing was based, had the greater advantage. It had access to the raw materials needed and had the facilities to build all the necessary munitions, ordnance, locomotives, and ships. It was this overwhelming advantage that eventually defeated the South and ended the war.

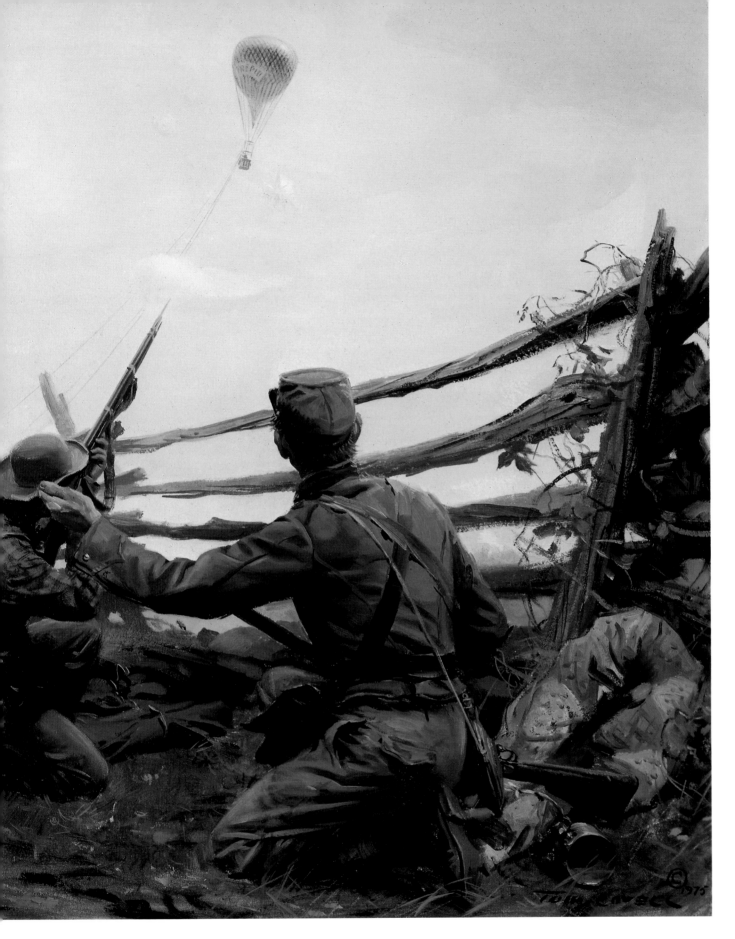

One of the new techniques was the use of the reconnaissance balloon. Protagonist for its use in the North was Professor Thaddeus S. C. Lowe, who personally proved the effectiveness of this aerial vantage point by diagramming Confederate positions. The balloon's weakness was its slow maneuverability and vulnerability to ground fire. Here Confederate soldiers are desperately trying to shoot down the balloon with muskets and rifled cannons.

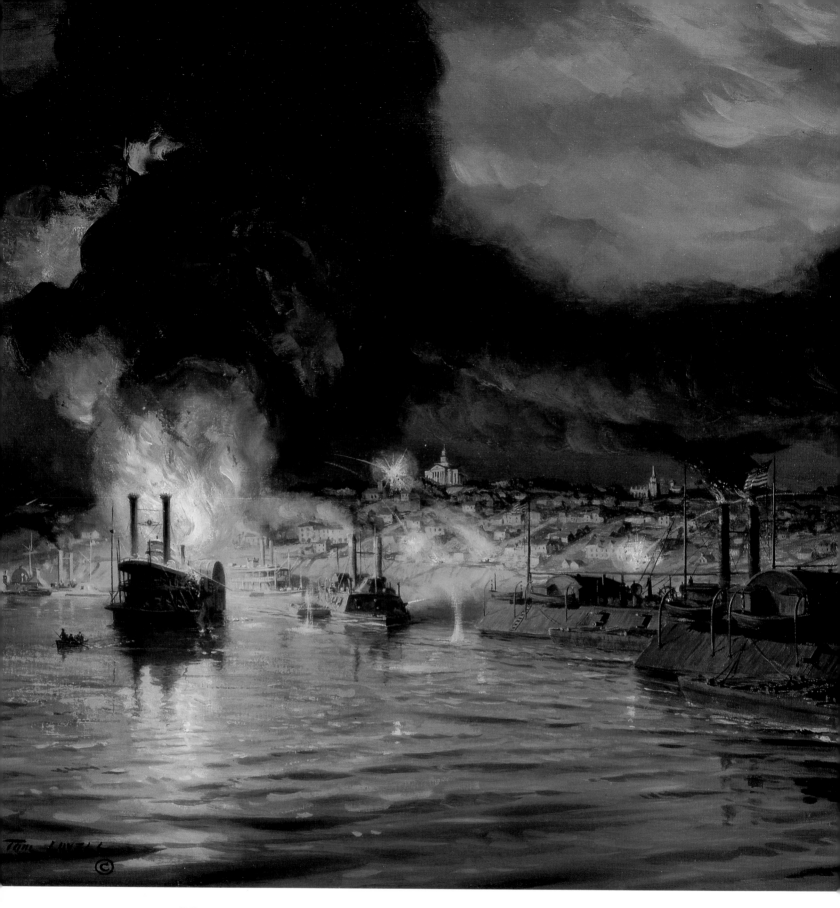

THE UNION FLEET PASSING VICKSBURG

It had been a long-term Union objective to gain access to the deep South by opening the length of the Mississippi River to its gunboats. This was prevented, however, by a series of strong Southern forts and batteries along the river. Subjugating these forts and batteries, one by one, took a long time, with the largest remaining one at Vicksburg.

As part of the military strategy to take Vicksburg,

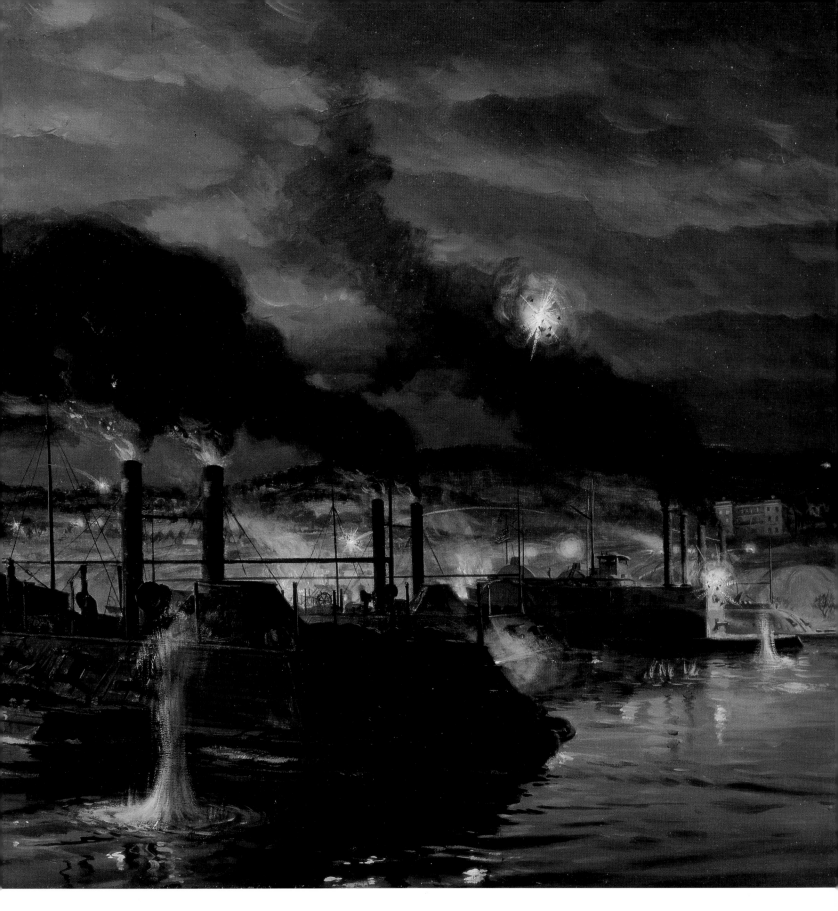

General Grant took his army in a flanking maneuver around the city to the south, where he could not be resupplied by land. A Union fleet was poised above Vicksburg, prepared to run the batteries and join up with Grant's troops. On the night of April 16, 1863, a large Union flotilla, under the command of Rear Admiral David Porter, successfully ran the blockade under heavy fire, with the loss of only one steam transport and extensive damage to another. A second flotilla of transports six days later also succeeded in running past the batteries. With the joining of Union land and naval forces, the fall of Vicksburg was only a matter of time. It surrendered on July 4, 1863. Here Lovell has presented the height of the action as Porter's ships pass the Confederate batteries under heavy fire.

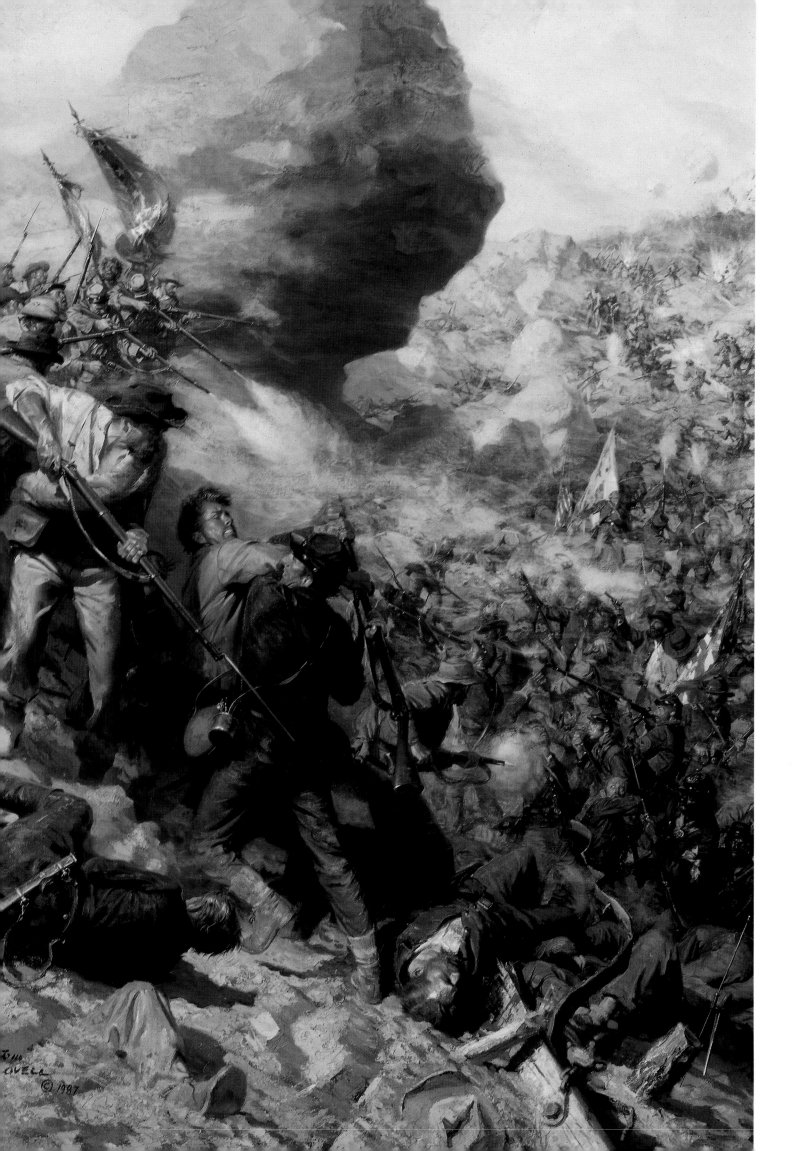

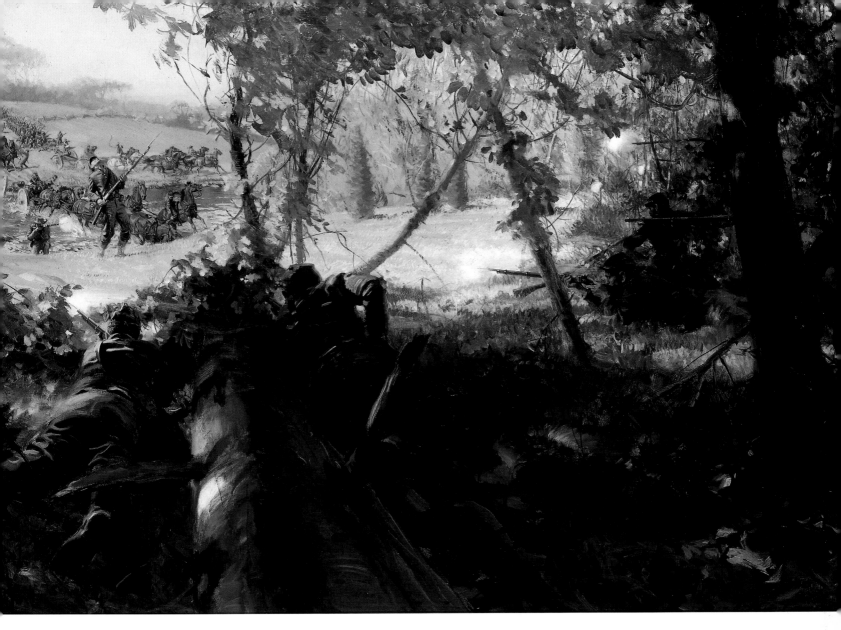

◀ BATTLE OF THE CRATER

In the first two years of the war, the South won numerous victories. It took a long time for Lincoln to find competent generals who would pursue the enemy aggressively. Even in the latter part of the war, during the siege of Petersburg, Virginia, when its Confederate defenders were surrounded, the battle was lost through the incompetence of the Union general in charge of the assault.

After weeks of work, Union sappers had dug a series of underground passageways under the enemy lines and filled them with gunpowder. Union troops were poised to charge in after the powder was set off and to drive out the defenders. When ignited, the explosives created a huge crater, killing and wounding many Confederate soldiers, sending the survivors into flight. However, the crater became a deadly trap for the North because the invading troops who raced into the crater were unable to advance up the steep sides. After a short period of confusion, the Confederate troops regrouped and poured a withering barrage of gunfire onto the hapless Union soldiers below. The heavy Federal casualties were compounded by the absentee commander's orders to send successive waves of reinforcements into the same trap.

BERDAN'S SHARPSHOOTERS— SECOND DAY AT GETTYSBURG

The invention of the breech-loading rifle provided the North with a superior weapon. Both sides started out with weaponry that had to be reloaded and primed after each firing, a process taking up to half a minute. With the breech-loading Sharps rifle, the piece could be reloaded and fired five times in a minute—a tremendous advantage. During the second day of fighting at Gettysburg, a special company of sharpshooters, armed with the new weapons, helped to cut down the charging Confederate troops in a battle that halted the South's furthest advance into the North and began its slow but inevitable descent to defeat.

ATTACK ON BATTERY WAGNER

The Union superiority of supplies and numbers was well matched by the tenacity of Rebel troopers. The North, using waves of attacking regiments, in an attempt to drive a smaller Confederate force from an entrenched position at Battery Wagner off the coast near Charleston, took unacceptably heavy losses and failed to capture the battery. One of the Union regiments was the Massachusetts Fifty-fourth (Black), which sustained over fifty percent losses in the forefront of the charge. Although eventually driven back, in this first testing of Black troops in the war, they proved themselves to be as valiant under fire as their white counterparts.

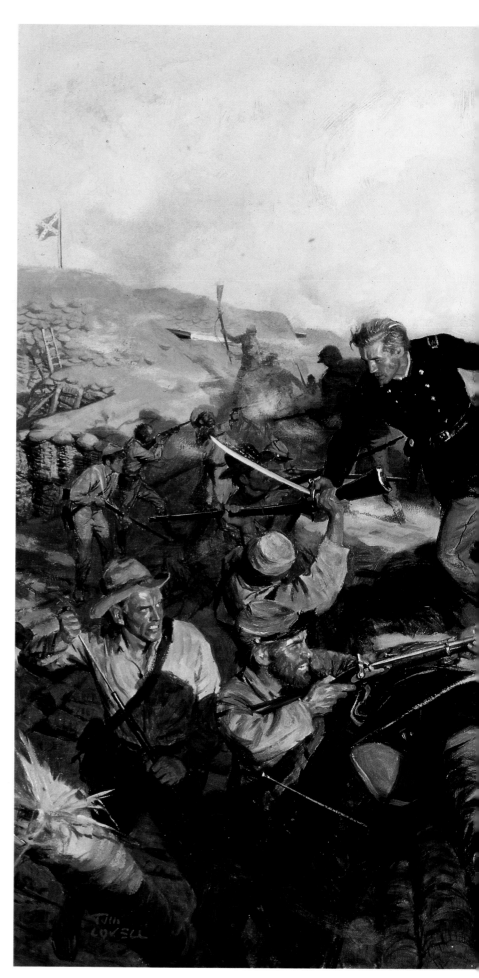

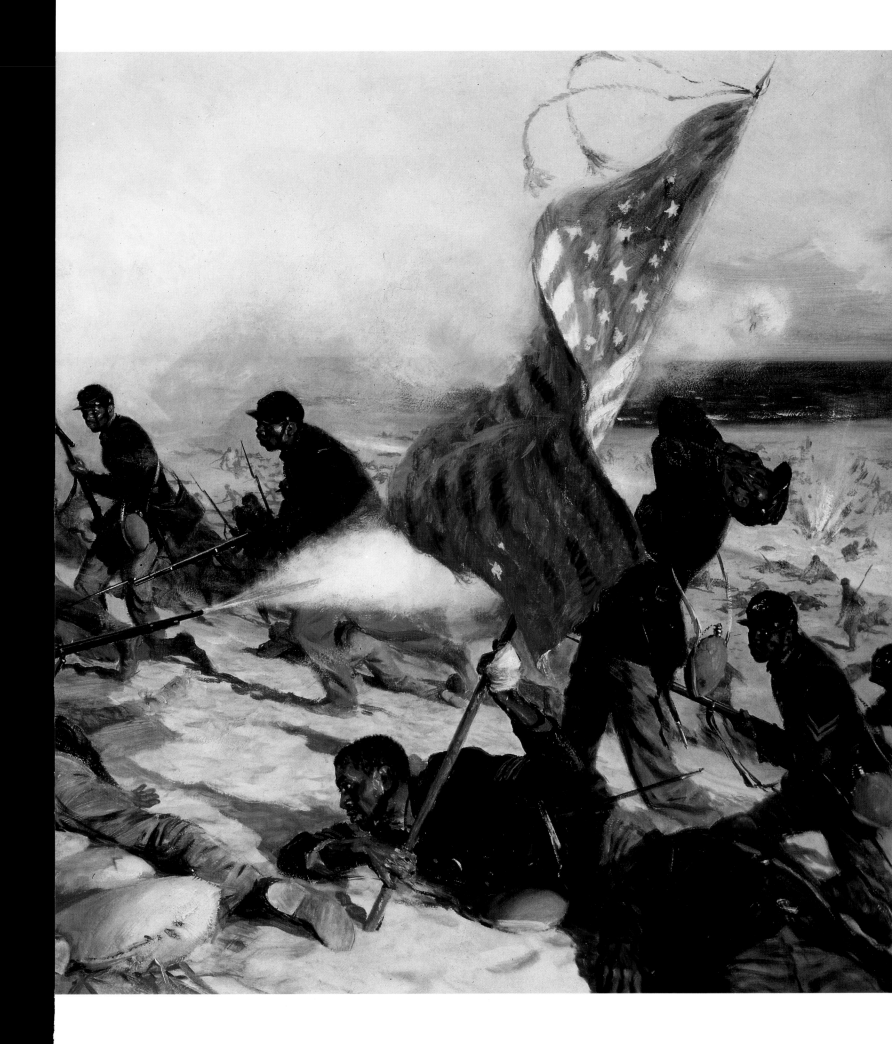

SURRENDER AT APPOMATTOX

The surrender of General Lee to General Grant at Appomattox Courthouse, Virginia, on April 9, 1865, was an impromptu ceremony which did not end the war, but for all practical purposes, the Southern cause was finished. General Joseph E. Johnson surrendered his army nine days later on April 18, at Durham Station.

Lee had been desperately trying to link up his remaining troops with those of General Johnson in North Carolina, but Grant repeatedly turned Lee away and kept the armies divided. Finally, accepting the impossibility of his position, Lee sent a message to Grant requesting a meeting.

General Lee, in dress uniform, arrived first, accompanied by his aide-de-camp. Grant was late and was still wearing his soiled campaign uniform. Several Union generals witnessed the event as the two generals signed the terms of surrender. No photographers were present, and eyewitness accounts were at some variance. After extensive research, Lovell reconstructed the affair as accurately as possible, including the likenesses of the participants, the details of uniforms, and the interior of the room. This painting, commissioned by the National Geographic Society, has since become accepted as the most authoritative depiction of that key event.

Shown at left standing next to General Lee is his military secretary, Colonel Charles Marshall. Accompanying General Grant, seated at the small table on the right, were officers of his staff, including Major General Philip H. Sheridan, Colonel Orville E. Babcock, Lieutenant-General Horace Porter, Major-General Edward O. C. Ord, Major-General Seth Williams, Colonel Theodore S. Bowers, Colonel Ely S. Parker, and Major-General George A. Custer on the far right.

TOM LOVELL
THE ARTIST

"The artist came into the world
blessed with a heightened perception of color,
spatial relationships, and the fitness of visual things.
Let him exercise these faculties, and they will do
his bidding at an increased return all his life."
T.L.

TOM LOVELL
THE ARTIST

Tom Lovell's decision to become an artist came relatively late. Born in New York City in 1909, his childhood was spent in Nutley, New Jersey. He describes his childhood as "a happy time. . . . The woods started past my father's barn and remained my playground during the early years."

An inveterate reader, he developed an early interest in the American Indian. This was reinforced during visits to the New York Museum of Natural History, where he sketched artifacts, weapons, clothing, and the like. But although drawing always seemed natural to him, it was mainly a rainy day occupation.

There was no particular exposure to art at home, and there were no art classes in school. During summer vacations, he worked at various jobs—first as a messenger for the Wright Aeronautical Corporation in Patterson, New Jersey, and later as the caddy master at a local golf club.

He was, however, still strongly interested in Indians, and, as the Valedictorian of his senior class in

high school, the topic of his speech at graduation was "The Ill-treatment of the American Indian by the U.S. Government." It was probably less relevant to the assembly than prophetic of the direction of Lovell's future career. As Tom described the event, "In retrospect, I wonder how the three hundred hapless parents felt, being scolded by a sixteen-year-old on an otherwise cheerful occasion."

Tom graduated from high school in February, 1926, and landed a job with the U.S. Shipping Board as a deckhand on the U.S.S. Leviathan, flagship of their fleet. He soon discovered that work on the North Atlantic during the winter was both miserable and hazardous. A lot of time was spent removing old paint and applying new, which the saltwater spray would "cut" almost as fast as it was applied! Outside the harbor at Cherbourg, France, while preparing to unload a rope sling of mail, he barely escaped being crushed when the two-ton cargo was prematurely released over his head. These conditions and the poor pay of forty dollars a month convinced him that he could do better in some other occupation.

His next job was as a timekeeper for the W.J.D. Lynch Construction Company. The project involved the laying of miles of reinforced concrete pipe—up to 52 inches in diameter—by a crew of mostly immigrant laborers. With sometimes as many as two hundred men deployed along the work line, accurate record keeping was vital. Each man was issued a numbered brass check, and the number was entered into Tom's tally book along with the man's name if he could spell it.

Sometimes Tom augmented the record with a description, such as "eagle beak" or "red boots" in order to keep everyone straight. He developed a great respect for the men who worked ten hours a day in deep trenches, often in mud up to their knees, summer and winter. Tom was popular with the men, especially since he also delivered their envelopes on pay day.

By the time the summer of 1927 ended, Tom had finally come to the conclusion that he seriously wanted to become an artist, and he began to look for a good art school. He found it at Syracuse University. Their College of Fine Arts had a well-regarded course

of instruction, along with liberal arts subjects. There was a strong emphasis on the fundamentals of drawing from casts, still life, and drawing and painting from the live model. Tom progressed through these stages steadily, inspired by one of his teachers, Hibbard V. B. Kline, to pursue illustration. Fellow classmate, Harry Anderson, shared the same ambition.

By the end of his Junior year, Tom gathered his work into a portfolio and took it to New York City. He called on various publishers who might be potential clients and, after a few false starts, found his way to the Hersey Publications offices. They were publishers of a line of "Pulp" magazines (so-called because they were printed on cheap pulp paper stock) with titles specializing in Gangsters, Detectives, Westerns, Fantasy, and other such subjects. The editor was impressed with Tom's drawing ability and asked him if he could handle "dry brush." When assured that he could, Tom was given a manuscript; never having tried it before, he quickly returned home to learn how.

This technique was greatly esteemed in the Pulps because it could create an effect of an expensive halftone by means of a cheaper line engraving. As Tom describes the process, "the dry brush technique is achieved by dipping the brush into a bottle of India ink, then brushing out most of the ink on a scratch pad, thereby spreading the hairs of the brush. Then, when applied to the drawing surface, it creates a stroke of many, fine parallel lines, yielding a grey tone instead of solid black." The technique requires considerable dexterity and does not allow for going back once a stroke has been laid down. For this reason, the various tonal areas had to be carefully planned ahead of time, spotting lights and darks, along with the grey areas.

The Pulps had come into their own with the onset of the Depression because they offered a thick book of stories for only ten cents. Proliferating on the newsstands, they needed a lot of inex-

pensive artwork, which provided an excellent market and training ground for young artists.

After the acceptance of his first job, Tom was given a whole issue to do, black and white illustrations, as well as a cover in color. The going price was six dollars for an illustration and sixty dollars for the cover. This was good pay at the time, especially for a student. Lovell continued to do pictures for gangster stories that summer and on through his Senior year—each month being provided manuscripts for a complete issue.

SLEEPING DOG SKETCH The various members of most illustrators' families get pressed into service as models for pictures; even the family dog can have his day.

TOM'S DAUGHTER DEBBIE The Lovells' daughter Debbie studies herself in the mirror as Tom portrays her in a color scheme of blues and greys.

By the time Tom earned his Bachelor of Fine Arts, he was already a working professional. He had also met a lovely fellow student, Gloyd Simmons, whom he courted and enlisted to model for him. Because of the color of her smock, she became known as "Pink" or "Pinkie."

It was now 1931 and not a propitious time to consider marriage. Tom shared studio space in New York with his Syracuse classmates, Harry Anderson and Al (Nick) Carter. He took on all the work he could get, branching out to Street and Smith and Popular Publications, and illustrating for *The Shadow* magazine, *Wild West Weekly*, and many other titles.

With some money in the bank, Tom and Pinkie took their vows. They found a small apartment in Montclair, New Jersey, near his parents' home and remodeled the top floor of his father's barn to make a studio. It was a good place to get started, and he continued to keep busy through the worst of the Depression.

At this time, New Rochelle, New York, just north of New York City, was an illustrators' art colony. J. C. Leyendecker and Norman Rockwell were among the early settlers; by now, many younger artists had also moved there, including Bob Harris, John Falter, Dick Lyon, Harold Anderson, Graves Gladney, and Emery Clarke. Tom had become acquainted with Bob Harris when they met in the reception room of an art director's office. After learning from Harris that John Falter was moving out of his studio, Tom and Pink decided to relocate there to share in the professional and social stimulus of the group.

By now Tom had his eye on the "Slicks" (major magazines, such as *Good Housekeeping, American, The Ladies Home Journal, Cosmopolitan*, and the like), which were printed on slick, coated paper. This was the top market, and he would be moving into competition with such illustration giants as Walter Biggs, Harvey Dunn, John Gannam, Harold Von Schmidt, Dean Cornwell, Donald Teague and Mead Schaeffer. To prepare himself, Lovell stopped working for the Pulps and spent six months making new samples. He was given much helpful professional guidance by Teague and Schaeffer, who were also in New Rochelle. When ready, he made some appointments with art editors, and Graves Gladney volunteered to go along as his "man" to handle the portfolio during

**GANGSTER MAGAZINE BLACK
& WHITE DRYBRUSH** As this early Lovell
drybrush illustration for a gangster pulp magazine
demonstrates, the hairs of the brush are first splayed
out, then dragged across the paper to create
halftone or grey areas. This requires careful prior
planning, with no going back for corrections.

the interviews. It was very gratifying to be given a manuscript on his first presentation at *This Week* and another story from *Redbook* on his second appointment! He decided he'd better go home after that, but his new career was under way.

As opposed to the blood and thunder action of the Pulps, the stories in the Slicks were generally much more sedate, with the emphasis usually on romance. This was a new challenge: to make an interesting picture from undramatic situations. Sometimes it was difficult, even after four or five readings of a manuscript, to find a sentence or paragraph on which to base a picture of consequence. Occasionally, however, manuscripts by writers such as Edna Ferber, Paul Gallico, Sinclair Lewis, or Louis Bromfield would be assigned which offered the opportunity to make substantive illustrations, and Tom made the most of them.

Meanwhile, many of the New Rochelle illustrators were moving north to another artists' colony at Westport, Connecticut. In 1940, the Lovells decided to move as well. Harold Von Schmidt was a central figure in Westport, active in town politics and sports, as well as one of the top illustrators in the tradition of Howard Pyle and Harvey Dunn. This gave Tom the opportunity to meet and be inspired by "Von." It was also here where he first met John and Doris Clymer and Bob and Cordelia "Cordy" Lougheed. They were all at similar phases with their families and careers, with much to share, and they developed lifelong friendships. The Lovell family now included son David; daughter Deborah came along later.

As World War II came along, although Clymer, Lougheed, and Lovell were beyond draft age, each wanted to contribute to the war effort. Aircraft spotting stations had been established along the coastline, with civilian volunteers manning them. Tom and Bob Lougheed took on this duty, spending many hours logging planes and looking for enemy aircraft that never came. Bob, who was from Canada, soon joined the Canadian Army. Tom and John Clymer talked it over and in 1944 decided to enlist in the Marine Corps with the objective of being combat artists. A less than perfect left eye nearly prevented

Lovell's acceptance, but he convinced the examiner that if he could successfully paint pictures as a civilian, he could do the same as a Marine. Tom and John were issued consecutive dog tags—perhaps the only two Marines who knew each other's number. The two successfully survived boot camp at Parris Island, South Carolina, but instead of combat postings, they were sent to the Marine barracks at 8th and I streets in Washington, D.C. There they were

THROAT SPRAY M 1 Working side by side in dungarees, Lovell and John Clymer often used each other as models. This idea came from boot camp experience at Parris Island where, with 80 men in a barracks, if anyone caught a cold, everyone shared it. Tom made it the subject of a *Leatherneck* cover, and John obligingly posed for this painting.

assigned to illustrating Marine publications, *Leatherneck Magazine*, and the *Marine Corps Gazette*. Later, they also did a series of large paintings of Marine Corps history now hanging in the Marine headquarters and other public buildings in Washington, D.C. When the war ended, they (and their families) were both happy to return to civilian status and to resume their interrupted careers.

For Tom, this was not so easy. The field of illustration is very competitive, and many new people had found their niches in it. Lovell walked the streets of New York as if he were starting over. Finally, he was given an advertising assignment by the Dixon Crucible Company to depict the moving of canons from Fort Ticonderoga in an effort to drive the British out of Boston. This provided him the subject for a strong

picture, and with its publication, he had reestablished himself.

After the war, a new group of men's magazines slanted to the returning veterans came into popularity. The best of this group was *True* magazine, which published adventure stories, all based on true or factual material. Although not always first-class writing, the subjects usually involved events that made good pictures possible. Tom enjoyed his affiliation with *True*, which gave him the opportunity to paint pictures of the Civil War, whaling, lighter-than-air craft, underwater salvage operations, the war in Africa, and other dramatic subjects.

This was ideal preparation for the next series of assignments for *National Geographic* magazine.

Here the emphasis was on the broader sweep of history, recreating events that had not been pictured, often involving masses of figures. Among the commissions were the story of Abraham, the early days of the Olympic Games, the conquests of Alexander the Great, the Crusades, the Vikings, the Norman Invasion of England, and the Surrender at Appomattox. Research for these assignments was vital. Although the *Geographic* had an array of experts and advisers, Tom often found that their "word" facts were of little help in arriving at "picture" facts. Usually his own personal research and experience were much more useful. Whenever possible, he visited the sites to determine what was most likely and most logically to have occurred, in order to paint an event authoritatively.

The story of "The Vikings," for instance, required a trip to Scandinavia. This was preceded by much reading and by making a number of charcoal sketches. The sketches were a good bridge for the language gap in Stockholm and Oslo and stimulated answers to many of his questions. Some of the information was hard to find, especially on details of Viking ships and their sailing capability. Sometimes the Scandinavian experts disagreed with each other, and it was necessary to choose between them. Good basic information on the construction of the ships was found from excavated hull fragments in a museum at Roskilde Fjord near Copenhagen. Later, Tom traveled to Ireland and a place called Clonmac-

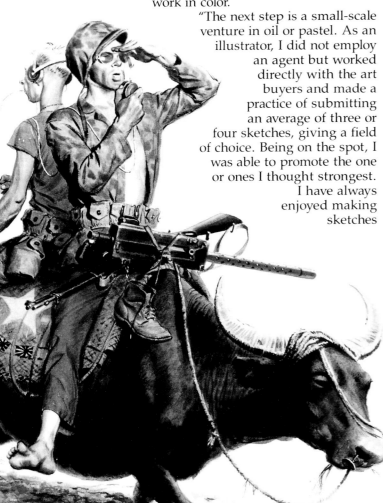

noise, gathering architectural details for the background planned in a painting of a Viking raid far up the Shannon River. Afterward he made several scale models of Viking ships, including one cut to the waterline, which he could pose on a flat surface representing the sea from whatever perspective he needed.

By now Tom had evolved a procedure for picture making that he could control at every stage. In his words, "To me the making of comprehensive sketches is of first importance. The nature of what I do requires in-depth research to learn everything possible about the subject—costumes, weapons, rigging of ships, architectural detail, and the like. Sketches in charcoal first establish patterns of light and dark and drawing. I have found that if a picture 'does not work' in black and white, it is not likely to work in color.

"The next step is a small-scale venture in oil or pastel. As an illustrator, I did not employ an agent but worked directly with the art buyers and made a practice of submitting an average of three or four sketches, giving a field of choice. Being on the spot, I was able to promote the one or ones I thought strongest. I have always enjoyed making sketches

and (in illustration days) knew that they made life easier for the art directors who lived with deadlines and the constant hazard of last-minute problems. Often a written agreement between art department and artist would specify that manuscripts would be forthcoming on established months, and dates of delivery, providing security for both parties.

"Following preliminary sketches, I would make charcoal drawings from the model, then 'square up,' i.e., enlarge by gridlines to canvas proportions, redraw the figures directly on the canvas, always with the luxury of the charcoal drawings beside me.

"Pulp covers sometimes pictured figures in dramatic (lurid) lighting conditions. To cope with this, my model was posed in a cubicle of black cloth and bathed in a 'Baby Anderson' spotlight, generally red or green. With a model lighted on one side with a startling red glow, the effect of complementary green shadows was hard to overlook on the newsstand.

"Presented with complex subject matter, as in most *Geographic* assignments, I 'squared up' sketches on large sheets of rag paper and worked out complete drawings of figures, perspective, etc., until I had better understanding of my needs, leaving the charcoal drawing unfixed. Then a model would be called in to pose for photographs of parts I needed, e.g., figures, drapery, cast shadows, etc., and I would rework as necessary in the final drawing.

"A tissue overlay provided outlines of major areas, and this would be transferred to the canvas surface with a homemade paper coated with dust of 6B charcoal pencil. On coarser canvas, this was a fuzzy affair, but I had my drawing to consult when necessary. Such a procedure may seem tiresome, but it has worked well for me. It allows battles of proportion, drawing, and perspective to be fought beforehand, allowing one to tackle a relatively fresh canvas. If the drawing of a pony isn't going right, it can be dusted away with a bit of chamois and started again. Enough problems arise in color and value as the work progresses.

"From the beginning, I learned to draw the figure in the manner of George Bridgman and at sketch

level never use models. It has always been my practice to draw from the mirror for information: detail of hands, placing of highlights, drapery, and action. There are times when a figure drawn without a model is more convincing. In theory, it would be ideal to pose a figure under the exact light condition and paint directly. In practice, this is usually impossible. Example: Here is an Indian on horseback, riding toward you in the dusk of a winter evening. The setting dictates the entire color scheme, flesh tones and all. Often, firsthand observation is invaluable. Sometimes a still-life part of a painting can be set up in some parts of the studio approximating the necessary light conditions. Usually, one is painting a winter scene in mid-July. If, by chance, footprints in the snow are needed and nature obliges, give thanks and observe. Sometimes I use modeling clay or 'sculpey' as a drawing aid. Realizing the difficulties of posing mules in the Pecos River in flood, I made a small head, painted it mule color, and had an untiring aid to prop up in a coffee can. In like manner, ship models, wagons, cardboard hats, helmets, weapons, dogs, an emaciated buffalo calf, a sparrow on toothpick legs, etc., have given good service.

"Ship models are particularly useful. Unless one is familiar with a certain hull or rig, they are difficult to draw. For this magazine assignment, small cardboard 'Iron-clads' were useful in the painting of the 'Fleet passing Vicksburg.' With all of these prior stages in hand, the final painting can proceed, with full attention concentrated on pulling it into a unified picture. In other words, I could go ahead and paint like hell!"

In the '60s, Tom was invited to do several murals for the Morman Church, based on their history. Two of the paintings 5' × 7' were the largest he had done, and all are installed in the Salt Lake City Temple. This, in turn, was good preparation for his next major project.

In 1968 Tom was visited by a representative of the Abell-Hanger Foundation and offered a commission to do a series of fourteen large paintings to record various aspects of the history of the Southwest, particularly in the Permian Basin area, focused on the oil industry. The prime mover and originator of the Foundation was George Abell, and Tom worked directly with him through many letters and sketches. The project took four years to complete. The paintings are now on permanent display at the Permian Basin Petroleum Museum in Midland, Texas.

The National Academy of Western Art (NAWA) was established in 1973 at the Cowboy Hall of Fame in Oklahoma City at the instigation of Dean Krakel (then Director of the Cowboy Hall). Tom was invited to participate in their first exhibition, and he became a charter member, exhibiting regularly ever since, except in 1977 when he took time off to build his new house in Santa Fe, New Mexico.

Bob and Cordy Lougheed had moved from Connecticut to New Mexico several years earlier, and periodically they would send the Lovells information about promising real estate available. One such property sounded irresistible, and the Lovells took the next plane west. It turned out to be a choice location of seven acres, with vistas of the Jemez mountains to the west, the Sangre de Cristo mountains to the east and a broad valley north to Colorado.

They bought the land and dug their well in 1975. Tom invested much of his time over the next two years planning the adobe building and studio, serving as both architect and contractor. The house was completed in 1977 and became the Lovells' pride and joy,

SULTAN OF ZANZIBAR Having backed the wrong side, the Sultan was ordered into exile by the British at the close of World War I. A harbor tug has brought the little man and his family of forty-one wives to the steamer, and he has been informed that the ship offered accommodation for only six.

This picture was an exercise in the manipulation of values to play down the sultan's wives and to direct attention to the Sultan as the center of interest in the story. This was accomplished by placing a harbor tugboat in the foreground—just out of the picture—which would cast its shadow over the boatload of women and its smoke over the left side of the passenger ship, forcing the viewer to look up the gangplank and at the figure at the rail.

with good studio space for Pink and Deborah, as well as for Tom.

Lovell had stopped accepting illustration assignments in 1968 in order to devote himself full time to Western art. He had also come full circle, returning to his boyhood fascination with Indians. Now he could pursue his interests in depth—painting by daylight and doing reading and research by night. To follow the Plains Indians and early history, he also made field trips to various locales in Colorado, Wyoming, Idaho, and the Dakotas, as well as nearby Arizona, Texas, and Nevada.

In 1975 Tom was invited to join the Cowboy Artists of America, centered in Phoenix. He has exhibited regularly at their annual shows. Public interest in Western art, long pent-up because so little had been available, was enthusiastically responsive, and the art market burgeoned. It was a brief but heady period during the oil boom, brought down to earth with its bust in the '80s. With the speculation removed, Western art has stabilized and continues to enjoy good public support and healthy prices. Lovell has been affiliated with Settlers West Galleries in Tucson, Arizona, and with Don McCulley's gallery in Dallas, Texas.

Good friends have fallen; Bob Lougheed died in 1982 and John Clymer in 1989. Both are greatly missed. In 1986, Tom's wife Gloyd also passed away after a long illness. In Tom's words, "She was a talented painter, being proficient in still life and portraiture. Through the fifty-two years of our married life, she was my helpmate, best model, manager of the household, and caring mother of our children. I have never known a kinder, more unselfish person."

More fortunate than many bereaved husbands, Tom still has his mission of painting to continue and a message to convey. He increasingly looks for more humanitarian themes in his work that can communicate the common values of the races. In his pictures, Tom is still on the side of the Indians, with many of their stories yet to be told.

THE BLACK BED

This picture is another fantasy—a love tryst between a beautiful girl and a handsome young officer. The bed serves as a symbol of their love as its curved lines surround the figures in a circular shape, complemented by the draperies which continue the containing pattern.

ARREST OF THE CARDINAL

Based upon a true story, the self-anointed James II, of the northern Michigan Beaver Islands, was arrested by the Michigan U.S. District Attorney as a representative of the Attorney General of the United States. The situation chosen depicts the "King," dressed in a red robe "like a Catholic Cardinal," accompanying the arresting officials to the cutter, U.S.S. Michigan, for trial. This charcoal sketch presents the "King," with his robe and contrasting collar, as the dominant element in the picture and is very close in concept to the final painting.

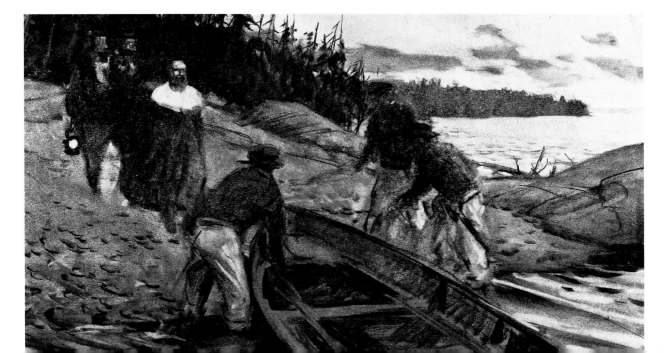

CHRISTMAS AT CRIPPLE CREEK

The boisterous holiday revelry of the newly rich owners of the Cripple Creek Silver Mine, as exemplified by the dance hall girls and the cigar-smoking prostitute, is a strong contrast to the lonely figure at its center. The burning candles symbolize that time is running out on an old man, who very likely has a great deal to regret.

BOYS AND THE FROG

This is the preliminary black and white composition for a story in *True* magazine. In it the artist demonstrates a part of the thinking process that precedes the final painting. Intended only for himself, Lovell has established the values or tonality of the picture. Set against a light grey indication of distant foliage across the stream, the figures carry the contrasts of dark and light; the opposing groupings of the boys and the sheriff are bridged by the dark foreground and branches of the cottonwood trees.

CULTURE
AT SILVER CITY

This picture was fun to do. The contrast between the formal setting of a concert hall and the outrageous behavior of the uncouth audience (made up of miners, cowboys, and Indians), a tempestuous diva, and a besieged symphony orchestra results in an exciting melange, and Tom himself had a field day with it.

"Except for the diva (Pink posed for her), this was done without models or scrap of any kind. Done in 2-color (red and black), as were most illustrations of the day."

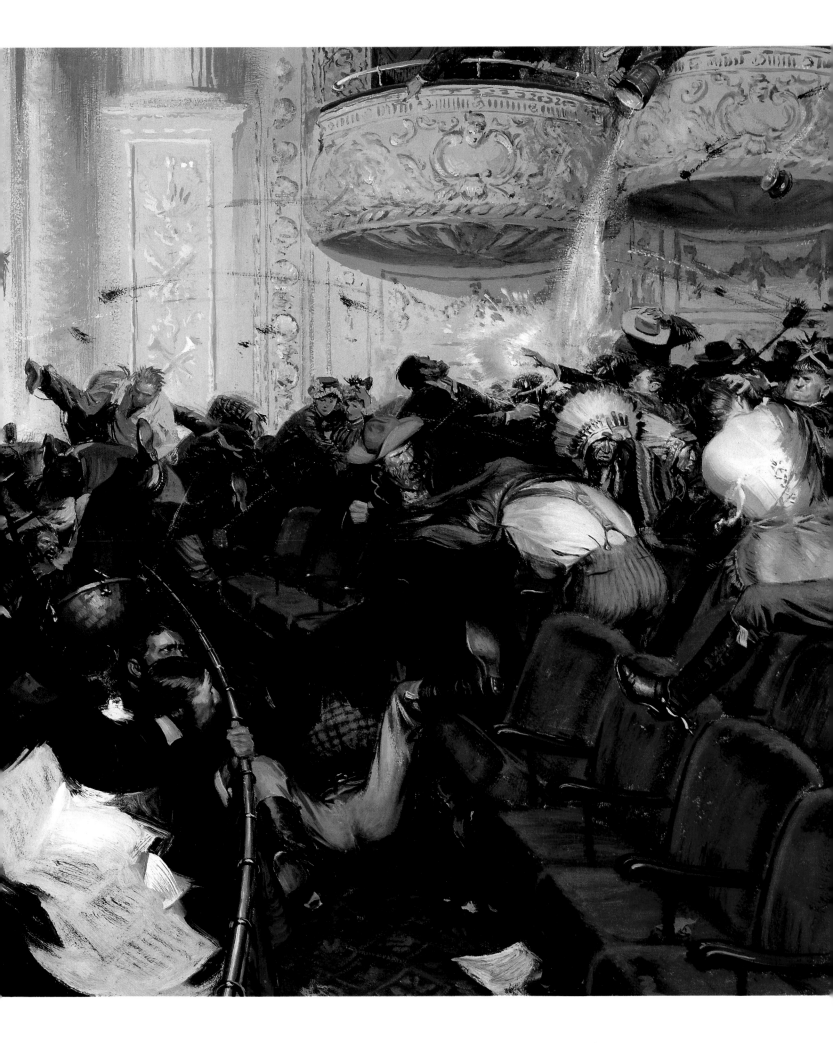

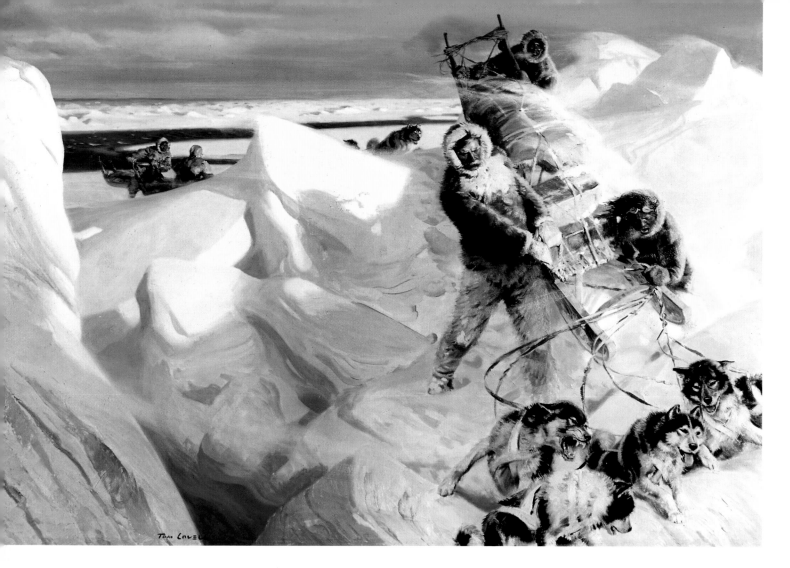

ADMIRAL ROBERT E. PEARY

Many explorers before Peary tried and failed to reach the North Pole. The explorer Fridtjof Nansen had come closest, in 1893, but like the others, was turned back by the formidable obstacles of terrain and temperature.

Admiral Peary made his final assault on the North Pole after his eight previous expeditions had failed. By a special strategem, the party was divided into groups, each breaking trail further and then returning to base camp. Peary's group, comprised of himself, his black assistant Matt Henson, and four Eskimos, successfully reached the Pole on April 6, 1909.

THE GRAVEYARD

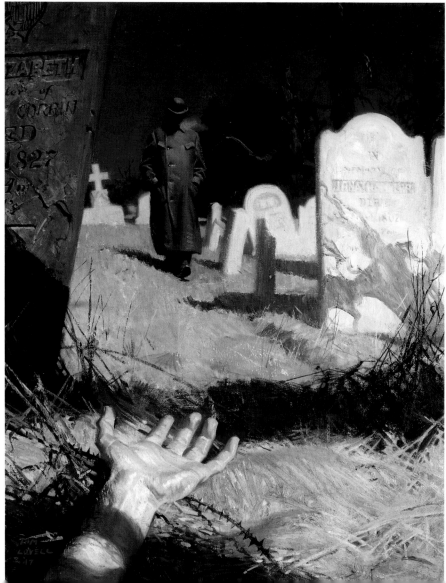

A body is about to be discovered in a moonlit cemetery. One of the functions of the illustrator is to intrigue the viewer into reading the story. The hand of the corpse seems to beckon the reader to find out what happened and to invite its discovery by the approaching figure in the background.

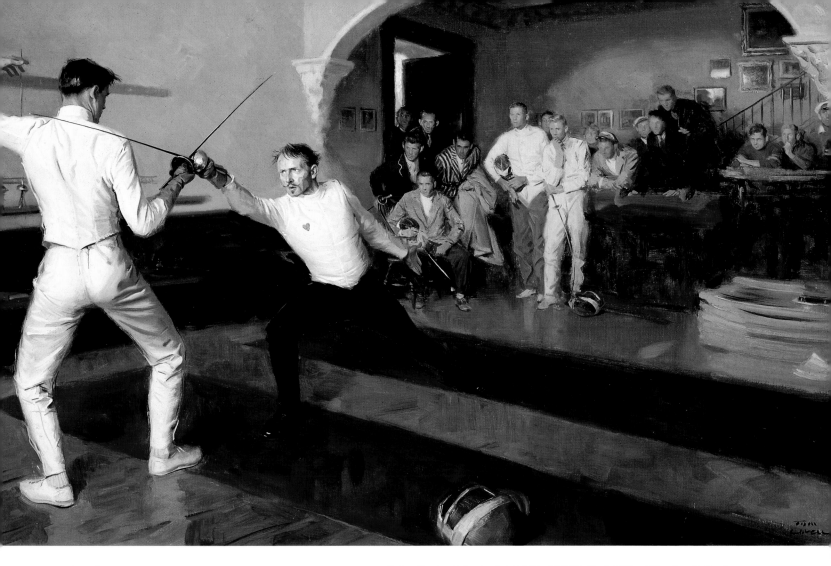

YOUTH AGAINST AGE

A fencing class in a boy's school in Switzerland formed the background for an almost tragic duel between an enraged student and his fencing master. Here Lovell has used the converging lines of perspective, as well as the archway, to focus attention on the central figure of the master.

THE SMOKE-FILLED ROOM

One of the features of the "good old days" was the manipulation of the voters during elections. The most brazen usurpation of the democratic procedure was the nominating process, when party bosses hand-picked their own pliable candidates in private conference rooms. Reporters covering this lengthy deal-making procedure held behind closed doors described the setting as a "smoke-filled room." This descriptive phrase became a cliché for the abuse of power and the need for reform.

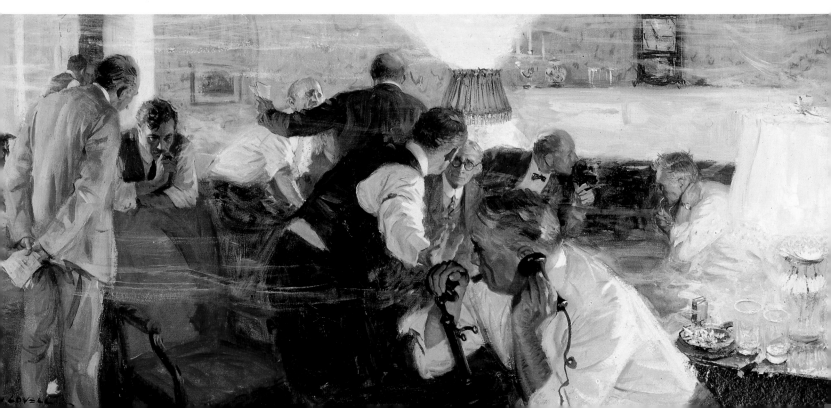

THE CONTINENTAL SOLDIER

This painting was commissioned by the Continental Insurance Company to replace a version done decades earlier by F. C. Yohn as a symbol of the firm. The figure had to appear heroic but also had to be an authentic soldier. Research was done at the West Point Museum, and the painting later won a Gold Medal at the annual exhibition of the Society of Illustrators.

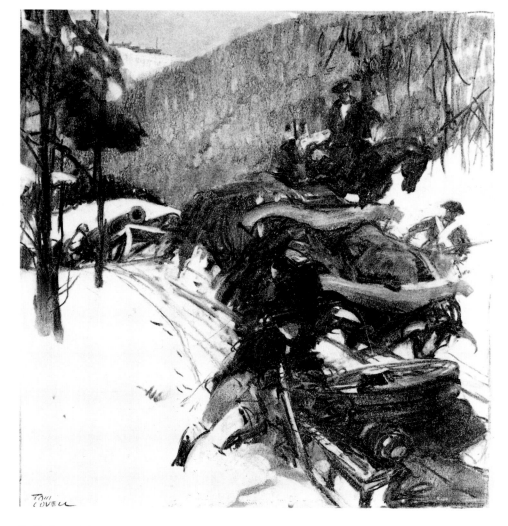

Preliminary Charcoal Sketch

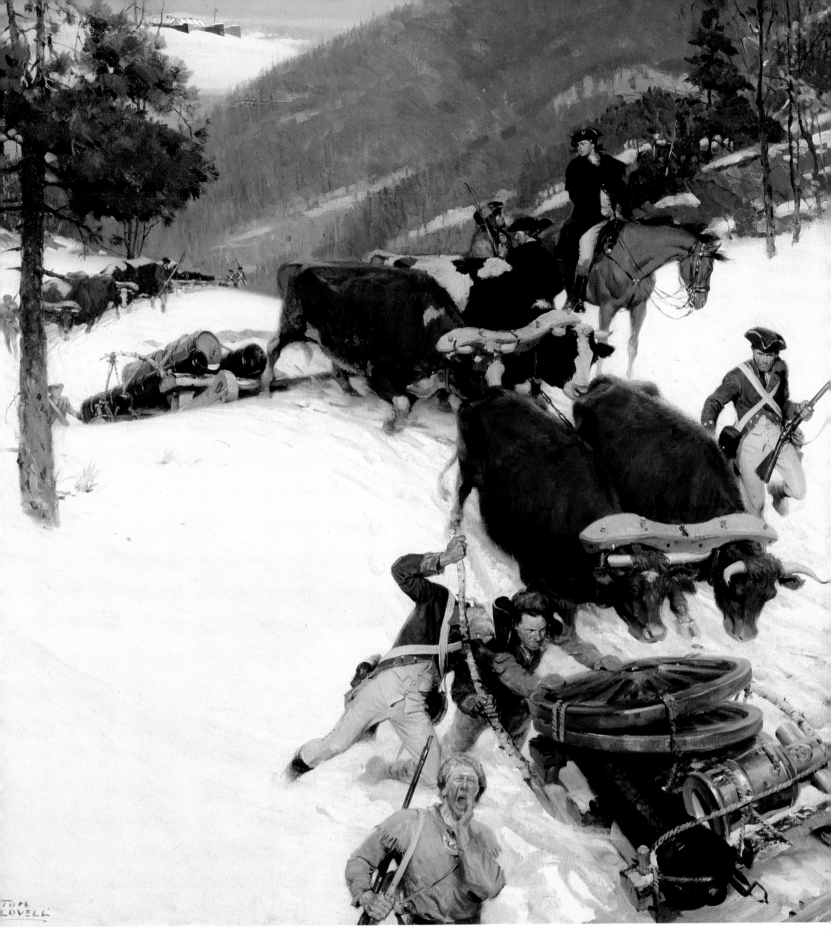

THE NOBLE TRAIN OF ARTILLERY

This was a key picture for Lovell. It was his first major illustration assignment after his military service ended, and it gave him the opportunity to do a subject based upon American history. A visit to the small museum at Fort Ticonderoga provided information on the cannons and mortars. He then made clay models of the oxen team and the cannons. The setting was imaginary but in keeping with the terrain. The finished painting follows its preliminary charcoal study remarkably closely. Appropriately, the painting is now on longterm loan in the permanent collection at the Fort Ticonderoga Museum.

[147]

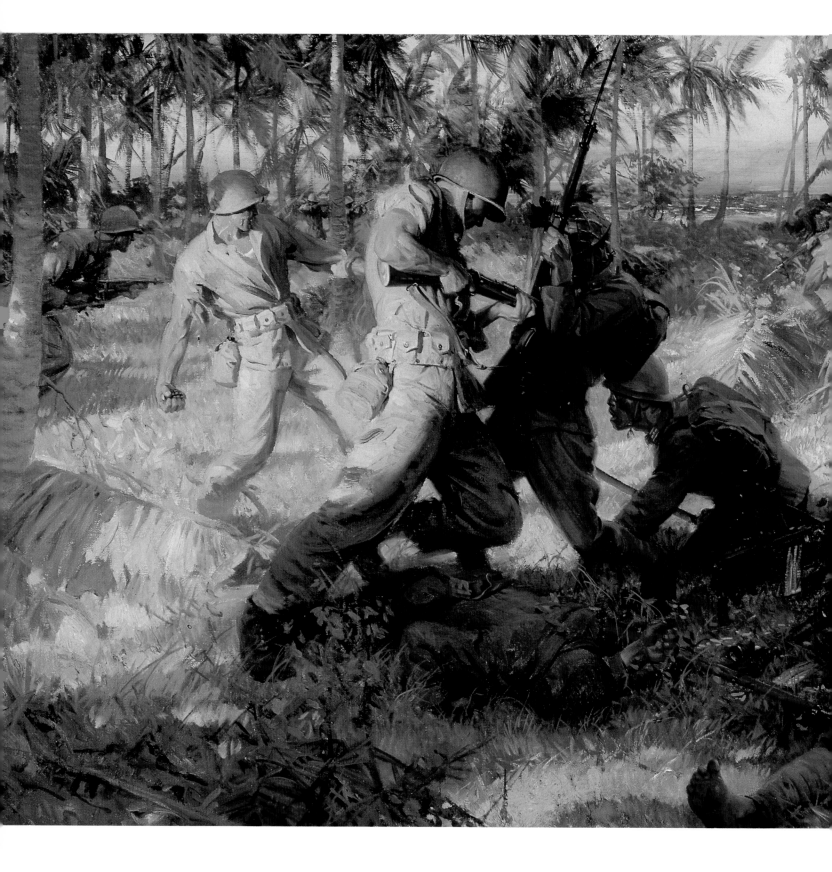

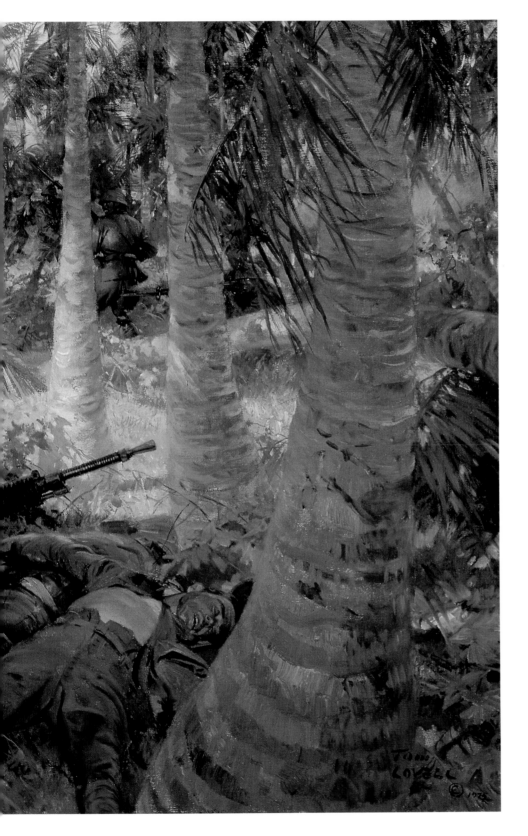

BATTLE
OF TENARU
RIVER

The invasion of Guadalcanal was
another bloody struggle. Here,
depicting the Battle of Tenaru
River, the artist shows the men of
the First Marine Division in
hand-to-hand combat with de-
fending Japanese troops. Unlike
most of the jungle fighting
where visibility was limited to a
few yards, this action takes place
in an open area, formerly a culti-
vated palm grove, with a patch of
the Pacific visible in the back-
ground.

TARAWA LANDING

Next to Iwo Jima, the landing at Tarawa was the bloodiest of the Pacific war. Here, the landing craft of the Second Marine Division are prevented from closer approach by a barricade of steel obstacles imbedded in the sand. The men had to wade the long distance to the beach under intense fire from the dug-in Japanese, whose pillboxes were nearly impervious to naval shelling. Each had to be assaulted, one after another, once the Marines reached shore. A terrible price was paid to take that small but critical atoll.

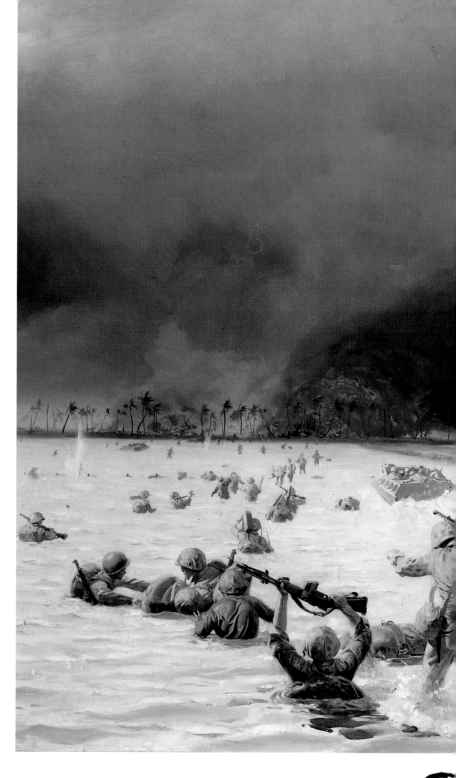

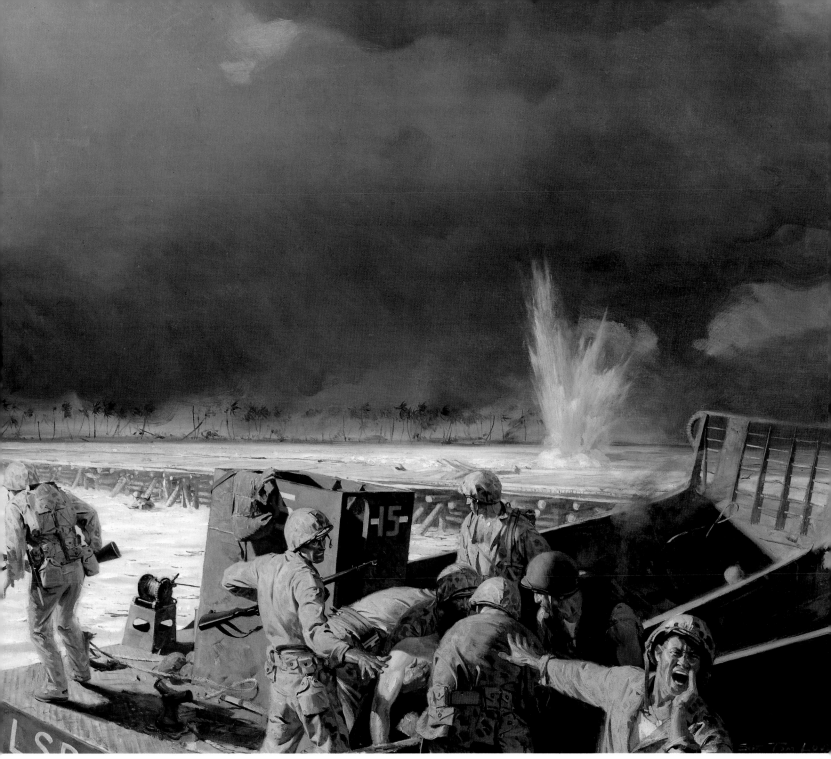

THE PARATROOPERS

When the felt-tip sketching pen was invented, it promised to be a wonderful new tool for artists, with its reservoir of ink in the barrel which could be primed by pushing down on the felt nib. Unfortunately, the nib often dried out at the wrong time. With practice it could be mastered, but, like drybrush, required prior planning and allowed for no mistakes or corrections. This drawing of paratroopers in action owes some of its vigor to the directness required by the pen itself.

VIKING TRADING ON THE VOLGA RIVER

One of a series of paintings done for the National Geographic Society, this depicts the selling of a slave girl for silver coins and other trade goods. The Vikings ranged over all the known water routes; here they are trading with Persian merchants at Bulgar, 1,000 miles up-river on the Volga. The drawing of the girl was to determine the flow of drapery in a river breeze—in this case from an electric fan.

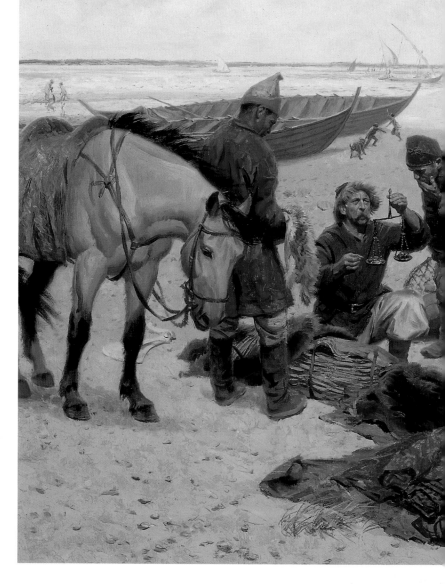

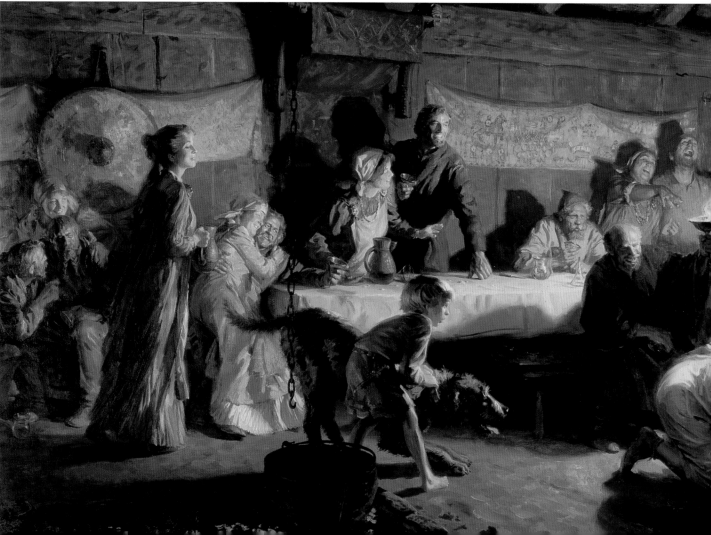

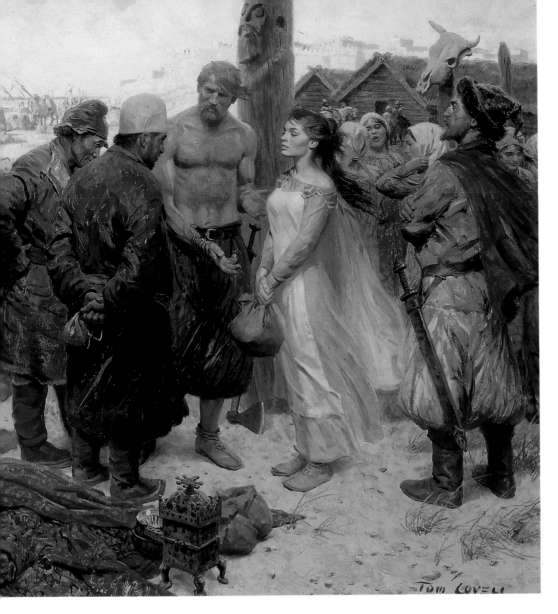

Preliminary Charcoal Sketch

VIKING WINTER FEAST

In reconstructing the by-play of the activities of a Viking feast, each of the figures was planned for its role in telling the story, then posed, clothed or unclothed, to work out the action and anatomy, as well as the light and shadow patterns from the torchlight. This was incorporated into a full-scale cartoon in unfixed charcoal on draftsman's paper. Refinements were then made on the figures, and the cartoon outlines then were transferred to the canvas with a homemade carbon (charcoal) paper.

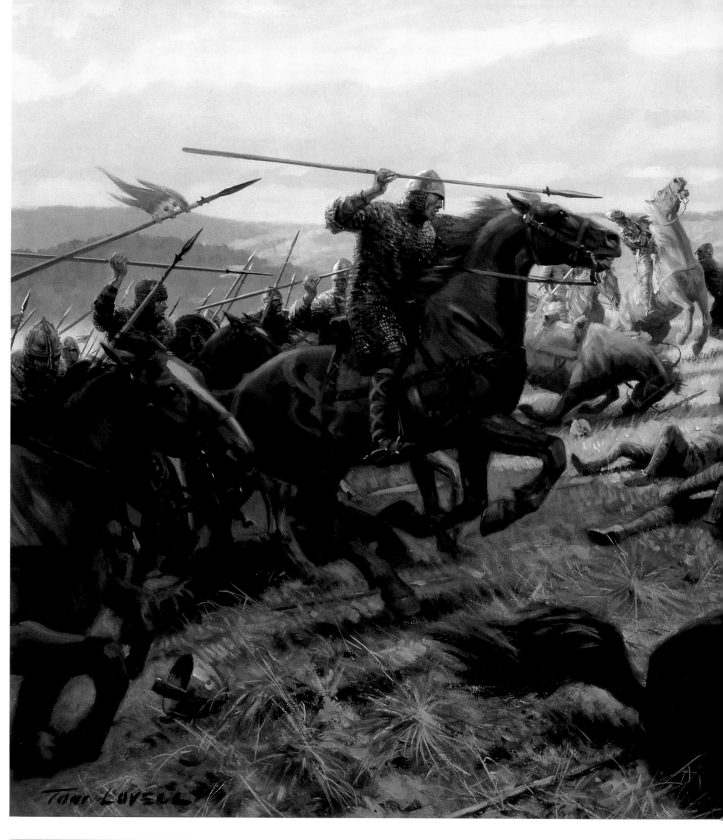

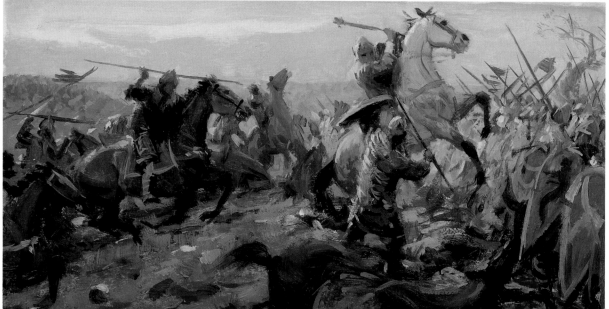

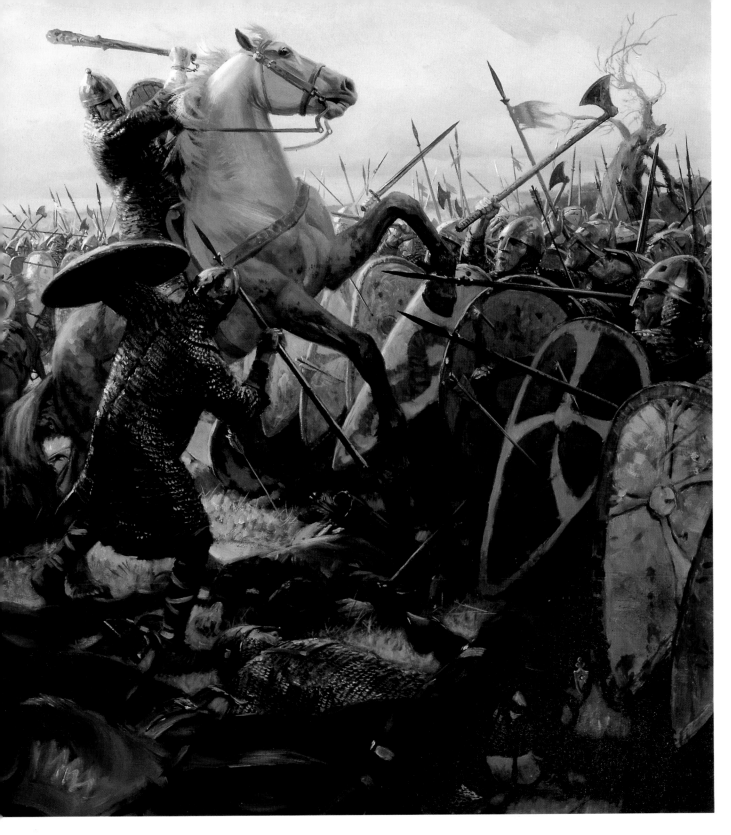

BATTLE OF HASTINGS

This key battle in 1066, a date remembered by every Briton, resulted in a Norman victory over the English King Harold. The battle turned when the Normans, unable to dislodge their adversary from a strong position at the crest of a hill, feigned retreat and drew the English into an exposed pursuit, where they could be counter-attacked by the Norman cavalry. King Harold was killed, and the troops were slaughtered, opening the way for William, Duke of Normandy, to become William the First of England.

Preliminary Oil Sketch

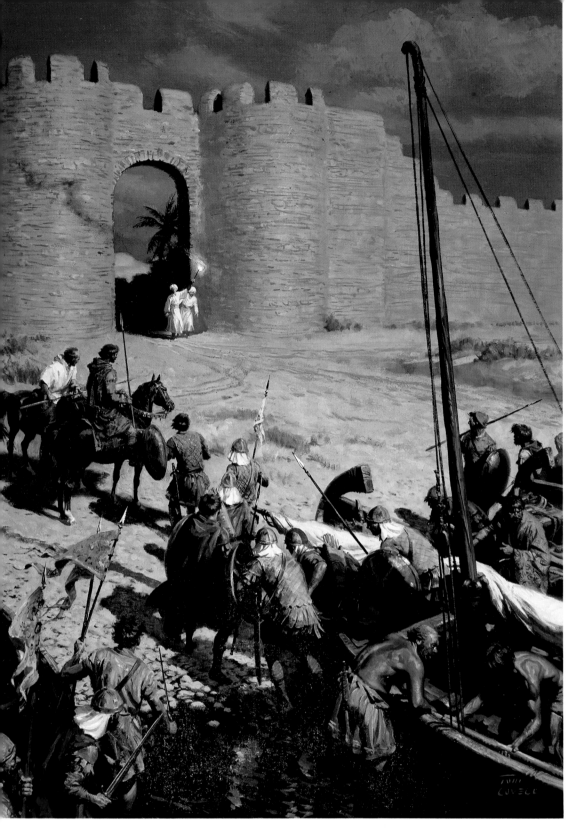

FALL OF NICAEA

After the failure of a long siege and various strategems of assault, it was a collaborator inside the gates who, by signal at night, opened a gate in the wall that led to the invasion and fall of Nicaea.

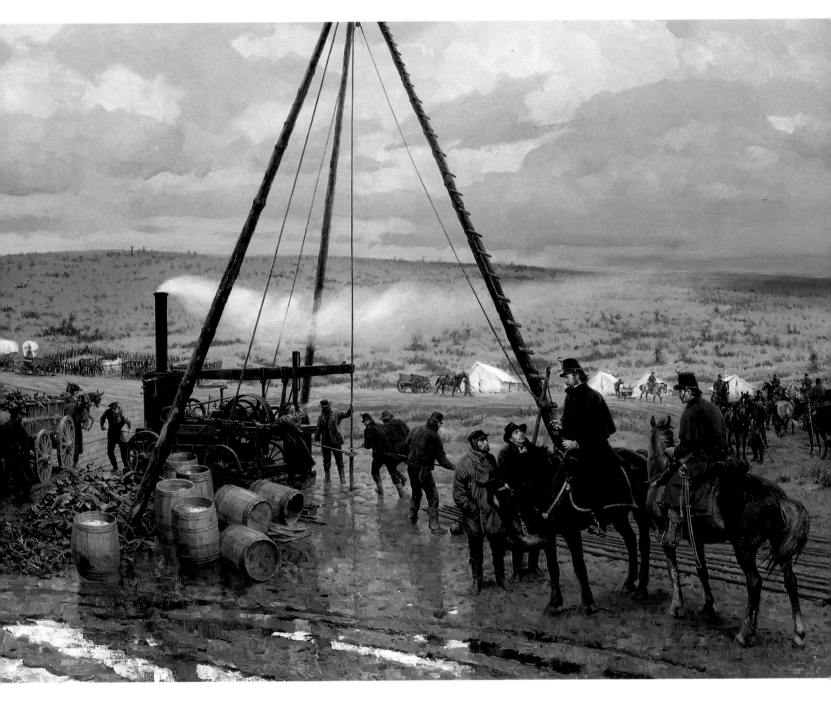

CAPTAIN POPE'S WELLS

This is a large painting from the Permian Basin series, depicting the drilling of the first deep well in West Texas in the 1850s. The well was to provide water for the railroad to be built along the nearby border of New Mexico. Pope was a topographical engineer called in to supervise the project, which required drilling to a phenomenal 1100 feet. The "drills" were oak poles, sixteen feet long, threaded together, which had to be pulled out every two hours to clear the cuttings out of the hole. Everything in the picture had to be reconstructed because none of the equipment had survived. With the guidance of George Abell, Tom made sketches of the steam engine that would have driven the drill, and constructed models of some parts of the operation that were involved. The final painting, from an engineering as well as an artistic standpoint, is an effective reenactment of that early drilling triumph.

THE THAW

A temporary respite from winter's icy grasp gives promise of the better days of spring ahead. So, too, does the raised hand of the mounted warrior, bringing relief to the lonely trapper.

Having taken advantage of the break in the weather to tend his traps, this isolated hunter has encountered, perhaps, his greatest fear. Both men being armed indicates that the days of peaceful coexistence between cultures has passed, but the gesture of peace and sheathed weapon indicate that this warrior does not wish to fight today.

This painting is typical of the work Tom Lovell is best known for today: understated artistic elegance and an enduring faith in the nature of man.

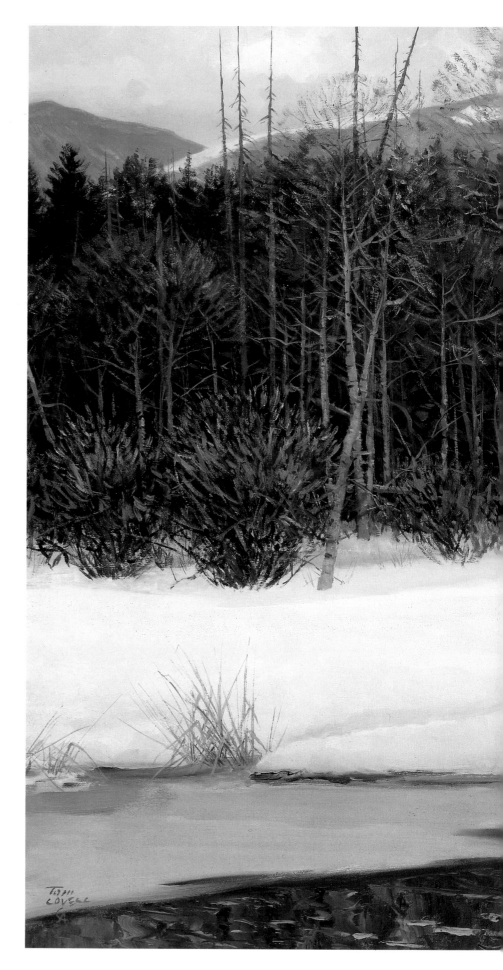

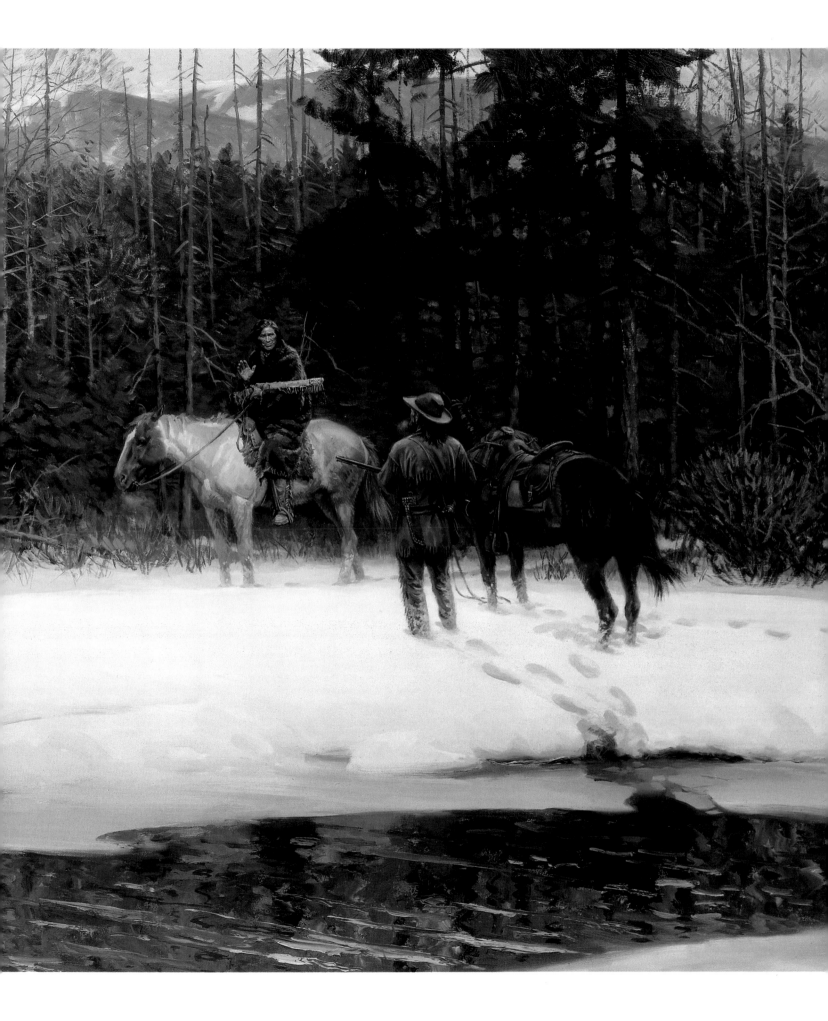

TO A WIND VANE

A copper tern sat poised on a rod
And bowed to the wind all day.
He seemed to say as he looked on high
At the hills of Santa Fe,
"Where is the salt and where is the sea?
For that is the place where I would be."
But the hills just smiled and had their way,

For they knew the tern had come to stay.
The years have passed and the winds still blow
While the copper tern roosts down below,
But now he thinks that the mountains seem
Like the rolling sea in his ancient dream,
And the blue cloud shadows drifting by
Will more than fill his copper eye.

—Tom Lovell

LIST OF PLATES